YOUR PHOTOS STINK!

DAVID BUSCH'S LESSONS IN ELEVATING YOUR PHOTOGRAPHY FROM AWFUL TO AWESOME

David D. Busch | Rob Sheppard

D1404866

Cengage Learning PTR

CENGAGE
Learning®

Professional • Technical • Reference

Australia, Brazil, Japan, Korea, Mexico, Singapore, Spain, United Kingdom, United States

CENGAGE
Learning®

Professional • Technical • Reference

Your Photos Stink!:
David Busch's Lessons in Elevating Your
Photography from Awful to Awesome
David D. Busch, Rob Sheppard

Publisher and General Manager,
Cengage Learning PTR:
Stacy L. Hiquet

Associate Director of Marketing:
Sarah Panella

Manager of Editorial Services:
Heather Talbot

Product Team Manager:
Kevin Harreld

Project Editor:
Jenny Davidson

Series Technical Editor:
Michael D. Sullivan

Interior Layout Tech:
Bill Hartman

Cover Designer:
Luke Fletcher

Indexer:
Katherine Stimson

Proofreader:
Mike Beady

> For product information and technology assistance, contact us at
> **Cengage Learning Customer & Sales Support, 1-800-354-9706**
>
> For permission to use material from this text or product,
> submit all requests online at **cengage.com/permissions**
> Further permissions questions can be emailed to
> **permissionrequest@cengage.com**

All images © David D. Busch and contributors unless otherwise noted.

Library of Congress Control Number: 2014949463

ISBN-13: 978-1-305-08445-2

ISBN-10: 1-305-08445-4

Cengage Learning PTR
20 Channel Center Street
Boston, MA 02210
USA

Cengage Learning is a leading provider of customized learning solutions with office locations around the globe, including Singapore, the United Kingdom, Australia, Mexico, Brazil, and Japan. Locate your local office at: **international.cengage.com/region**

Cengage Learning products are represented in Canada by Nelson Education, Ltd.

For your lifelong learning solutions, visit **cengageptr.com**

Visit our corporate website at **cengage.com**

Printed in Canada
1 2 3 4 5 6 7 16 15 14

For Cathy

Acknowledgments

Once again thanks to the folks at Cengage Learning PTR, who have pioneered publishing digital imaging books in full color at a price anyone can afford. Special thanks to product team manager Kevin Harreld, who always gives me the freedom to let my imagination run free with a topic, as well as my veteran production team including project editor, Jenny Davidson and series technical editor, Mike Sullivan. Also thanks to Bill Hartman, layout; Katherine Stimson, indexing; Mike Beady, proofreading; Luke Fletcher, cover design; and my agent, Carole Jelen, who has the amazing ability to keep both publishers and authors happy.

And many thanks to the members of the Cleveland Photographic Society, who generously provided a huge selection of before/after photos from which the images showcased in this book were selected. This is my second collaboration with CPS (*David Busch's Digital Photography Bucket List: 100 Great Digital Photos You Must Take Before You Die*) and, as always, I was amazed at the quality and variety of images provided by these skilled photographers.

About the Authors

With more than two million books in print, **David D. Busch** is one of the bestselling authors of books on digital photography and imaging technology, and the originator of series like *David Busch's Pro Secrets* and *David Busch's Quick Snap Guides*. He has written dozens of hugely successful guidebooks for the most popular digital camera models, including all-time #1 bestsellers for many of them, additional user guides for other camera models, as well as many popular books devoted to dSLRs, including *Mastering Digital SLR Photography, Fourth Edition* and *Digital SLR Pro Secrets*. As a roving photojournalist for more than 20 years, he illustrated his books, magazine articles, and newspaper reports with award-winning images. He's operated his own commercial studio, suffocated in formal dress while shooting weddings-for-hire, and shot sports for a daily newspaper and upstate New York college. His photos and articles have been published in *Popular Photography, Rangefinder, Professional Photographer*, and hundreds of other publications. He's also reviewed dozens of digital cameras for CNet (CBS Interactive) and *Computer Shopper*.

When About.com named its top five books on Beginning Digital Photography, debuting at the #1 and #2 slots were Busch's *Digital Photography All-In-One Desk Reference for Dummies* and *Mastering Digital Photography*. During the past year, he's had as many as five of his books listed in the Top 20 of Amazon.com's Digital Photography Bestseller list—simultaneously! Busch's 200-plus other books published since 1983 include bestsellers like *David Busch's Quick Snap Guide to Using Digital SLR Lenses*. His advice has been featured on National Public Radio's *All Tech Considered*.

Busch is a member of the Cleveland Photographic Society (www.clevelandphoto.org), which has operated continuously since 1887. You can read more about the Society and the contributing photographers in Appendix A. And be sure to visit Busch's website at http://www.dslrguides.com/blog.

Rob Sheppard is the author/photographer of hundreds of articles about photography and more than 40 books, a well-known speaker and workshop leader, and a Fellow with the North American Nature Photography Association. Rob started photographing when he was 10, built his first darkroom when he was 13, and learned photography when *LIFE* magazine was still around. He had his first photographs published when he was still a teenager and has had his photography featured in books, magazines, and other publications for 40 years.

He was the long-time editor of *Outdoor Photographer* where he was privileged to work with some of the greatest nature photographers from around the world. He has also been a judge in local, regional, and international photo contests, including the prestigious BBC Wildlife Photography Competition. His website is at www.robsheppardphoto.com; his blog is at www.natureandphotography.com.

Contents

Chapter 3
Visualizing in Black-and-White 59

Chapter 4
Creative Cropping 85

Chapter 5
Composition 109

Chapter 6
Exposure 143

Chapter 7
Getting Up Close 157

Chapter 8
Effective Lens FX 185

Chapter 9
HDR Effects 197

Chapter 10
Photoshop Transformations 211

Chapter 11
Cloning and Compositing 241

Chapter 12
Scenics 269

Appendix
About the Photographers 289

Preface

If you're interested in taking your photography to the next level, you'll want to enroll in the camera clinic conducted by expert photographers David Busch and Rob Sheppard, who provide essential lessons in clever ways to elevate your picture-taking skills. Unlike books that emphasize Photoshop trickery, this indispensable guide takes a more holistic approach that starts with capturing the best possible image *right in the camera,* and then fine-tuning it with changes in perspective, better lens selection, cropping, or modest adjustments in an image editor.

While providing a wealth of tips, the authors ease your journey to pixel perfection by giving you a deeper understanding of exactly what elements go into producing an exceptional photograph, and how you can apply those concepts to your own images.

Introduction

Your Photos Stink!

Now that I've gotten your attention, I should probably note that your photos probably *don't* stink, and neither do any of the pictures included as part of the 100-plus individual lessons in this book. It's more likely that you have examined one of your own pictures with the critical eye of someone who is looking to achieve imaging perfection, but who also knows enough to spot what might seem—to you—to be fatal flaws. Every time you look at one of your own shots and muse, "That stinks!" what you are really telling yourself is that you can do better. This book was written to help you look for and spot those future flaws *before* you press the shutter release, so you can capture better images right off the bat, raising the bar as you elevate your photography to a new, more satisfying level. That's what the photographers who contributed images to this book have done: each submitted their first try at a particularly challenging subject, and then showed us what they did to craft a much more satisfying photograph.

Having your photos critiqued is always a little scary. You are putting a little of yourself out for examination and commentary. You are vulnerable. So we have to give the brave souls of the Cleveland Photographic Society, whose photos you see in this book, a great deal of credit. It takes courage to put your work out in front of everyone like this, no matter who is doing the critiques. Given that the contributors are each accomplished photographers in their own right, including well-respected, often-exhibited professionals and non-pros who are every bit as good as those who make their living from photography, their risk-taking is especially impressive.

When I first conceived this book, I asked the Cleveland Photographic Society photographers to search through their own work to find some "before" and "after" images. I wanted them to contribute photographs that they had been dissatisfied with, and pair them with at least one different image that showed how they tackled the problem to produce improved results. To be honest, most of the "before" photographs offered by the 40 contributing photographers don't stink; they are often quite good, and many of us would be happy to capture such an image. However, the best photographers aren't satisfied until they take their work to the next level. So, the "after" shots are generally *much* better, and the photos selected for this book were chosen because they illustrate one or more techniques that can be used in a variety of situations to produce more compelling images.

Rob and I then took these photographs and examined them with a highly critical eye, looking for ways in which even the best of them could be improved even further, and taking the time to explain some interesting techniques and why they work. In some cases, our suggested changes are small; in others, the modifications are simply alternate ways of presenting an image that is already very good. More than a few times we suggested some drastic options that truly transformed the original concept—hopefully, for the better. But each of the lessons in this book was designed to help you boost your photography from its current level (whether awful or average) to awesome.

Of course, when reading the critiques, keep in mind that photography is more art than science, and there is no absolute way of defining "winners" or "losers" in the same way you can measure the performance of runners at a track meet. Photography is, of course, a subjective art and each photographer shoots and edits to his/her own vison. So, the suggestions made here follow generally accepted practices but are not meant to minimize the photographer's original presentation. Critiques are, of course, subjective and cannot be anything else. Art of any kind is always a matter of taste. You may even discover that different critiques in this book may offer what seem to be conflicting ideas. There are no absolutes about photography and the success or failure of any image must be based on how that image and that technique works for its subject and purposes, not with any arbitrary "standard" about what one "must have" for a good photograph. That can mean that what works for one photo might be totally wrong for another.

So, use these lessons as starting points for your own evaluation of your photography. Use them to stimulate discussions with other photographers. You won't always agree with everything you read in this book. That's fine. Use what works for you and ignore the rest while enjoying some of the beautiful photographs seen here. And have some fun thinking about how the ideas you read might or might not apply to your own photos. Then get your camera out and practice those ideas with subjects you care about. Practice does make perfect when it comes to better photography!

Great Techniques

Eye-catching photos can be created right in the camera, without the need to resort to Photoshop tricks. However, the best techniques can involve a combination of camera work and some slight adjustment of tonal values, color balance, or cropping. Throughout this book, I'm going to first show you the photographer's original image, his or her second interpretation of that image, and, in many cases, an additional version with some changes I made.

Fruit Water Splash

Photographer: Mawele Shamaila

This is always such a fun idea! Shots of items dropped into water catch the eye because they are so striking, even in Shamaila's unadorned original image, seen in Figure 1.1. Certainly, many attempts were necessary before the photographer captured this particular shot—and it was worth the effort! The original image has a unique quality because of the angle of the dropping fruit and the pattern and color of the water column following the fruit into the water.

Photographer Techniques:
The photographer shot fruit dropping into water then creatively changed its look by flipping it over and smoothing out the background.

Suggested Improvement Techniques:
Give the subject some space so it does not feel cramped against the top of the frame; look for ways to clean up the background and simplify it.

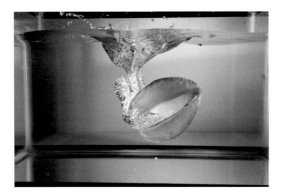

Figure 1.1 Dropping a star fruit into a fish tank was just the start of creating a memorable photo.

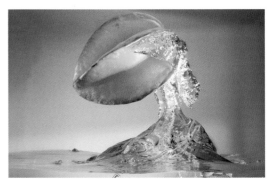

Figure 1.2 Using an inverted camera (or, more logically, by flipping in an image editor), "leaping" fruit is pictured.

Then the photographer did something very creative and unusual—he flipped the picture over so that now it looks like the fruit is exploding out of the water on a column of water erupting from the surface (see Figure 1.2). The lighting on the water column makes it look like ice, and the reflection of the fruit in the water underneath it provides a nice added touch of color.

The photographer cropped tight to the "top" of the inverted fruit to avoid showing the edge of the aquarium, but that makes the image look cramped within the space of the composition. Although the photographer executed the basic idea in the camera, judicious editing can make a great shot even better. Both Photoshop and Photoshop Elements have useful tools to fill in space. So for this image, add space to the top of the photo in either program and then fill that in using the content-aware tools. Immediately, the fruit looks less cramped against the top of the composition, as you can see in Figure 1.3, which features a couple other cleanup techniques I used and will describe next.

Notice the bottom of the image that shows the top of the water line (located at the bottom of the image); that space isn't adding much to the effect. By removing that distracting visual edge, the picture is strengthened. It also brightens the background and minimizes the patterns that are showing up from the light and shadow. Remove the small slashes that look like defects in the image as well.

The patterns in the background are a bit of a distraction even though they are out of focus. The viewer will see those tonal variations and immediately think that this image was captured in an aquarium, rather than fully engaging with the very cool aspects of the shot. The background is fairly easy to replace. Copy the important elements of the photo to a new layer, leaving the background blank. Put an empty layer underneath, as I did for Figure 1.3, and then use the Gradient tool to create a background that shows a change in darkness from top to bottom. Experiment with brightness and contrast. The entire image is strengthened because you don't have the distraction of the shadow lines in the background. As good as the original inverted version was, the final image is much stronger.

Figure 1.3 Minor cleanup of the background and foreground yielded a dramatic image.

Letchworth Infrared Pond

Photographer: Rick Wetterau

Even the original infrared shot of the landscape, shown in Figure 1.4, is excellent. The light to white foliage and dark sky is typical of the dramatic look of infrared. This is a scene that works especially well in infrared, too, and looks like a subject that most photographers might pass on by for normal photography. Wetterau used an infrared converted camera so no IR filter was required over the lens. The viewfinder image was bright and unaltered, and he was able to capture the original image using a normal exposure (no tripod)—in this case 1/250th second at f/8 at ISO 100.

Photographer Techniques:
The photographer captured this photo at a pond at Letchworth State Park in New York State, with a camera converted for infrared shooting, and a wide-angle zoom lens.

Suggested Improvement Techniques:
Apply a special effect consistently over the photograph; darken bright edges so that the viewer's eye stays on the important parts of the picture.

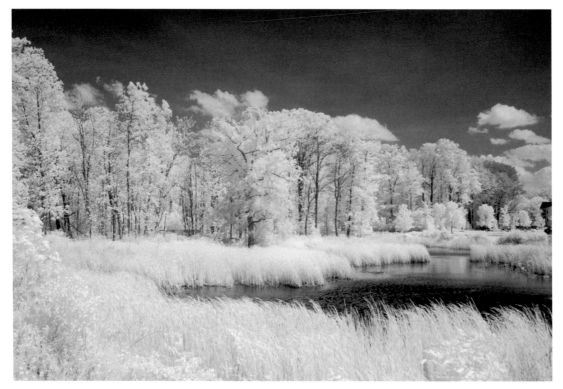

Figure 1.4 When white balance is correctly set for infrared, the image has brick/black/cyan tones.

Then, back home, the photographer performed some traditional IR processing called "channel swapping" that converted the image from the sepia-like rendition you get when an IR camera's white balance is properly set for IR (as opposed to the magenta look that results when white balance is not adjusted). Using the Channel Mixer found in some variation in most image-editing programs, the red channel was set to 0% red and 100% blue, while the blue channel was adjusted to 0% blue and 100% red, yielding the image shown in Figure 1.5.

Probably the most interesting aspect of the second image is the more natural-looking blue sky in the channel-swapped image. The rest of the image has a warm tone to it that contrasts nicely with this blue-toned sky and adds impact. Consider darkening the very bright foliage at the bottom of the photo. That vegetation is so bright that it attracts our eye and fights a little bit with the beautiful scene.

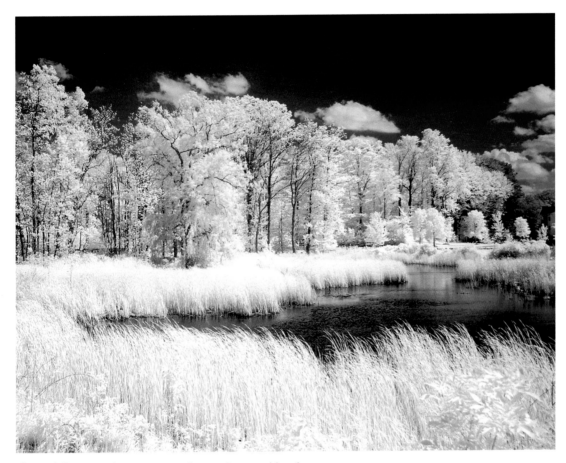

Figure 1.5 Channel swapping produces a dramatic blue sky.

Decisive Moment

Photographer: Susan Onysko

What an amazing opportunity! Two girls in colorful outfits playing on a broken dock. It's a natural moment that would be difficult to plan. But, of course, just as the girls are interacting, a family walks through the middle of the photograph. This happens to all of us in real-world photography situations. We can't make the world stop while we take our picture. (See Figure 1.6.)

But the photographer knew that there was something here worth photographing, so she stayed

Photographer Techniques:
The photographer waited patiently to capture a unique moment of two girls playing on an old dock.

Suggested Improvement Techniques:
Brighten the image slightly to improve the tonal rendition and lighten the dark face.

Figure 1.6 A compelling moment, interrupted by passers-by.

with it. Instead of snapping the photo and later fixing it in an image editor, Onysko waited until she got a remarkable shot (see Figure 1.7). The panoramic perspective along with the simplicity of the space around the girls creates a unique and impactful image.

Andre Cartier-Bresson, considered the father of photojournalism and founder of the Magnum photo agency, was known for a style called *The Decisive Moment* (referring to timing, where everything comes together at the exact right instant to create a memorable image). It was immortalized in his 1952 book of the same name. Many people mistakenly assume that he simply waited, took that one great shot, and that was it. If you ever get a chance to see his proof sheets, you'll see that he did exactly what the photographer did here—lingered and shot photographs until he captured that decisive moment.

The decisive moment the photographer preserved is shown in Figure 1.7. The timing is perfect. The action shot has some really cool qualities that are better than the first photo. The dock, the girl, the leap, the other girl looking back, the reflections—they all come together for a wonderful photograph. Some might feel that the image is slightly underexposed. The whites are gray and the dark tones, especially the face of the jumping girl, are dark. Brightening the image somewhat, including opening up the dark areas, gives the photo more of a sunny-day feeling and adds a touch more life to this already excellent image.

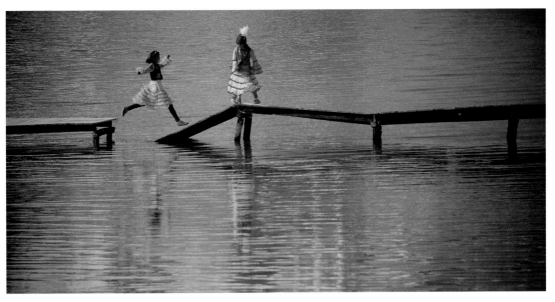

Figure 1.7 Patiently waiting for the decisive moment produced a much more interesting picture.

Swept Away

Photographer: Barbara Pennington

Seashells are classic photographic subjects that make for great photo opportunities. The photographer found an attractive shell and attempted to capture it at the edge of the water and the sand (see Figure 1.8). This image allowed the photographer to connect sand and water, plus show off some of the interesting foam from the waves.

Unfortunately, that edge between water and sand is constantly changing. So as Pennington worked with her subject, its position was moving, which made it difficult to find the right bal-

> **Photographer Techniques:**
> The photographer struggled to capture the image of a seashell that tumbled along at the edge of the surf, so she attached it to a stick to help anchor it in the changing conditions.

> **Suggested Improvement Techniques:**
> Not much. You might consider an alternative crop tighter to the shell and the foam.

ance of seashell, water, foam, and sand. The exposure was good, and use of a telephoto lens for a particular perspective worked, but the shell did not cooperate. Rather than continuing to be frustrated, Pennington attached a stick to the shell to anchor it to the sand. This allowed her to set up the camera in exactly the right spot for the conditions. She found a good angle that allowed some color to reflect on the water as well (see Figure 1.9). The light also added some dimensional qualities to the shell. By anchoring the shell, she was able to carefully plan out the composition of the shot. Although this is already an attractive image, cropping in tighter emphasizes the shell and the foam around it (see Figure 1.10).

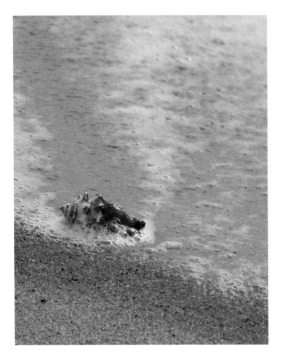

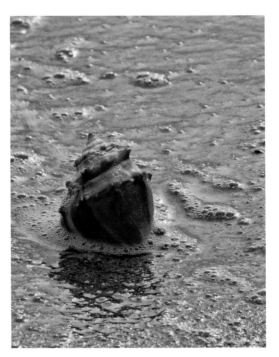

Figure 1.8 A meandering seashell, swept by incoming waves, was difficult to photograph.

Figure 1.9 A stick helped position the shell in place more strategically.

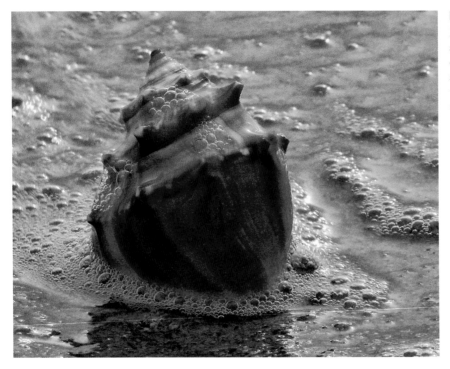

Figure 1.10
Moving in closer for a tighter crop added emphasis to the shell's texture and the surrounding foam.

Flying High

Photographer Susan Bestul found a dramatic moment here, made even more poignant by the fact that Jane Wicker, the wing walker pictured, along with her pilot Charlie Schwenker, were killed in an airshow crash some months after the shot shown in Figure 1.11 was taken. Bestul captured this action against the blank sky and the original image really emphasizes the feat. A blue sky on that overcast day might have been nice from some pictorial point of view, but the blank cloudy sky created a simple background that truly emphasized the plane and the action.

The photographer's original cropping and adjustments definitely emphasized the action even more (see Figure 1.12). The wing walker

> **Photographer Techniques:**
> The photographer brightened the underexposed original image and cropped it to feature the plane.

> **Suggested Improvement Techniques:**
> Blacks and whites could be improved tonally to produce a slightly better rendering of the image, plus there are other options for composition that can emphasize different aspects of the image.

stood out in the image due to the contrast. But the original image had a very distracting out-of-focus flag that needed to be excluded from the original image, and Bestul did just that for Figure 1.12.

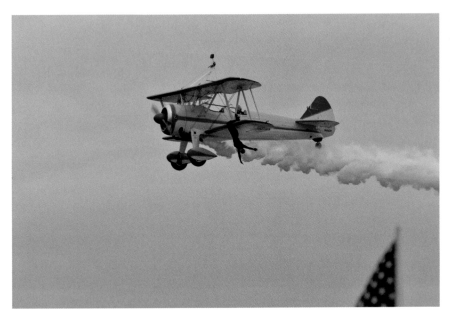

Figure 1.11
An overcast day made the original image appear dull on first glance.

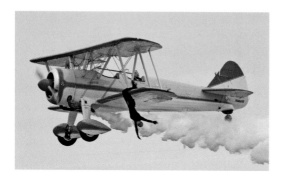

Figure 1.12 However, within the shot was a dramatic moment.

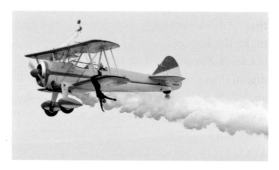

Figure 1.13 The photo can be cropped to show the trailing smoke…

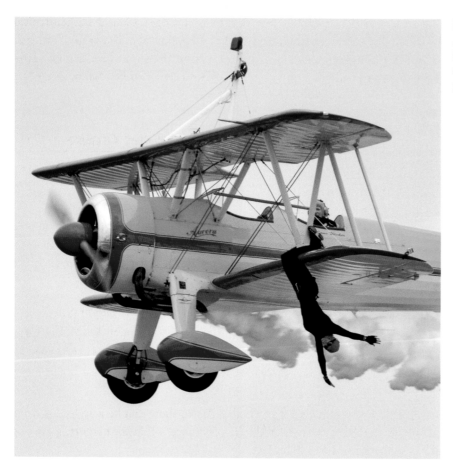

Figure 1.14 …or given a tight focus on the death-defying performance.

The original image was a tad underexposed because of the bright sky. The camera overreacted to that. Still, the photographer was able to brighten the image to bring out color and detail as well as make the background sky look even better. You could go a little further; there are no whites or blacks in the adjusted image. Fine-tuning blacks and whites is an important part of adjusting a digital image, especially when it comes from a RAW file. In order to fully use the range of tonalities and color available in a display or print, you need to adjust the black tones so that some dark area within the image is represented as a pure black and make sure the lightest tones represent a true white.

Although the cropping is great, there are other possibilities. One thing to think about when you crop is that changing the boundaries of an image essentially puts the subject in a box rigidly defined by the edges of the image frame. That isn't necessarily a bad thing, but it doesn't always use the potential of composition to produce a stronger and more effective story.

This type of composition is very dynamic and gives an impression of speed. Consider accentuating the trailing smoke as I did in my version shown in Figure 1.13 (cropped from the original image). Another possibility is to come in tighter with a square composition (shown in Figure 1.14). This emphasizes the wing walker and the pilot in a way that is not shown in any other composition. All in all, this is a great image of two brave performers.

I Can Fly *Photographer: Charles Sefcek*

The low angle on the original shot really captured this biker getting air in this arena. The empty space around the biker definitely gives an impression of height and elevation above the ground (see Figure 1.15).

A tighter crop of the image emphasized the biker and his action with the bike (see Figure 1.16). The photographer processed the photo to give it better blacks and better contrast and color. The original also has a slight greenish cast that is typical of such settings, but the color bias weakens the hues of the rest of the image. By placing the subject more to the right, the biker appears

> **Photographer Techniques:**
> The photographer strengthened contrast and color of the image, including retouching the biker and bike, plus the image was cropped to emphasize the action.

> **Suggested Improvement Techniques:**
> Crop the image to highlight the space below the biker to show that he is soaring through the air.

to have space to fly into. It is important to keep space below him to show that he is indeed getting big air. If you place the subject to the left, you give the feeling of speed—that the biker is flying out of the image very quickly and you had better look fast.

Notice that these examples do not straighten the photo. That makes the red line of the background more dynamic, which reinforces the shot. The cropped version appears more dynamic due to the use of space and angles.

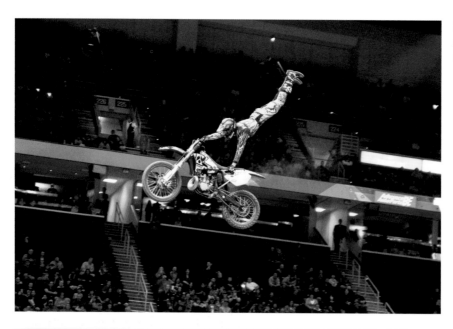

Figure 1.15
A low angle shows the biker in mid air.

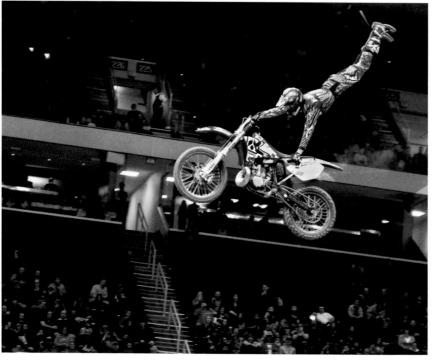

Figure 1.16
Cropping at the top and right side adds to the impression of height and movement toward the left side of the frame.

2

Capturing the Spirits of People and Animals

You probably love to capture your friends, family, neighbors, or even colleagues at work in both candid and more formal portrait settings. Many adventurous photographers enjoy photographing total strangers in street photography or photojournalism scenes. Human beings are the most fascinating subjects of all, with the possible exception of pets and animals, if only because non-humans can be even more unpredictable than their human counterparts.

People and animals provide opportunities for photography with endless variations. Change lighting a bit, and a person can be pictured as sinister, glamorous, playful, or wise. Animals, too, can take on different looks, depending on things that are both under and out of your control. This chapter will show you how some fellow photographers approached capturing the spirit of people and animals.

Daniela *Photographer: Shannon Rice*

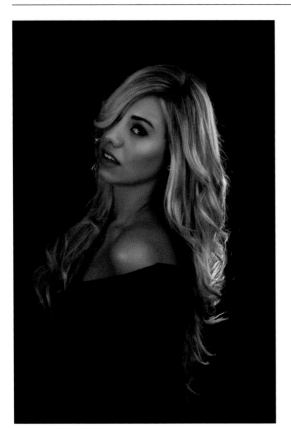

Figure 2.1 Hair lighting emphasized the model's long blonde hair.

> **Photographer Techniques:**
> The photographer snapped a model in a studio, using slight adjustments in posing and lighting to capture a glamorous look.

> **Suggested Improvement Techniques:**
> Refine an over-the-shoulder pose and allow the model's hair to frame her face.

Photographer Shannon Rice understandably wanted to emphasize the striking blonde hair of model Daniela, and, for Figure 2.1, worked with an over-the-shoulder pose with the full length of the young model's hair highlighted with hair lights positioned behind her. The initial effect was great, but there is some room for refinement. Daniela's left side is a bit too heavily cloaked in shadow, and one of her best features—her eyes—don't pop. In portraiture, the eyes should always be sharp, well-lit, and with the most emphasis on the pupils rather than the whites of the eyes.

For Figure 2.2, Rice asked the model to rotate slightly away from the camera, raise her shoulder, bare a little of her left arm, and look directly at the lens, which resulted in a much more effective image. For this portrait, the model's blonde hair provided sufficient separation from the background, so a hair light or background light weren't essential. A pair of soft lights at about 45-degree angles from the axis of the lens provided gorgeous illumination. Having just one eye visible is fine and, in fact, provides a bit of mystery to this image. Daniela's visible eye is bright and sharp, and has a single catch light that makes the eye look alive.

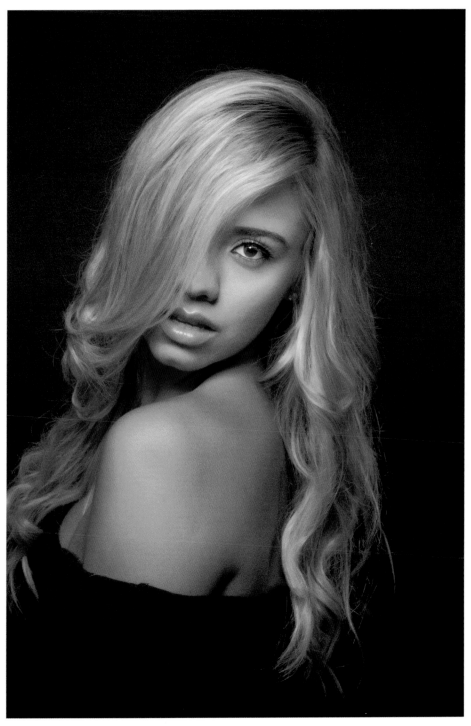

Figure 2.2 A different pose used the model's hair to frame her face.

Girl with Daffodil

Photographer: Ed Rynes

This is a lovely portrait of a young woman—the photographer's granddaughter. Rynes obviously saw a touching moment with this wonderful light and took the picture without worrying about the relatively unattractive surroundings (see Figure 2.3). Sometimes those moments have to be captured when they appear. We still have the ability to control the image to get an attractive photograph even when the setting is not so attractive, as was the case here.

The photographer did a nice job of cropping the photo (see Figure 2.4). The viewer doesn't need

> **Photographer Techniques:**
> The photographer captured a casual portrait of a young woman, then he cropped and processed the image to give it a studio feel.

> **Suggested Improvement Techniques:**
> Balance the brightness at the corners and be aware of how color balance affects the skin tone and mood of the photo.

to see the top of the girl's head. The side of her left arm was fairly bright, anyway, so cropping that out alleviates a distraction from the picture and allows the viewer to focus on the mood of the subject. The eye is always attracted to the brightest portion of an image.

Although this is a wonderful picture, there are some things that can be improved. First, the photographer darkened the hands so much that they are starting to look gray and artificial. Second, the upper-left corner is bright and the upper-right corner is dark, which can be a distraction for the viewer. If both corners were dark, the image would have a dramatic look and stylized appearance.

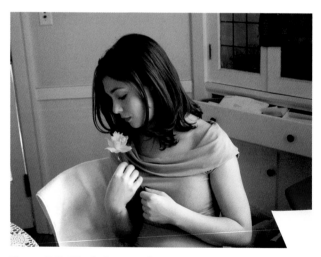

Figure 2.3 The lighting and moment were captivating, even if the background was not.

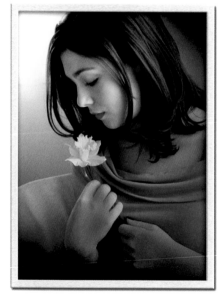

Figure 2.4 Tight framing focused attention on the child.

Rynes' vision is well-conveyed in his presentation and makes for a stunning image. I thought it might be interesting to see the photo in a warmer tone and have presented it here as an alternative.

The photographer changed the color balance (white balance) to what is shown in Figure 2.4, which has a slight blue cast and was not in the original photo. People tend to prefer a slightly warmer tone; however, if you want a moody, melancholy look, then go for a bluer cast that actually reads as a strong mood.

Figure 2.5
An alternative rendition, with the upper-right corner lightened.

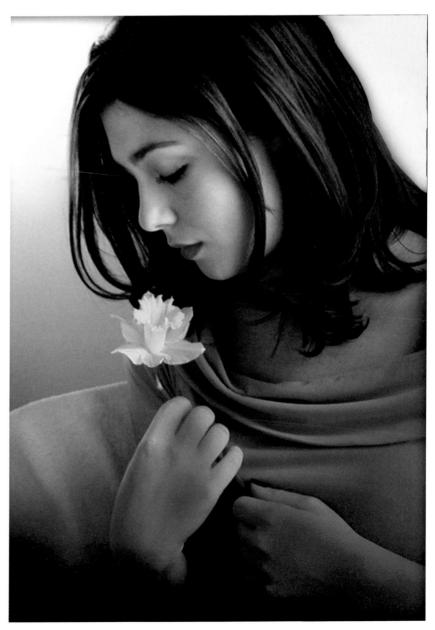

Elinor

This is another lovely portrait of a woman, the photographer's mother, taken with a Lensbaby Scout, using the Sweet 35 optic. She found a perfect moment with this gentle light and took the picture without worrying about the environment around her, as seen in Figure 2.6. The gesture of the woman's hand and the expression on her face combine to produce a genuine image. She is looking off camera at arts and crafts on display at a festival, Balluck reports. She is engaged and that improves the portrait.

The photographer cropped in tight to the subject to show off her personality and features (see Figure 2.7). Balluck then cropped the image

> **Photographer Techniques:**
> The photographer captured a woman at a nice moment with gentle light, then cropped the image and converted it to black-and-white.

> **Suggested Improvement Techniques:**
> Nothing needs to be improved from the adjusted image. A great-looking color photo from this original shot as well as a variation in cropping adds to the portrait.

into a vertical that emphasized a nice head-and-shoulders portrait. The border treatment is effective and works well with the portrait. The original shot had a soft light, but needed some slight modifications to bring out the features of the subject's face. Balluck still retained detail in her mother's white hair. Then she changed the image to an attractive black-and-white interpretation with a sepia tone.

Figure 2.6
The photographer captured her mother as she viewed arts and crafts.

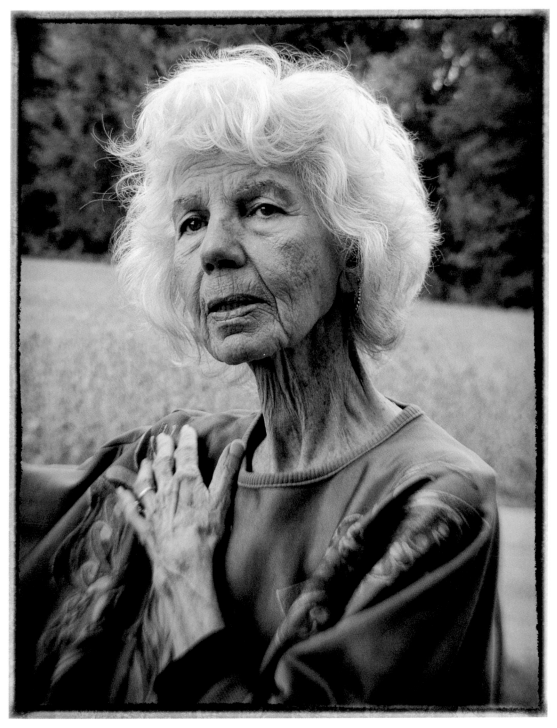

Figure 2.7 A formal portrait extracted from a snapshot.

The original image has some nice characteristics to it as a color photo. (See Figure 2.8.) The colors look bright and lively and give personality to the subject. It also looks interesting cropped. It's simply a different interpretation of the scene and provides a different impression of what the woman is doing.

Figure 2.8
A brightened and cropped version of the original color "snapshot" makes an excellent photo, too.

Civil War Reenactor *Photographer: Brian O'Riordan*

Civil War reenactments have become very popular and are a great opportunity for photography. The performers by and large love what they do and are open to being photographed in all of their costumed glory. At a reenactment at Hale Farm and Village in Northeast Ohio, photographer Brian O'Riordan captured a reenactor who definitely looks the part (see Figure 2.9).

This was obviously a grab shot, so the photographer had to take what was available for the background—a cluttered, busy, and distracting assemblage. O'Riordan cropped in to the man's

Photographer Techniques:
The photographer captured a Civil War reenactor against a busy, unattractive background, so he cropped the image to emphasize the man's face.

Suggested Improvement Techniques:
Keep in mind the original objective for taking a photograph then crop and process to emphasize it.

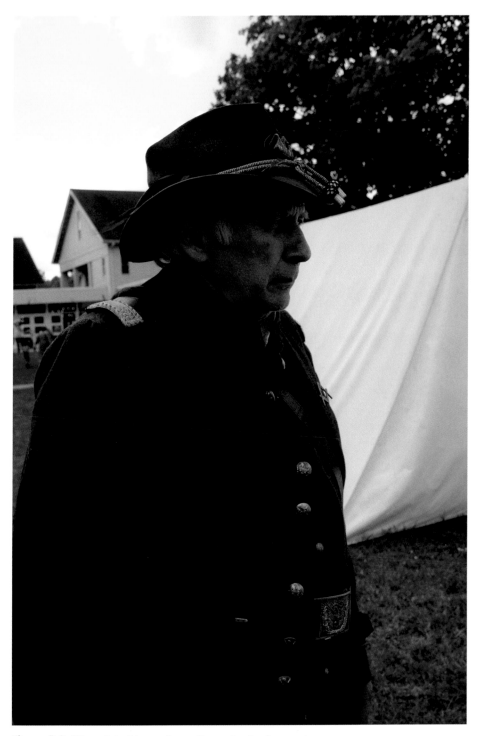

Figure 2.9 The original image has a distracting background.

face and created a tight portrait (see Figure 2.10). The processing of the image and the crop definitely emphasized the face and brought out the character of the man. But the crop was so tight that we don't see much evidence of the Civil War dress and accessories.

Judicious cropping of the original photo would have provided more details of the setting (see Figure 2.11). Also, getting rid of the black tones within the image and changing the image to a black-and-white image with sepia tones provides a more vintage look (see Figure 2.12).

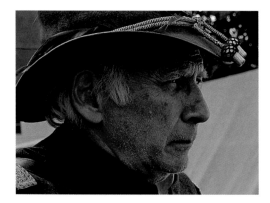

Figure 2.10 A very tight crop removes some of the historical flavor.

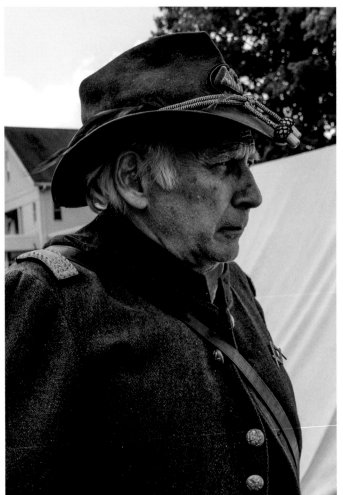

Figure 2.11
A less severe crop retains the Civil War look.

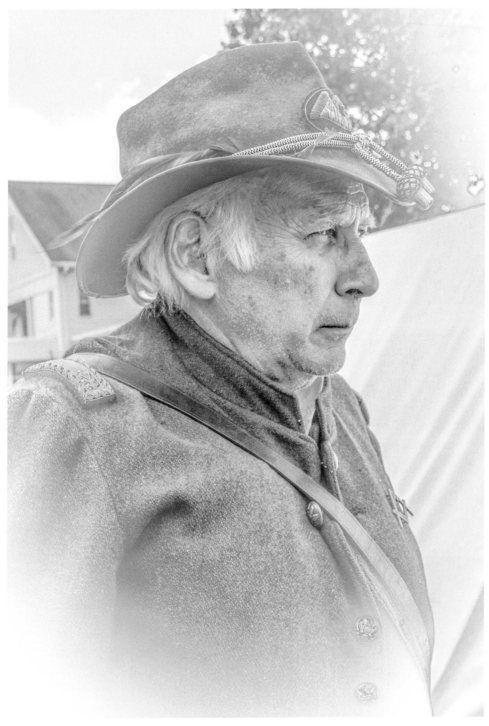

Figure 2.12 Fading the image creates a vintage look reminiscent of a Daguerreotype.

Old Blue Eyes

Photographer: Susan Bestul

The photographer placed the camera at a perfect height to capture her subject's beautiful blue eyes—at eye-level to the subject, which positioned the brim of the hat so that it revealed the eyes without cloaking them in shadow.

The photographer recognized that the bright triangles at the upper corners were distractions, so she cropped the photo to remove them from the image (see Figure 2.14). Bestul also removed a dark, out-of-focus pole behind the man's head at the top of the frame, keeping his hat to add character to the shot.

Her slight adjustment of the colors in Figure 2.14 increased the saturation to get better color in his eyes. Since this also reddened his face a bit, I used the HSL panel found in many image editors to tone down only the red channel. With this minor change, the eyes actually gained more presence as well as giving a more pleasing

> **Photographer Techniques:**
> The photographer took an engaging photo of a man with striking blue eyes, then removed the distractions at the upper corners and adjusted the color.

> **Suggested Improvement Techniques:**
> Avoid increasing the saturation of all colors when you really need to enrich the hues of just one. The Hue/Saturation/Lightness control of many image editors can be used to enhance one color without oversaturating the others. Try some darkening of the photo away from the man's face to give it more emphasis in the image.

look to his face (see Figure 2.15). For this version, I also experimented with some simple darkening of the photo away from the man's face. This is a traditional darkroom technique used for portraits and works very well on this image.

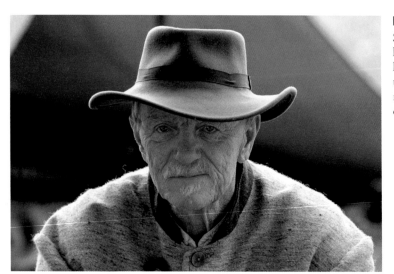

Figure 2.13
Shooting at eye-level kept the brim of the hat from obscuring the gentleman's remarkable blue eyes.

Figure 2.14
Brightening the image helped bring out details in his face.

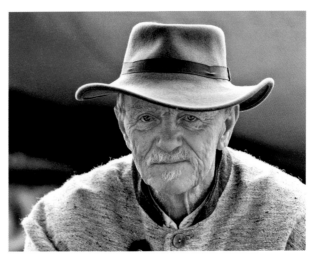

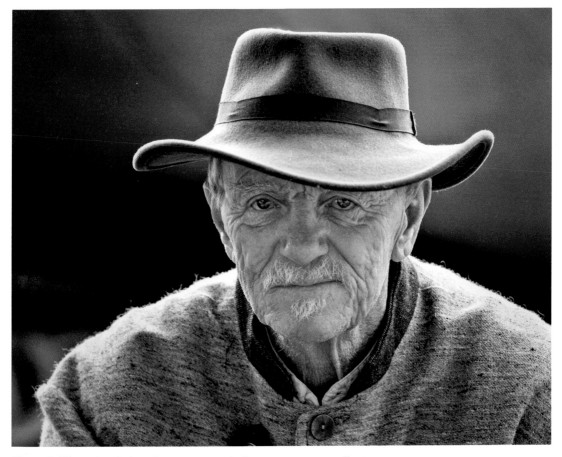

Figure 2.15 With a slight color cast removed, the portrait is quite effective.

Rick

Photographer: Nancy Balluck

There is definitely a nice moment captured in this portrait, which the photographer says was inspired by the "look" of actor Jeff Bridges in the movie *True Grit*. (See Figure 2.16.) The pensive thoughts of this man were captured as he smoked a cigarette. His face is well lit and there is an interesting contrast in colors between the man and the background. Balluck used a Lensbaby Composer lens with Double Glass Optic and a very wide f/stop to create sharpness around his face, but allowed the rest of the picture to be blurred. The color photo is attractive, though the colors in some ways are contrary to the mood of the man and the moment.

> **Photographer Techniques:**
> The photographer spotted a man in a relaxed state and captured a candid and casual portrait.

> **Suggested Improvement Techniques:**
> None.

The photographer cropped the photo to tighten the composition, then changed it to stark black-and-white (see Figure 2.17). She added a strong vignette around the outside of the image as a dramatic touch, then used a slight sepia tone to give the photo some color.

Balluck made some very interesting and effective choices in how she refined this photo. It's interesting that she cropped it to such a degree that the Lensbaby effect is no longer all that obvious. In translating the colors into black-and-white, she kept the blue dark and made the red dark as well. This is a good choice because it highlights the smoke and places strong emphasis on the man's face.

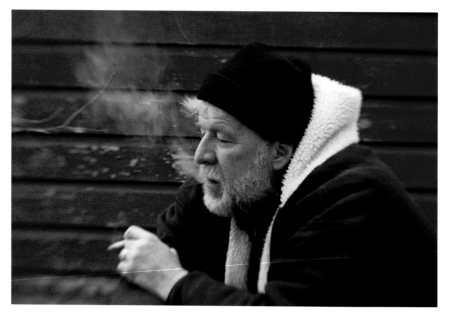

Figure 2.16
The color version is a great portrait.

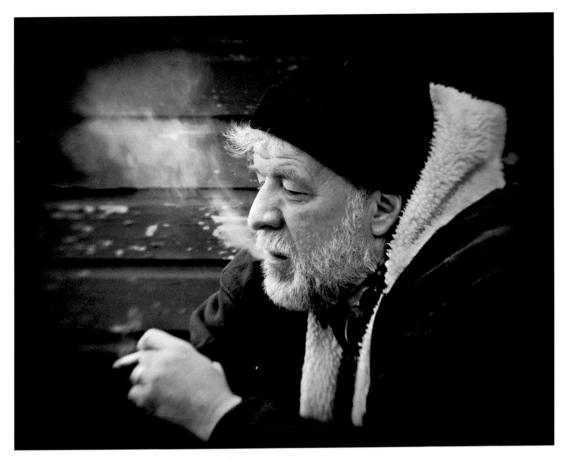

Figure 2.17 In black-and-white, the image has even greater impact.

If the background red was lighter, the picture would lose a lot of the great mood that the photographer has established, even with the dark vignette around the outside of the photo.

That dark vignette is very effective for this photo. It is strong and obvious, but it's entirely appropriate for the mood of the image. Without that darkening, the photograph is not as dramatic (see Figure 2.18). The photographer did not follow arbitrary rules about how to use such darkening and instead paid attention to what the photograph needed.

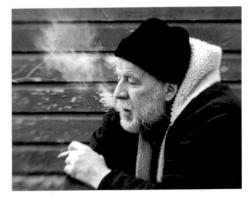

Figure 2.18 Without the vignetting, the photograph is not as dramatic.

Kayla's Concert

Photographer: Joe Polevoi

Digital photography opened up opportunities for getting better shots under existing light because you can use such high ISO settings. Polevoi shot these images at ISO 3200 and got outstanding results, something that was not possible with color film of the past.

This is a great example of the photographer being alert and ready to capture nice moments. The first shot is okay—it certainly shows off the performers (see Figure 2.19). But the second shot captured the expressive moment when the young women were celebrating their performance (see Figure 2.20). That is a terrific moment captured because the photographer was prepared.

Photographer Techniques:
The photographer at a student concert captured the soloists after their performance and caught an expressive moment that went beyond the standard shot.

Suggested Improvement Techniques:
Open up the darkest parts of the photo slightly, then use noise reduction techniques and darken the outer part of the photo to better emphasize the subjects.

Even with all the advances in digital technology, digital cameras still struggle with the darkest parts of an image. It was worth spending a little time on this photo to get a slightly better recognition of the darkest tones without affecting the bright tones. This made the hair and shirts of the subjects stand out. Shooting at such a high ISO resulted in noise, which showed up especially in the background and the darker areas of the photo. Simply using some noise reduction adjustments, such as those of Lightroom or Camera Raw, gave the image a better look and reduced the problems of noise.

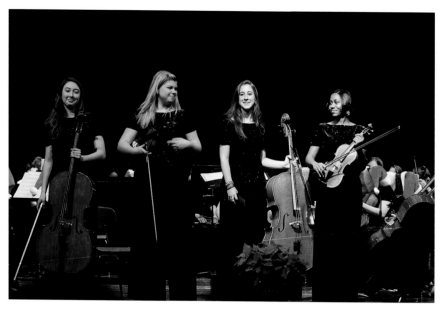

Figure 2.19
After the concert, the performers await the applause of the audience.

Figure 2.20
Seconds later, their exhilaration is obvious.

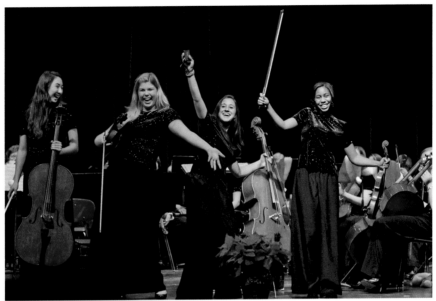

Consider darkening the outer parts of the photo. Seeing a little bit of the orchestra and the background gives context to the photo, but they don't need to be as bright as the performers. Darkening the outer edges of the photo provides a spotlight on the girls, which emphasizes them in the photograph.

Chris-to-pher *Photographer: Angelo Jacobs*

This is a lovely, simple portrait of a young boy (see Figure 2.21). The photographer was down at the level of the child—an important practice to help the viewer engage with the photo. The boy's eyes express familiarity and comfort with the photographer. This gives the image a sense of presence that holds the viewer's attention.

Jacobs converted the color to black-and-white (see Figure 2.22). He also toned down the upper right and left corners, which were a distraction, and darkened some of the areas away from him, which does help emphasize the child within the picture. The image certainly is a pleasant black-and-white photo.

Photographer Techniques:
The photographer created a nice portrait of a child in his bedroom then converted the color photo to black-and-white.

Suggested Improvement Techniques:
Watch how colors are translated into different shades of gray to achieve the optimum black-and-white tonalities.

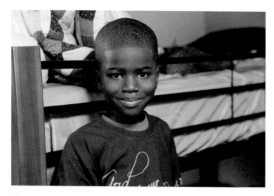

Figure 2.21 A lovely portrait of a child, shot at eye-level for the best perspective.

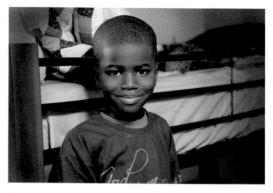

Figure 2.22 In black-and-white the image has a classic look.

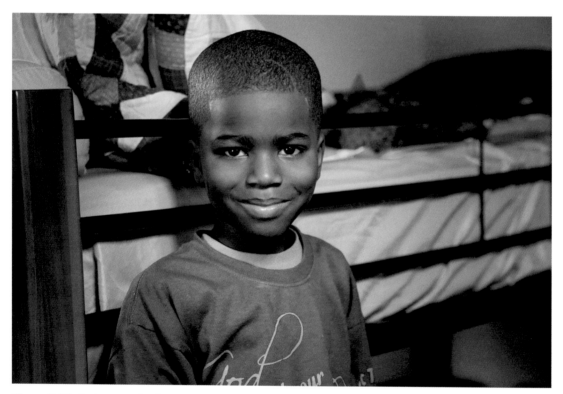

Figure 2.23 Lightening the shirt emphasizes his face.

There are a couple of things that keep the photo from being optimum in black-and-white. Conversion to black-and-white is never simply about removing color. It's always about how colors are translated into different shades of gray. I chose to lighten the shirt, as shown in Figure 2.23, adding some more dimension to the image.

The color version of the image is actually quite attractive. By just darkening the upper-left corner and entire left side of the image, then darkening some of the surrounding areas, the photographer created a colorful and interesting photograph (see Figure 2.24). The different colors add dimension to the image.

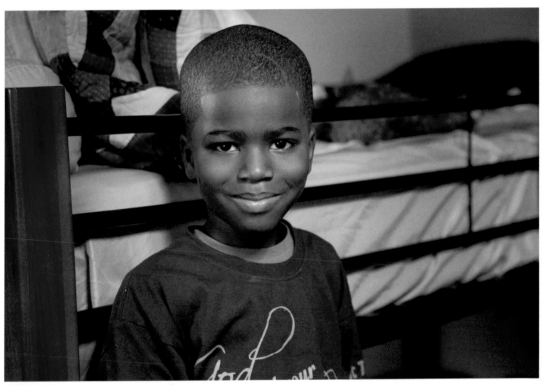

Figure 2.24 The color version can be improved with some darkening at the edges and corners.

Grandson
Photographer: Robert Boyle

These two photos are a great example of how important it can be to get down at the level of the subject. The first image (see Figure 2.25) was taken from above, from a typical adult height. The composition is interesting, but there was very little engagement with the subject.

In the second image, Boyle got down to the level of the child. The viewer is now engaged and feels like part of the boy's environment (see Figure 2.26). Even with the distractions of the dark furniture at the right, the boxes at the left, a harsh shadow on the background, and the very bright foreground, the viewer is still drawn to the child's face and his intense concentration.

> **Photographer Techniques:**
> The photographer changed the angles for a photograph of a child, trying a low perspective and settling on a shot at the child's eye level.

> **Suggested Improvement Techniques:**
> Crop the image to remove distractions around the edges. Correct the blue color cast on the boy's face and then tone down distractions.

Figure 2.25 When you photograph a child from an adult's perspective, the viewer doesn't engage well with the youngster.

Figure 2.26 Moving down to the boy's level is much more effective.

Simply cropping the photo made the image stronger (see Figure 2.27). This got rid of some of the distractions in the background and removed a portion of that bright foreground resulting from the use of the flash. The boy became more important in the photograph as well.

However, there are two white balances. The camera provided a pleasant warm white balance, but the color of the light was not the same as the light from the flash. The flash created a colder light on the boy's face. Lightroom and Camera Raw offer an Adjustment Brush tool that allows you to change the white balance of a small area of the photograph without affecting the rest of it. The image is improved when the boy's face is a warmer color.

The image was strengthened even further by darkening the outer areas of the photograph, toning down the bright rug at the bottom, softening the harsh edge of the flash shadow on the back wall, and reducing the saturation of the green box by the boy's head.

Figure 2.27
Tighter cropping
makes the picture
even better.

Melanie

This is an appealing portrait of a woman (see Figure 2.28) in a relaxed and comfortable pose. The photographer was close to eye-level and connected directly with this woman through her eyes. This gave the image a strong sense of presence. The light was simple and dramatic with a dark background.

The photographer corrected the image in the cropped photo (see Figure 2.29). Now the space is being used in an interesting way rather than simply centering the subject in the photograph.

> **Photographer Techniques:**
> The photographer captured an attractive portrait of a woman against a black background, then processed the photo for better color and tonality.

> **Suggested Improvement Techniques:**
> Be very wary of underexposure. It can cause problems with color, tonality, and noise. Watch the edges of the photo to avoid awkward cropping.

Figure 2.28 The original image looks flat.

Figure 2.29 Brightening and cropping makes the off-center pose more effective.

The composition provides some interesting cropping options because it's not a strong rectangular shape, yet it's not a square either. When framing approaches that of a square, often it's better to go ahead and use that square composition so that you use the space in a more deliberate way.

There are other more traditional options for cropping—4 × 5 or 4 × 3. When you use these proportions on the already cropped photo, something interesting happens. The top of the head is cropped. (See Figure 2.30.) That's not necessarily a bad thing. Notice how strong her eyes become. When you show the entire head of a person, you're telling the viewer that the top of the head is important. When you crop into the top of the head, you force the viewer to look at the rest of the photo, especially the eyes. This is a very modern and impactful way of cropping.

Along with being cautious in how you use the edges of the photo as you shoot, you also have to be careful of the exposure. You can underexpose a photo and get a decent-looking image, as the

photographer has done. However, if you look at the histogram, you can see a huge gap on the right side (see Figure 2.31). This means severe underexposure, which crowds most of the tones in the image into the shadow areas. Because of the way light works, sensors are not adept at capturing subtle variations in tones and color in darker areas, and tend to exhibit more noise.

Figure 2.30
A horizontal composition also works; you don't have to include the top of the subject's head.

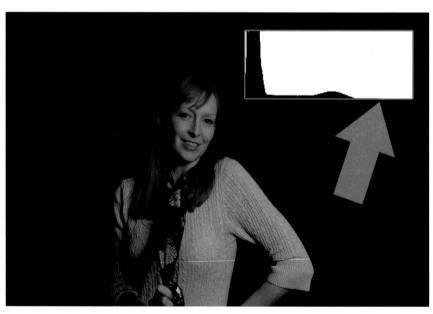

Figure 2.31
Check the histograms: when there are no tones at the right side, the photo is underexposed.

Model

Photographer: Ed Rynes

The two initial images show classic formal portraits (see Figure 2.32, left and right). The difference between the two is in the eye contact, and this obviously shows how important the placement of the eyes can be. The first image does show the importance of eyes within a portrait though.

The photographer shot at eye-level to the subject. In the first image, Rynes kept the top of the woman's head in the frame, and in the second, he did not. That is an especially interesting way of dealing with a portrait. As mentioned, when you crop into the top of a person's head, the eyes are emphasized even more.

> **Photographer Techniques:**
> The photographer captured a young woman in a stylized pose, first looking away and then looking at the camera.

> **Suggested Improvement Techniques:**
> When changing the background, be aware of what happens along the edges of the subject—viewers will notice. Be careful when using skin softening software that the skin still looks natural.

Figure 2.32 Left, the model is looking away from the camera. Right, she's looking directly at the lens.

In the first image, the background looks like mini-blinds. The photographer darkened the background to simplify it, but, in this case, the girl's hair started to blend into that new, dark background. A little outline remained and became a distraction. I recommend adding a radial gradient in an image editor that progresses from dark gray behind the woman to black at the edges, as seen in Figure 2.32, right. This allows her hair to show up and still preserves a dramatic look.

The photographer also used skin-enhancing techniques. When overused this software makes skin look unrealistic and doll like. It's an older style of editing portraits and sometimes makes the picture look dated. Don't be afraid to back off such an adjustment to maintain the appropriate skin texture. The technique should be applied similarly on all of the skin to avoid mismatches. Look at the model's upper chest and you'll see that the skin there has not been affected, producing an odd look because the skin of the chest looks so different from the skin of the face.

Child *Photographer: Ed Rynes*

Here is another pair of good images from photographer Ed Rynes. Kids can sometimes be a challenge to work with, but the photographer has obviously created a rapport with this girl to capture these intimate portraits. Both images are nicely composed and shot at the level of the child.

The first image is cute but the photographer didn't connect with the child very well (see Figure 2.33, left). She was obviously distracted. In the second image, the photographer found a way to coax a very cute pose from the girl (see Figure 2.33, right). Comparing the two emphasizes the importance of always capturing multiple images with any subject, and, especially when shooting children. The second pose works well with the girl, the dress, and the basket. Some slight image processing gave the image a painterly look, which works well with this composition and subject matter.

> **Photographer Techniques:**
> The photographer captured a young girl posing with a basket, with two poses, including a full profile.

> **Suggested Improvement Techniques:**
> Watch out for distracting details around a person's face; balance out tonalities between a face and the rest of the picture. Try darkening the outer parts of the photo to keep the viewer's eyes on the girl.

One challenge is what to do with the distracting details surrounding the girl's face. There are a couple of white lines that appear on her chin and under her nose. Their brightness makes them visually connected with her face. Details like these are important, especially when they involve facial features. The face is always a focal point of a portrait. If those distractions were near the hem of her dress, they might not be noticeable.

The girl's face is a little dark compared to very bright areas of her dress, making those areas out of balance with each other. In Figure 2.34, I've darkened the bright areas of the dress and brightened the face to make sure that the emphasis is on the face. A little darkening of the outer parts of the frame away from the girl helps define the image a little better and add a more dimensional quality to it.

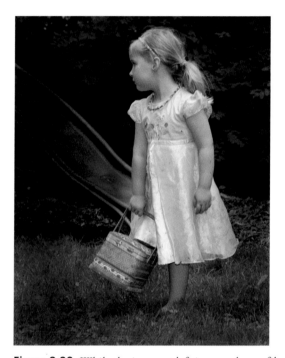 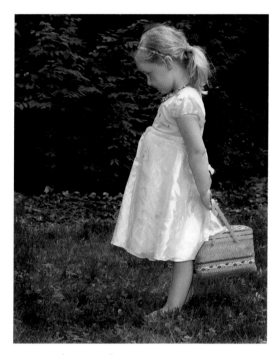

Figure 2.33 While the image at left is cute, the profile version at right is even better.

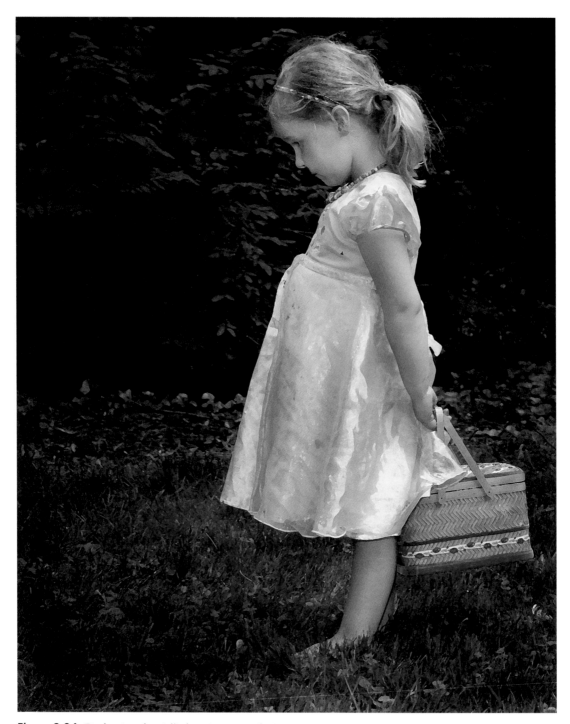

Figure 2.34 Darkening the girl's dress improves the image.

Tunisian Family

Photographer: Jon Theobald

The first image is a nice shot of the family, but the eyes of the mom and dad are cast in one direction, while the boy's are looking in a completely different direction. (See Figure 2.35, left.) This definitely detracts from the photograph. In the second image (Figure 2.35, right), the photographer was able to work with them to improve the pose and capture an image where they are all looking at the camera. This produces a much stronger image.

The biggest challenge is that the photographer was standing relatively far away from his subjects. The big expanse of white wall does not add anything to the image. Simply cropping the frame to focus on the family gives them more presence within the photograph (see Figure 2.36). The green object on the wall is definitely a distraction and can be removed with an image editor.

Photographer Techniques:
The photographer took a photograph of a friendly and congenial family, but in his first shot, their eyes were gazing in different directions. In the second image, the photographer corrected this distraction by having them all look right at him.

Suggested Improvement Techniques:
Crop the image to focus in on the subject, then remove distractions and darken the edges.

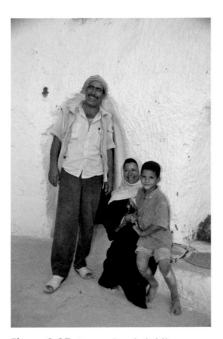 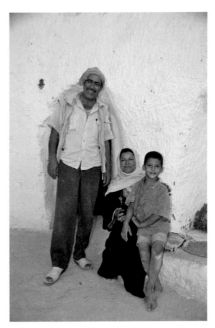

Figure 2.35 Parents' and child's eyes are cast in different directions (left); the image is improved by having them all look directly at the camera (right).

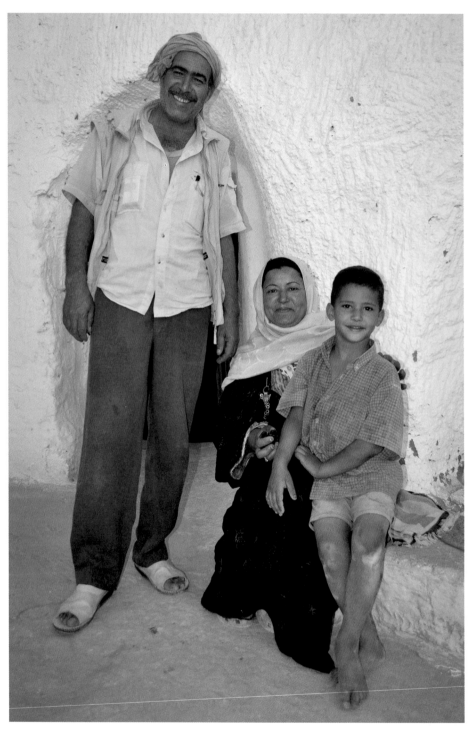

Figure 2.36 A tighter crop and background touch-up produces the finished photo.

Tunisian Camel Rider *Photographer: Jon Theobald*

When in an exotic location like this, try to capture a feel for the area and the activities. Sometimes that means photographing at less than ideal times of day. But getting a shot that reflects the visit to such a location can be an important photograph, regardless of what lighting or other conditions are encountered.

Photographer Techniques:
The photographer captured a shot of a woman enjoying a ride on a camel in the desert, first without flash, then with flash.

In the first image, the photographer captured a shot of a woman riding on a camel as she looked back over her shoulder (see Figure 2.37). In the second shot, the photographer used flash to add fill light, because the woman's face was in the shadows (see Figure 2.38). Fill flash can be used

Suggested Improvement Techniques:
Sometimes it's more important to follow instincts and find a motion in an image rather than trying to overthink it with "perfect technique."

when the photographer must deal with dark shadows under harsh sunlight conditions. The sensor may not be able to capture detail in the dark areas.

However, in this situation, there is a lot of light being bounced into the woman's face from all of the bright sand. The sand acts like a giant reflector. So her face is not actually as dark as it might be otherwise. The first photo is actually a better photograph of the woman and her mount. The second shot with the flash might be technically better, but it is not nearly as effective emotionally or in terms of telling the story.

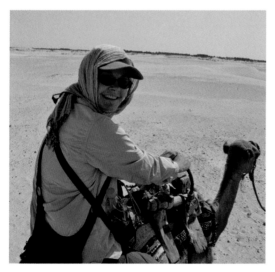

Figure 2.37 With harsh light the photographers often see a need to brighten shadows.

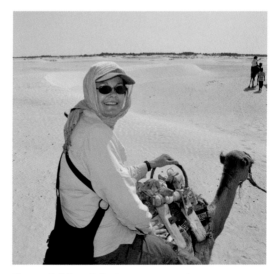

Figure 2.38 Fill flash may seem to be an easy solution.

The second shot appears to have been taken after the first, and at this point, the woman is sitting back "posing;" it does not have the energy of the first shot. In addition, the second shot includes some stray people and a camel at the upper right that are a distraction to the image. The second image is more like a simple snapshot with someone posing for the camera.

There is plenty of light in the first image, even in the shadows, to work with in an image editor. This picture was fairly easy to brighten—the face and the dark shadows—to make the image look better, as I've done for Figure 2.39. Look at the things that make that first shot come alive compared to the second shot: first, the expression on the woman's face—she looks excited about what she's doing as if this is really a lot of fun. She's also tightly holding on to the saddle of the camel, which indicates she's engaged. In the second shot, she's lost her excited expression, seems more casual, and is sitting up straight and seems less engaged in the ride.

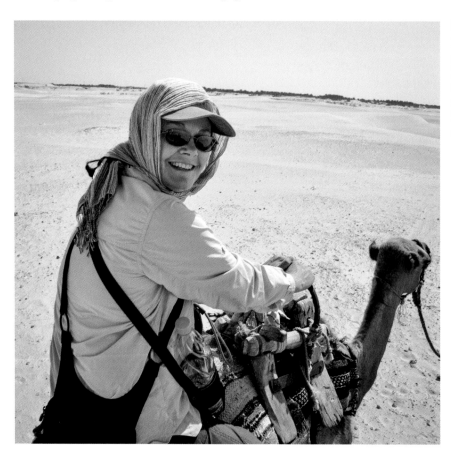

Figure 2.39
However, there was so much light bouncing off the sand, all that was needed was a bit of lightening of the rider's face.

Mary Jane

Photographer: Barbara Pennington

This is a respectful winter portrait of a mature woman—something we don't see a lot of. The original image (see Figure 2.40, left) is definitely underexposed, although the photographer has done an excellent job of positioning her subject away from the edges of the frame. The photographer recognized the lighting and exposure problems, adjusted the exposure, and added flash. The flash brightens up the woman's face and creates a nice catch light in her eyes (see Figure 2.40, right).

Photographer Techniques:
The photographer shot portraits of a woman in the woods. She corrected for exposure and added flash for better light.

Suggested Improvement Techniques:
Added brightness and contrast can really help an image pop. Be aware of what is happening along the edges of the composition.

Figure 2.40 Dull lighting muted the colors in this portrait (left); fill flash brightened the image and provided contrast (right).

However, the second image is also a tad underexposed, although not as much. In addition, the woman's head is touching the top and right edges of the frame, making it appear that the top of the composition is "pushing down" on her and that she is leaning on the right side of the frame. Generally, it is best to use the edge of the frame more deliberately—either put a little space there to allow the subject to be free of the edge (as shown in the brightened version in Figure 2.41) or crop to use the edge to emphasize the face. Notice how after cropping the hat the eyes become more significant (see Figure 2.42). Again, a portrait with the top of the head cut off, usually adds more emphasis to the eyes.

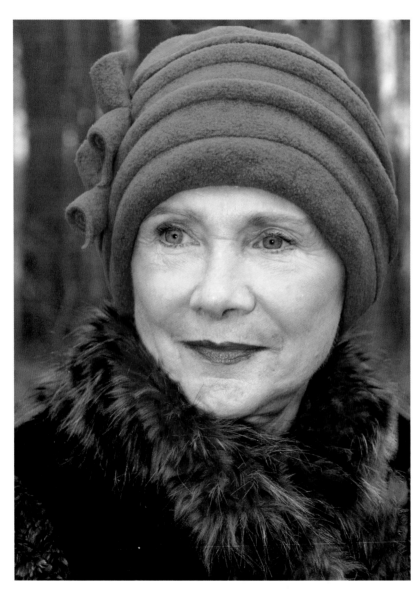

Figure 2.41
A little contrast boost makes the image even better.

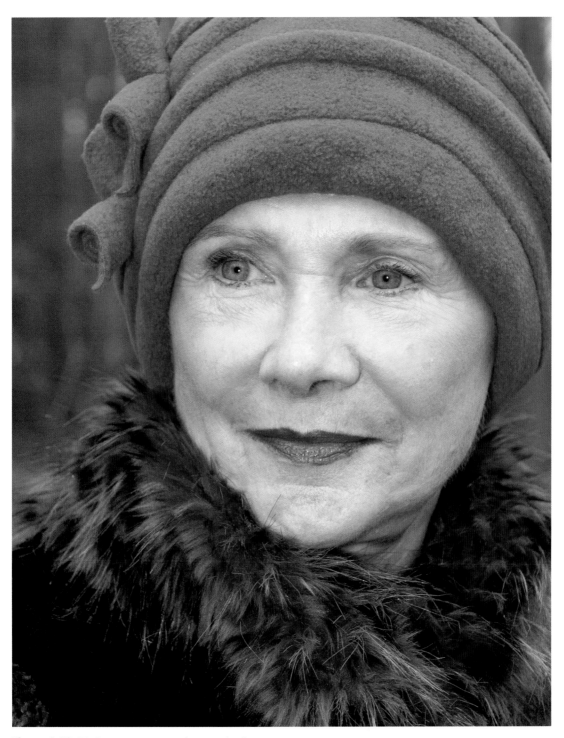

Figure 2.42 Tighter cropping emphasizes the face.

Bonaire Iguana *Photographer: Donna Schneider*

Iguanas are a fascinating wild animal from the tropics, and make for great subjects. Both of these images are tightly shot from a low enough angle to put us at eye-level with the animal. As with children, it is important to get down to an animal's level to connect with the creature.

The vertical orientation of the first shot works well with the posture of the animal (see Figure 2.43). However, a branch in the foreground is distracting because of the way it intersects with the lizard's feet. The background here is not enough out of focus to provide sufficient separation between the iguana and its surroundings. That said, there is a nice illumination on the animal that shows off the pattern of its skin quite well.

Photographer Techniques:
The photographer moved in closer to the subject to get a more dramatic look and allow for a shallower depth-of-field.

Suggested Improvement Techniques:
Try darkening some bright distractions and adding slightly more brightness to the animal so it does not look as gray; also, minimize the blank headroom over the head of the animal.

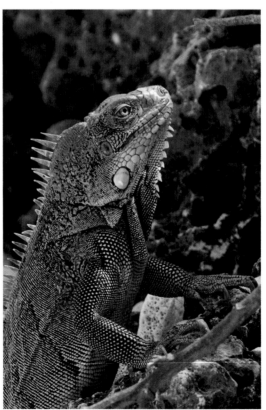

Figure 2.43
This vertical shot is effective, but the background is distracting.

The photographer really did a good job of improving on her first image. The horizontal second shot uses shallow depth-of-field (see Figure 2.44). The eye of the lizard is precisely in focus. It is important to keep the eyes sharp when photographing animals, insects, people, and so on. Because eyes are usually the focus of attention, if they are not sharp, the entire image may appear unfocused to the viewer. Moving closer to the subject and shooting from a different angle moves the background farther away. This throws the background out of focus and highlights the animal in a compelling portrait.

Moreover, the horizontal format here definitely works well with the posture of the animal. The overall image is one of a black-and-white creature with spots of color. This sort of semi-monochromatic photo can be quite interesting when there are nice touches of color. By brightening the animal slightly (see Figure 2.45), the picture has more pop and contrast, and the emphasis is still on the face of the animal.

An alternative crop could make the image appear even more dramatic. Try cropping from the top and left side of the picture. Although that goes against the photography "rules," it adds a more dynamic, edgy quality to the photo.

Figure 2.44
A wide aperture blurred the background, and the horizontal composition is stronger.

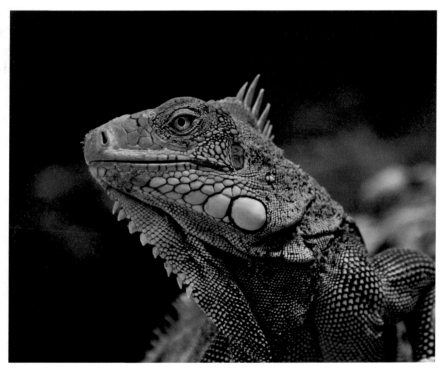

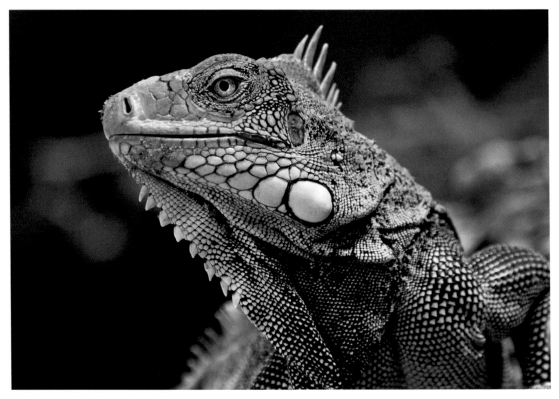

Figure 2.45 A slight contrast and saturation boost produced a dramatic image.

Tri-Colored Heron

Photographer: Harry Kaulfersch

In the original image (see Figure 2.46), the photographer was definitely dealing with a difficult lighting situation. The light filtering through the leaves illuminated the bird's face and added a catch light to the eye; however, the overall dappled light for the entire image was very spotty and harsh. This can be a difficult light to work with. By cropping the image, Kaulfersch emphasized a smaller area of the picture, and so removed some of the other areas with their problematic lighting. The new framing now strongly emphasizes the sharp contrast between the bird and its background, helping it stand out. (See Figure 2.47.)

Photographer Techniques:
The photographer cropped the original image to emphasize a head-and-shoulders portrait of bird. Then he enhanced the feathers and saturated colors.

Suggested Improvement Techniques:
Don't oversaturate the image. Viewers will think the image is unnatural looking. When adjusting a background around a subject don't let your subject blend in with the background.

Figure 2.46
Dappled lighting
made capturing this
bird difficult.

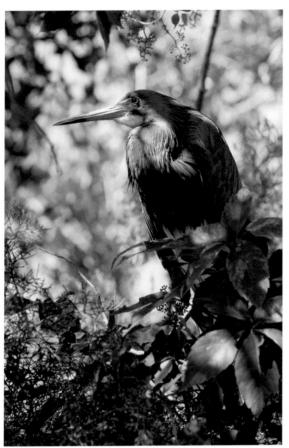

Figure 2.47
Cropping and
manipulating the
image provided
some improvement
but added too much
saturation.

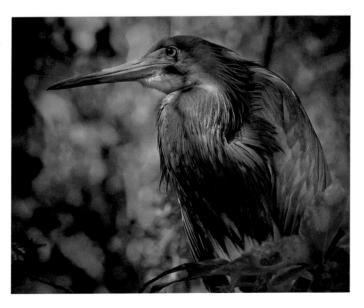

In addition, the photographer did an excellent job balancing out the tonal values of the bird in an image editor, so that we can see the feathers well in both the dark and bright areas. He also enhanced the feathers so that they are well defined. These feathers have a dimensional quality and texture that is very nice.

For my alternate version, I tried out a more natural look for the colors, and still doing some darkening of the background, especially along the edges, you start to get a more natural look of this bird in its habitat, as I've done for Figure 2.48.

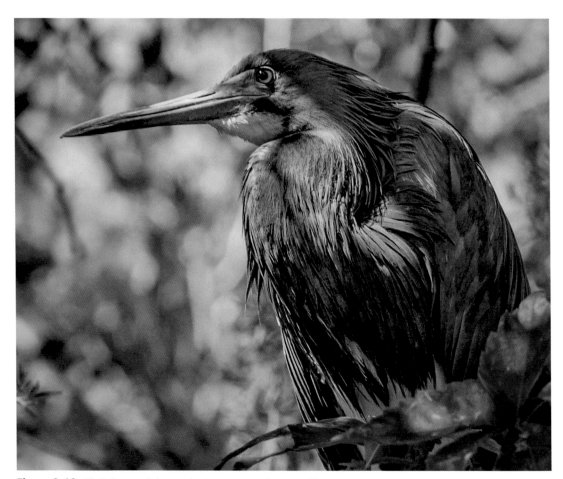

Figure 2.48 Slightly toned down, the image is much more effective.

Cleveland Red Panda *Photographer: Elizabeth Barker*

One of the great things about digital photography is that a shot can be reviewed immediately to see if it's a keeper. If there are problems with a photo, they can be corrected or the image can be deleted, and then we can take a better photograph while we are still there with the subject.

And this is exactly what the photographer did here. The first shot produced an image of the panda, but the photographer saw the potential problems with the photo (see Figure 2.49). The panda's pose is not terribly interesting; there is a distracting background; the light is not flatter-

> **Photographer Techniques:**
> The photographer recognized problems with the light and background in the first image so she moved for a better shot of the animal.

> **Suggested Improvement Techniques:**
> Try lightening the dark fur and experiment with some different framing options by trying alternate crops.

ing; and the light striking the side of the enclosure causes some degradation in contrast. In addition, the angle the lens is shooting through the glass has caused some problems with sharpness.

In the second, vertical shot (see Figure 2.50), Barker created a much better photograph. The timing of the shot captured the animal with an alert and lively expression. The light added an excellent dimensional quality to the face and created good texture in the fur. And nice catch lights brightened up the eyes.

Figure 2.49
Cute red panda, but the image can use some improvement.

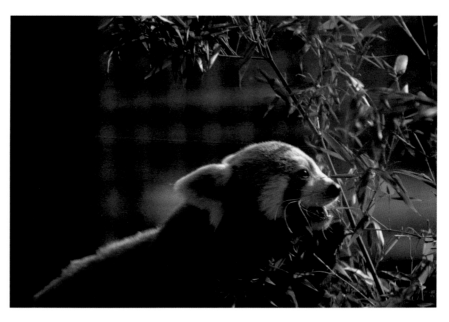

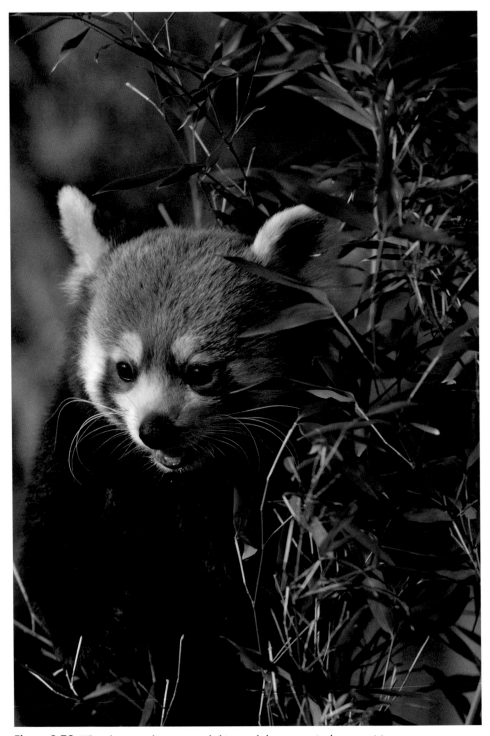

Figure 2.50 The photographer captured this much better vertical composition.

The overall composition works very well, too. The leaves of the bamboo fit with the animal and give the photo a natural feeling. In addition, there are no shapes or patterns in the background that distract our attention from the animal. Finally, the placement of the red panda is off-center and creates an interesting relationship with the greens of the rest of the photo. It's a very nice photo and doesn't need much in the way of changes. The photographer could brighten the black fur under the face, and the cropping I propose in Figure 2.51 is an alternative way to frame what is already a well-composed image; when this photo is cropped to a square, the face gets increased emphasis.

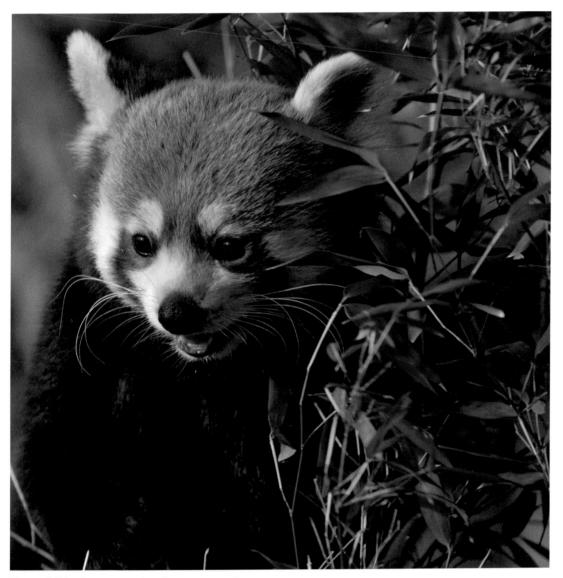

Figure 2.51 Cropping makes the image even better.

Casual Pet Portraits *Photographer: Dan Sandy*

Animals can be notoriously difficult subjects for photography because they don't necessarily want to cooperate with the photographer. This is especially true for cats; they tend to want to do their own thing.

> **Photographer Techniques:**
> The photographer shot pictures of cats under natural light for casual portraits and then changed the angle and light for the subject.

The photographer did an excellent job with the pictures. With the photograph taken from above (see Figure 2.52, left), the flat lighting made the top of the cat's head blend with its back and did not provide the best definition of

> **Suggested Improvement Techniques:**
> None.

the subject overall. However, the photographer worked around this limitation by using a very wide f/stop to get shallow depth-of-field. The eyes are sharper with this selective focus technique, and by using very shallow depth-of-field, the photographer created an interesting picture from less than ideal conditions.

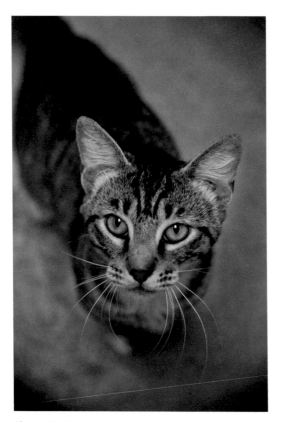 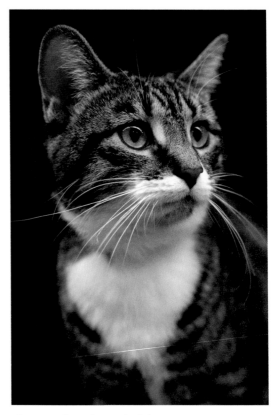

Figure 2.52 Great cat portraits, from a high angle (left) and using a formal pose (right).

The second image is an absolutely beautiful portrait of the animal (see Figure 2.52, right). The low angle is terrific and the illumination is a wonderful soft light that wraps around the cat, yet still has enough direction to provide a dimensional quality to the head and emphasize the pattern of the fur. This light also creates contrast between the cat and the dark background.

The photographer was very careful to make the closest eye the sharpest part of the picture, which is critical for portraits like this where depth-of-field is shallow.

Sandy's other cat images are equally impressive. The remarkable thing about this set is that the photographer has such a cooperative cat. The cat is obviously patient enough to deal with a more formal style of portraiture and the photographer knows how to work with the cat to get the best from it.

All of these images represent a great effort in getting down to the level of the cat for eye-to-eye photography. The shallow depth-of-field emphasized the face of the cat and captured the body out of focus. The photographer made sure that the eyes were the sharpest part of the image.

The second image has a little bit more personality (see Figure 2.53). The expression is actually quite interesting and engaging. But the headroom above the cat doesn't add to the photograph. In this case, it can be cropped to strengthen the image.

The photographer captured a remarkable expression in the last photo (see Figure 2.54). Regardless of whether this is a yawn or a meow, the picture is livelier than the others. This photo does have extra headroom that it does not need and might look stronger cropped.

Figure 2.53
Patience and a cooperative cat can reveal the feline's personality.

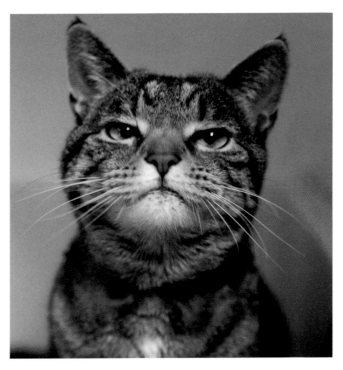

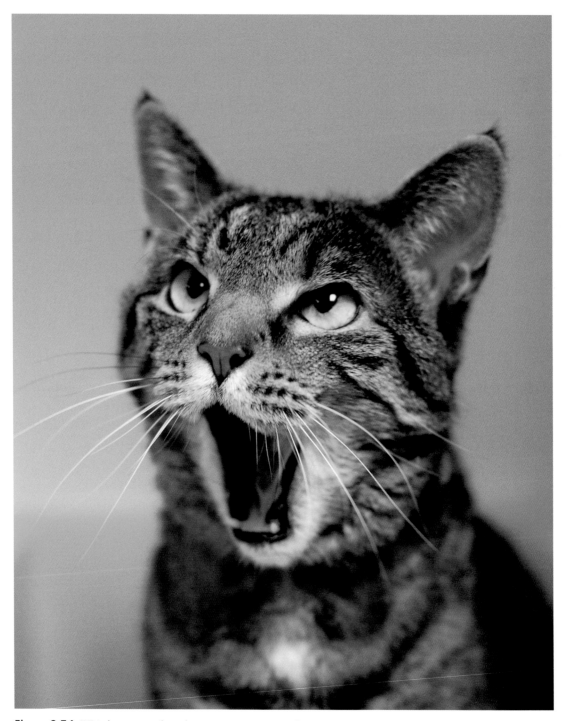

Figure 2.54 Wait long enough and a great expression might appear.

3

Visualizing in Black-and-White

In many ways, shooting in black-and-white is a return to our photographic roots. Monochrome images documented entire generations, even after the advent of color photography. Photojournalism, through World War II and beyond, was most widely practiced with black-and-white images. Amateur snapshots were most often printed in black-and-white until the early 1960s. Indeed, until color television became widespread, people of the time were acclimated to "seeing" images of the world in shades of black, white, and gray.

But today's generation of photographers grew up with color photography and, for many, with color digital photography. Capturing pictures in black-and-white may be a return to the roots of imaging, or, in many cases, a whole new way of creative expression. This chapter will look at how some photographers have explored monochrome imagery as a way of returning to the basics of light, form, and composition.

Viaduct Falls

Photographer: Debra Rozin

Waterfalls are one of the classic landscape subjects for photographers. The original image (see Figure 3.1) is a shot that most people would be delighted with. But Rozin explored the scene further and found a much better angle from which to photograph the cascade for her final image, shown in Figure 3.2. The black-and-white image is quite attractive and the slight sepia tone and framing technique adds an artistic effect. The photographer got down low to accentuate the river flowing swiftly toward the camera from the foot of the falls. The composition itself shows an "S" curve that displays movement.

The trees above the waterfall tell the viewer that this waterfall is in a forest.

Photographer Techniques:
The photographer used a low angle to capture the waterfalls and river, then converted the images to black-and-white.

Suggested Improvement Techniques:
Brighten dingy gray strands of whitewater in the foreground; darken the outer parts of the photo; and be aware of edge treatments that blend the edge and the actual image area of photo.

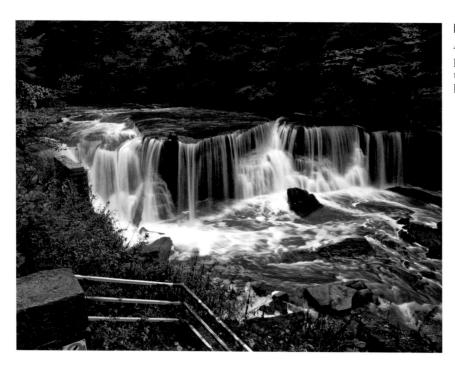

Figure 3.1
A high vantage point doesn't present this waterfall in its best light.

Rozin says the image was captured with a long shutter speed of about one second; the lengthy exposure added a smooth, silky look to the flowing water. Using long shutter speeds while shooting moving water is a classic technique that highlights the flow patterns within it.

As noted throughout this book, bright areas in the picture always attract the viewer's eye. The splash of white water at the far left pulls the eye a bit to the left out of the boundaries of the picture. Simply darkening that area in an image editor would help. In addition, the white water in the foreground has become a dingy gray compared to the white water of the falls. Brighten the white water in the foreground back to its original milky luster. The same technique can also be used to brighten some of the darker strands of water within the falls.

Edge darkening, a technique that has been part of almost every traditional black-and-white photographer's toolkit from Ansel Adams to photojournalist W. Eugene Smith, helps keep the focus on the center of the image. The challenge in this image, however, is that the top edge of the image area is similar in tone to much of the top of the picture. Where does the photo end and the edge start?

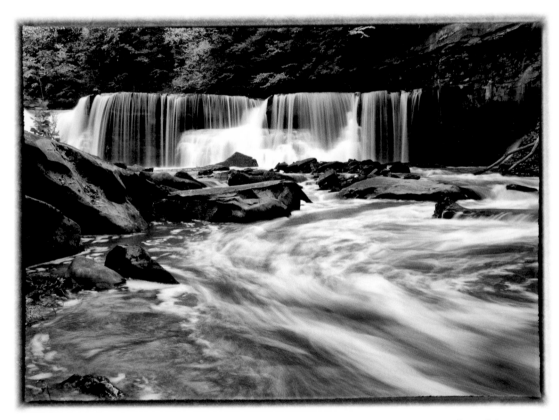

Figure 3.2 A lower view, darkened edges, and monochrome treatment shows the dramatic flow of the water.

Whitney Portal Falls

Photographer: Matthew Kuhns

Here is another eye-catching image of a cascading waterfall. The photographer has an excellent eye for detail and a great touch with black-and-white tonalities. The image is an attractive shot that focuses on the flowing water of the falls (see Figure 3.3). Kuhns' half-second exposure adds a silkiness to the rushing water, but there is not a lot of color in the original image. In addition, there are some distracting details around the falls.

> **Photographer Techniques:**
> The photographer cropped the original photograph of the waterfall to intensify the composition and then converted it to black-and-white.

> **Suggested Improvement Techniques:**
> Darken the bright detail at the lower right.

For the black-and-white version (see Figure 3.4), Kuhns tightened in on a detail of the falls for a bold and strong composition. This tighter shot creates an abstract design of the cascade that emphasizes the flowing water and the contrast between bright and dark tones.

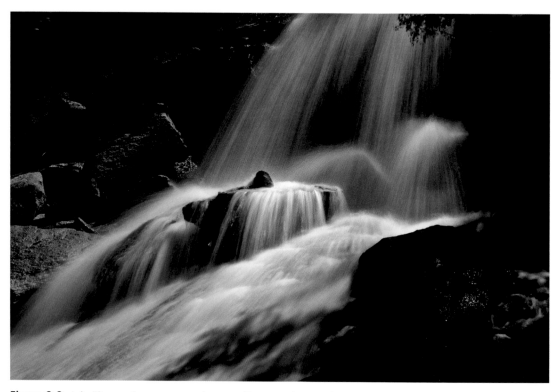

Figure 3.3 A half-second exposure produces a silky-smooth cascade.

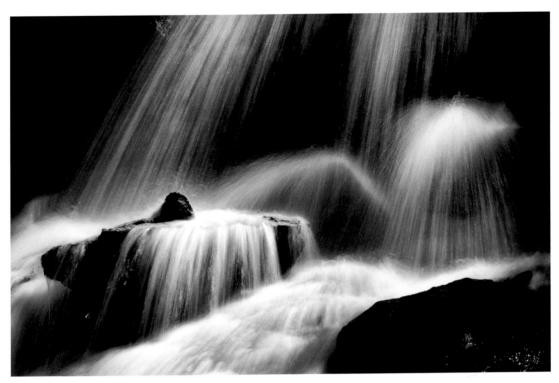

Figure 3.4 Tight cropping creates a more dramatic image.

The photographer's control of the black-and-white is superb. He intensified the dark areas to a rich black that contrasts beautifully with the white of the water. The white of the water is luminescent, without losing detail, so that the viewer can almost feel the misty water spraying all around. In addition, the photographer enhanced the detail to accentuate the individual strands of the water streams. All these details come together quite nicely in a dramatic image.

A very small thing to consider: the speckles of white at the lower right don't really fit in with the rest of the picture. By darkening them, that edge would be simplified. Such a change would also help balance the upper-left and lower-right corners of the photo.

The Arcade Circa 2012

Photographer: Jerry Hilinski

Hilinski found an interesting architectural structure for a photograph in the historical Victorian-era (1890) Arcade in downtown Cleveland, one of the earliest indoor shopping malls in the United States. Its 300-foot glass skylight and four balconies offer multiple opportunities for pictures like the original image shown in Figure 3.5. Hilinski's vision for composition and the instinct to convert to black-and-white are dead on. Employing some tried and true techniques from the earliest days of photography add even more drama and depth.

Photographer Techniques:
The photographer converted a color photo of the inside atrium of a hotel to black-and-white.

Suggested Improvement Techniques:
Give the image more contrast and richness by adjusting the blacks and whites; work on specific details of the image to help balance them with the rest of the photo. Create some edge-darkening effects to add a feeling of depth. Consider a sepia tone for added richness.

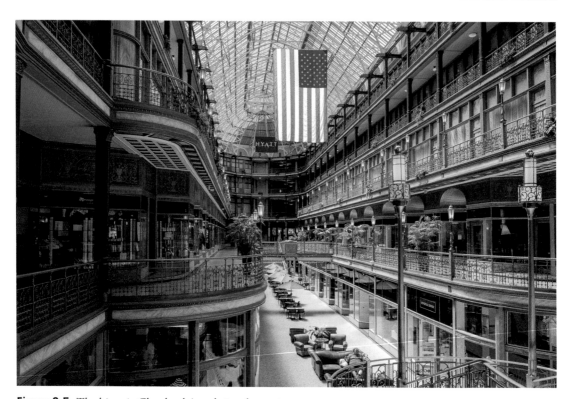

Figure 3.5 The historic Cleveland Arcade is a dramatic structure.

The photographer's composition has some interesting pattern contrasts from left to right and top to bottom. Pattern and texture are excellent ways of structuring a black-and-white image. The initial black-and-white conversion (see Figure 3.6) shows off the pattern and texture of the historical structure. But, remember, black-and-white conversions are never just about the removal of color. Good black-and-white imaging needs emphasis and contrast, and colors need to be converted to specific shades of gray.

In the first black-and-white version, the image is flat, but with texture and pattern. All images need to have solid black and solid white display properly. If not, the photo may look gray and flat. Of course, an exception to this rule would be a scene that was very foggy and low in contrast to begin with, and actually contained no real blacks or whites. This image is not such a scene and lacks blacks in its initial version. The result is that all of the patterns and textures are more or less equal in tone. In addition, parts of the flag start to blend in with the top of the skylight.

Because of the expanse of the interior, the depth of the scene from foreground to background is important. In Figure 3.6, the depth comes from the change in perspective of the lines of the arcade, not a change in tones. In addition, the top, right, and bottom edges are very similar in tone to the center of the picture. That means that the viewer's eyes are encouraged to drift off to the edges and

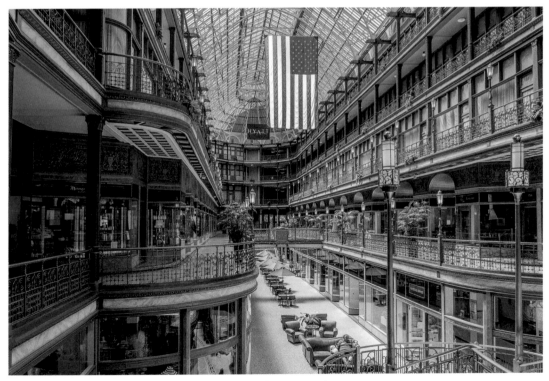

Figure 3.6 In black-and-white, distracting colors no longer intrude.

even outside the boundaries of the photograph. Ansel Adams taught how effective darkening the edges of any image is to retaining the viewer's attention on the photograph and its composition.

To adjust this image to add more depth and character, start by supplying the blacks and whites it needs to ensure a full range of tones. That adjustment immediately results in stronger contrast that is entirely appropriate to the dramatic structure. Next, tonal adjustments at top and bottom separate the flag from the top of the scene and de-emphasize the floor at the bottom.

Darkening the left and right sides and then gradually blending that darkening to normal tones adds depth from the foreground to background, as seen in my version in Figure 3.7. The change also creates a slight overall darkening to all of the edges that blend very subtly to the rest of the picture. This makes the left side of the atrium a little dark, so brightening just that portion slightly helps. Now the image has some depth and structure to the black-and-white that really works well with the photographer's original composition.

Adding a tint over the image adds a richness that accentuates the structure's age. Traditionally, black-and-white images almost always included a slight tint. Figure 3.7 shows the results of adding a slight sepia tone to the image.

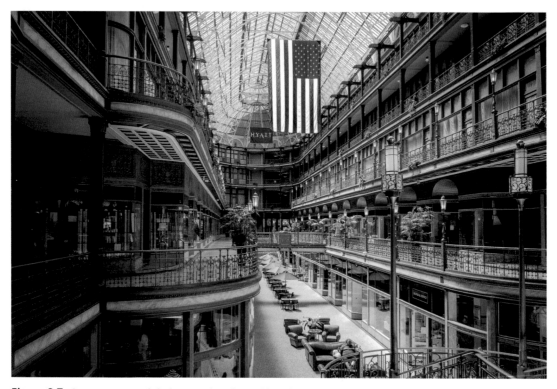

Figure 3.7 Sepia toning and darkening the edges add to the old-timey feeling.

Have a Seat *Photographer: Susan Bestul*

The photographer's eye triumphed in spotting this interesting arrangement of chairs and shadows. It's a wonderful arrangement. The composition is perfect, with the chairs contrasting with the line of shadows retreating into the distance. The unmodified color image is extremely attractive and has some great qualities without any modifications. For example, the exposure is spot-on; the whites of the chairs are white; and the shadows show up against the walk surface.

Even small details have been taken care of. For example, Bestul kept a little space at the left side of the frame—not *too* much, but enough to keep the shadows separate from the left edge of the picture. That helps the viewer better see and understand the shadows and their relationship to the chairs. She then cropped out some of the chairs, which makes the remaining chairs look like they go on forever. That's because whenever you show an entire subject so that you see its edges, you have defined how big it is for the viewer. As soon as you crop out part of that subject so that we cannot see the edges anymore, the subject can be imagined to be any size. In addition, cutting into the edges forces us as the viewer to see the patterns within the subject, which is exactly what happens here.

The light here is great. The shadows fall in a perfect place and the light illuminates the backs of the chairs to show pattern, too. The vertical framing works with the subject and the shadows.

The blue-toned shadows and the green grass are dark so that the pattern of the shadows contrasts with the pattern of the white chairs in the black-and-white conversion (see Figure 3.9). There is no need to make the grass brighter; while its texture is apparent, it is not as strong a pictorial element because it is dark compared to the things around it, and it remains unobtrusive.

Three strong elements are used to define a black-and-white image: tonal/brightness contrast, texture contrast, and sharpness contrast. The strongest element in this image is the tonal or brightness contrast. Tonal contrast will always dominate a photograph. It is stronger than any other contrast in black-and-white. So even though there is a texture contrast between the grass and the walk surface, it is not dominant. The tonal contrast is what captures attention. Because all parts of this image are equally sharp, contrast in sharpness is not an element here.

Bestul's black-and-white image is nicely done, including the intensification of contrast to emphasize the light and dark patterns. A slight improvement might be to darken the right side a tiny bit to create a bit of edge darkening. That would keep the eye from drifting off of the image to the right and keep the viewer's eye concentrated on the key parts of the composition.

Photographer Techniques:

The photographer converted a photo of an arrangement of chairs and their shadows from color to black-and-white.

Suggested Improvement Techniques:

The image looks good as it is. One possibility would be slight edge darkening on the right side.

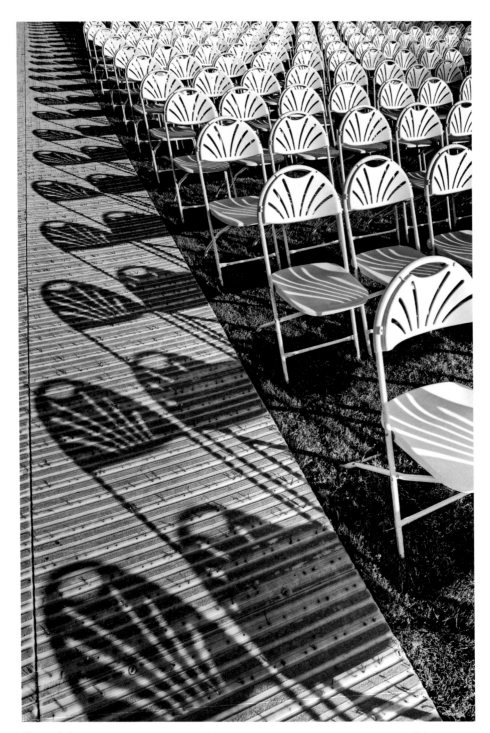

Figure 3.8 Most photographers would have missed this dramatic juxtaposition of chairs and shadows.

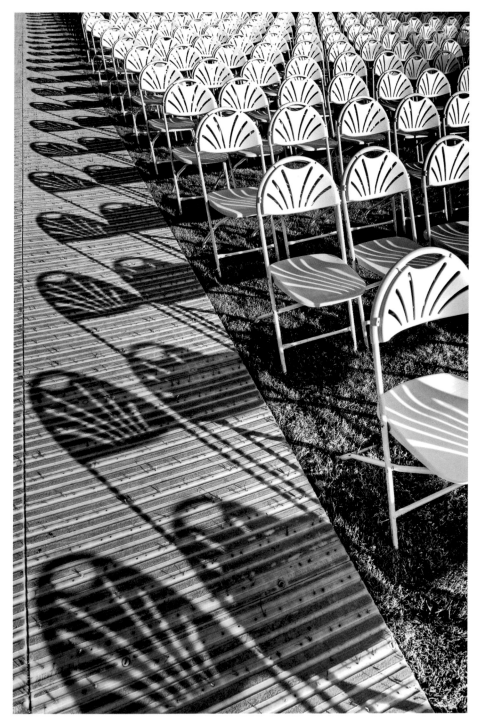

Figure 3.9 Even fewer would have seen the possibilities in a black-and-white version of the same scene.

Lakeview Beach *Photographer: John Earl Brown*

The original image (see Figure 3.10) offers a pastel look at a Lake Erie beach. The image is low in contrast. The pastel produced by the flat rendition is an interesting color, and would disappear if more contrast were added. The photographer recognized this when producing his black-and-white version, which is a very dramatic image with abundant contrast. (See Figure 3.11.)

Comparing the two images reveals exactly how much control the photographer has over a photo

Photographer Techniques:
The photographer converted a beach scene from color to dramatic black-and-white.

Suggested Improvement Techniques:
Try another cropping that uses some of the distant background to gain more of a feeling of space within the frame.

simply by adjusting the brightness of the various shades of gray, and fine-tuning how the colors are interpreted during the conversion. As mentioned earlier in this chapter, photographers too often think black-and-white is just an image with the color removed. Brown's image demonstrates that this is not the case. Compare his original image with the same picture translated to black-and-white

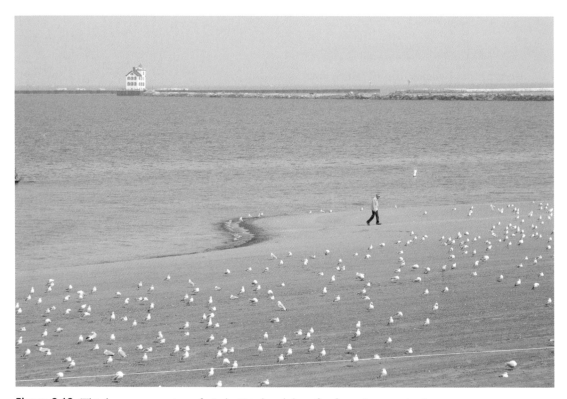

Figure 3.10 This low-contrast view of a Lake Erie beach benefits from the muted colors.

by simply removing the colors, as in Figure 3.12. The monochrome image doesn't have the same tonal values at all. In fact, the black-and-white conversion now looks rather boring because there is no separation between the water and the sand.

Black-and-white always involves some degree of interpretation, because humans (even those of us who are color blind) do not see in black-and-white. With his black-and-white interpretation, Brown created an interesting, almost abstract image that has a great deal of drama. He did an excellent job changing how the colors are translated into shades of gray so that there is indeed a distinct separation between the sand and water. There is also a strong separation between the gulls and the sand as well.

Figure 3.11
The photographer's cropping and added contrast produces an entirely new, abstract image.

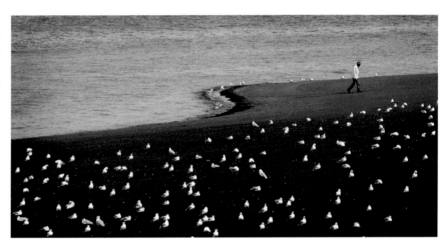

Figure 3.12
The original shot in black-and-white is bland.

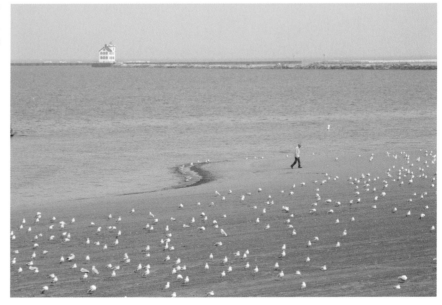

The photographer's cropping of the image made it more of an abstract design. As such, he's removed the view of the distant details, so that the photograph is less of a representation of an expansive vista and more of a pattern of light and dark tones, sweeping lines, textures, and the image of a lone human wandering among a sea of birds. The man in the image is in a nice position to create some contrast with the birds and to add a human interest to the shot. Overall, Brown's vision is quite artistic and complete.

But it's a measure of how well an image was conceived if you can find additional images within in it. That's the case here. By adding contrast to the top of the original image you'll find that a second extremely interesting photograph is hidden within. My interpretation is in no way better than Brown's original treatment; it's just a different way of exploring the same scene. (See Figure 3.13.) In my version, I added depth—a place for the viewer's eyes to go off into the distance. This alternate view creates an interesting visual relationship between the man and the lighthouse in the distance. Because of the additional sense of space, it adds another layer of loneliness or solitude, which may be interesting to the viewer. To darken that top detail, use a local control to darken just the rock jetty and the parts of the lighthouse. It does help to crop the image slightly, removing the distracting rock at the left side as Brown did too. This is one of the best black-and-white conversions I encountered while working on this book.

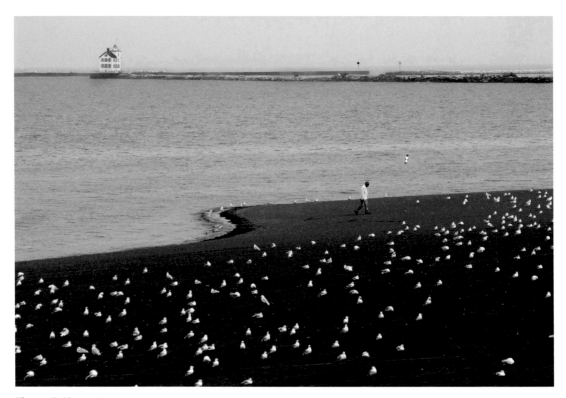

Figure 3.13 Adding the distant horizon creates yet another interesting image.

Edgewater Ice *Photographer: Rob Erick*

This is an interesting composition of a winter shoreline of Edgewater Park in Cleveland, which offers an amazing view of the city on Lake Erie (see Figure 3.14). The photographer's use of a strong foreground with an interesting background is terrific. The bold foreground has an excellent visual relationship to the city skyline in the background. The light is outstanding on both the ice formation and the city. The illumination offers an excellent three-dimensional feel to the ice and creates a rich feeling of depth in the photograph.

Exposure can be a challenge in situations like this, as Erick pointed out when he submitted his

Photographer Techniques:
The photographer converted an original color image to black-and-white and corrected underexposure.

Suggested Improvement Techniques:
Work toward getting the best exposure possible when photographing a scene. Proper exposure captures the best color and tonalities, and minimizes noise in an image.

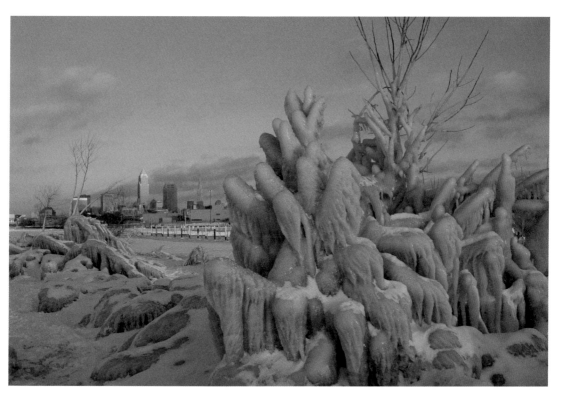

Figure 3.14 Underexposure can make even a well-composed and well-lit scene less effective.

"before" image, which he improved after the fact by converting it to black-and-white. It's worth looking at the histogram of the original image. Notice the big gap on the right side, representing what *should have been* the lighter tones. (See Figure 3.15.)

As noted before, a digital camera's sensor does not perform best when dealing with the darker tones, those which barely exceed the minimum threshold required to convert captured pixels into an image. The original image is essentially an exposure in the dark part of the sensor's range. A sensor is more proficient at capturing lighter tones, which would have been represented by the right side of the histogram, rather than at the left. Good exposures create a histogram with a mountain-shaped curve that extends from the left side to the right side, showing that blacks, middle tones, and whites have all been captured.

Although Erick corrected his exposure for other shots in the series, he decided to share a technique for making the best of an otherwise well-composed and well-lit scene that happened to be under-exposed. There was little he could do in an image editor to completely compensate for such severe underexposure in the example he selected for this lesson, but he knew he could still create an interesting image in color or in black-and-white.

The color image becomes more interesting when corrected—with clouds actually looking like bright clouds, and the foreground lighter in tone (see Figure 3.16). While it's true that colors, tonalities, and noise are not ideal because of the underexposure, the resulting shot is a dramatic picture with some attractive aspects to it.

The black-and-white image is an excellent rendering of the scene (see Figure 3.17). The black-and-white rendition adds some drama to the setting and the interesting ice formation. The photographer increased contrast and darkened edges. In this case, while the underexposure does not allow a full gradation of possible tones in the darker areas, this interpretation in black-and-white still works very well because it has a lively high contrast look to it. In fact, the added noise even gives a grungy look that is gritty, interesting, and possibly surreal.

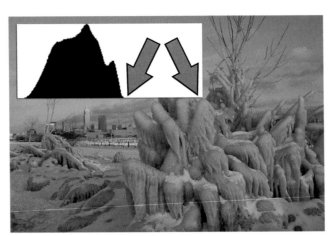

Figure 3.15
The histogram shows that middle and lighter tones are not present in the original.

Figure 3.16
Adjusting the tones
creates a better
image, even in color.

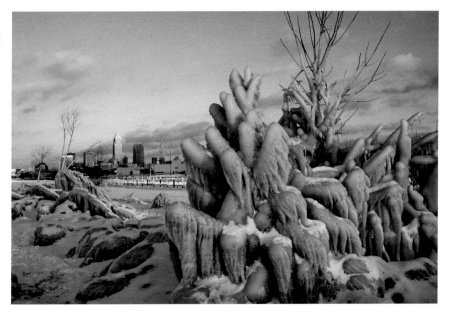

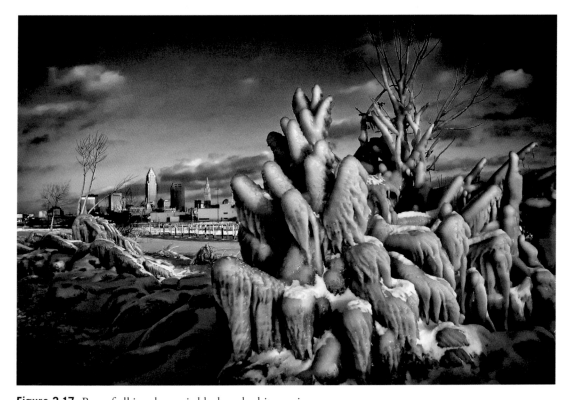

Figure 3.17 Best of all is a dramatic black-and-white version.

Manikin

<div align="right">Photographer: Ed Rynes</div>

As you'll see from the multiple offerings by photographer Ed Rynes in this book, he has an excellent eye for composition, the ability to find interesting subjects among the mundane, and skill in doing just enough processing to transform a good photograph into an outstanding one. The original image shown here in Figure 3.18 definitely has great potential. The color image is striking, too.

Photographer Techniques:
The photographer converted the original color image to black-and-white and enhanced the contrast.

Suggested Improvement Techniques:
Try to make the manikin's chest more balanced.

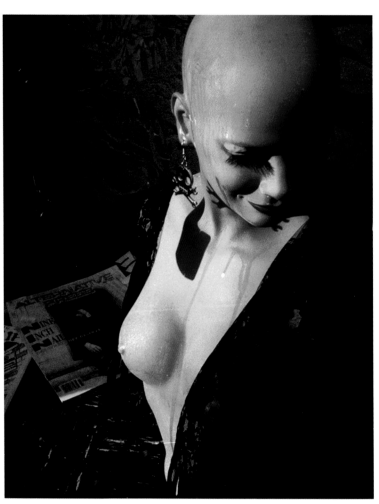

Figure 3.18
The high angle produces a striking image of an inanimate manikin.

The photographer's work on this image created a simple black-and-white design that became somewhat abstract, making the image quite dramatic. (See Figure 3.19.) This is a picture in which the blacks of the photo need to be pure black, while retaining the manikin's "skin" tones, as Rynes eliminated some stains that were present in the original image.

Because of the position of the manikin's head, the photographer's angle to the subject, and the light, the manikin looks like she has one breast centered on her chest. That is an unusual look, to be sure, and some might find it a little disturbing. Of course, photographs often can be disturbing, but that doesn't seem to be the purpose of the photographer's image. The photographer could have accentuated more detail in the "vest" to emphasize the size of her chest and call attention to the other breast as well, as I've done in Figure 3.20. However, the photographer's original vision was fine as is, and offers an engaging view of an unusual, inanimate subject.

Figure 3.19
In high-contrast black-and-white, the figure takes on an abstract quality.

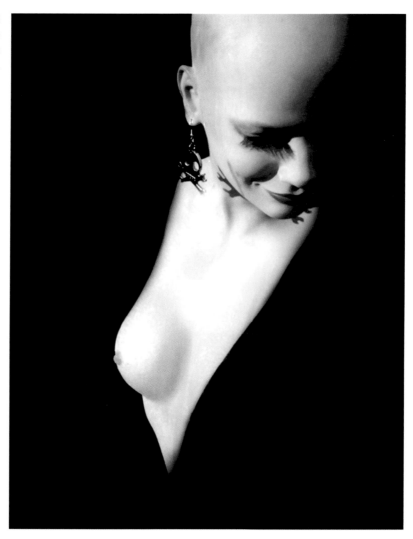

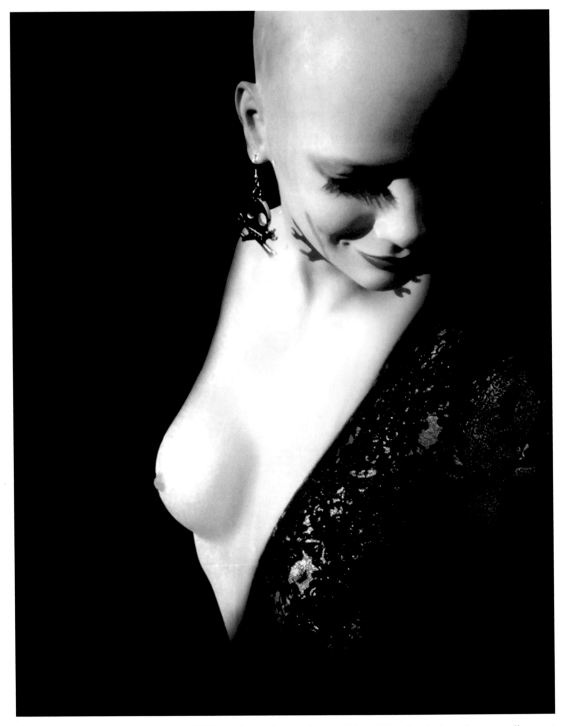

Figure 3.20 An alternate version with lightened areas brings the manikin to life—but is that what we really want?

Tim McGraw

Photographer: Erik Heinrich

Although this photo's official title highlights the country superstar, the image really isn't about Tim McGraw, who appears very small in the frame and could be any other singer in a cowboy hat. It's a striking shot that shows the relationship of a lone performer with his adoring audience as they crowd around the stage.

Photographer Erik Heinrich certainly had to deal with relatively flat lighting (notice the lack of strong shadows on the stage) in the original image of this concert scene. (See Figure 3.21.)

Photographer Techniques:
The photographer converted the original color image in flat light to black-and-white and enhanced the contrast using HDR techniques to add drama.

Suggested Improvement Techniques:
Look for ways to get the subject out of the middle of the frame.

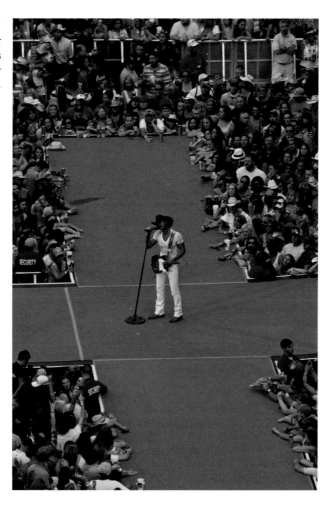

Figure 3.21
Country superstar Tim McGraw is surrounded by adoring fans.

That low-contrast illumination does highlight the audience, but it makes the image less dramatic. The photographer did a nice job of framing the performer from an angle that creates space around him; McGraw is isolated visually from the crowd and stands out in the image.

The photographer used a very contrasty style of black-and-white conversion, using HDR (high dynamic range) techniques (see Figure 3.22). It works well in this situation because the original image was so flat in contrast. This high contrast makes the singer stand out and gives a lively texture to the audience. Heinrich visually separated McGraw's white clothing from the surrounding stage.

Darkening the edges is a traditional method of providing emphasis on the center of a black-and-white image. This tends to draw the viewer's eye more into the middle of the picture and adds a dimensional quality. The photographer used a dramatic edge-darkening technique. The viewer can still see the crowd, but the emphasis is on the singer.

Centered images (see Figure 3.23) are rarely as interesting to a viewer as images that are off center. Viewers tend to focus on the centered subject and ignore the rest of the picture. When the subject is off center, viewers tend to look at relationships between the subject and the rest of the scene (see Figure 3.24), which could add an important dimension to this photograph. Instead of concentrating on Tim McGraw, we should be looking at the relationship between the singer and the audience.

An off-center composition can be obtained as an alternative by removing the much less important bottom part of the picture, which shows a big area of blank stage and much less interesting audience members than the top part of the picture. This could be cropped to a different proportion by removing the bottom of the scene or by keeping the same proportion and cropping. (See Figure 3.25.)

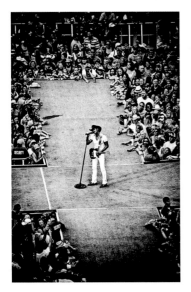

Figure 3.22 HDR manipulation makes the image more dramatic.

Figure 3.23 However, McGraw is centered in the frame, limiting the viewer's urge to explore the rest of the image.

Figure 3.24 Moving the singer out of the center allows him to seem more engaged with his audience.

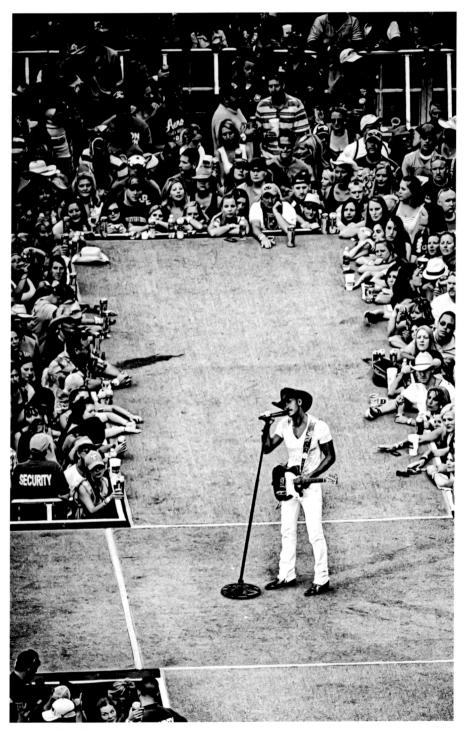

Figure 3.25 This version provides an alternate composition.

Endeavor

Photographer: Matthew Kuhns

Photographer Matthew Kuhns was fortunate to witness a historic moment of the space shuttle program (see Figure 3.26). The photographer's composition captured the Endeavor on its carrier Boeing 747 as it flew through the San Francisco area, past the Golden Gate Bridge. Many people photographed this event by using a telephoto and simply zeroing in on the jet and space shuttle. That might have provided a memorable photo, but would not have had any of the storytelling drama of Kuhn's picture.

The conditions of the flyby were obviously not ideal for color so the photographer decided to convert the image to black-and-white (see

Photographer Techniques:
The photographer shot the Endeavor on its final tour as it traveled past the Golden Gate Bridge. The time of day was not ideal for color, so the photographer converted the image to black-and-white.

Suggested Improvement Techniques:
Consider using specialized black-and-white conversion software. Think about the tonal range throughout the image and how they relate to one another.

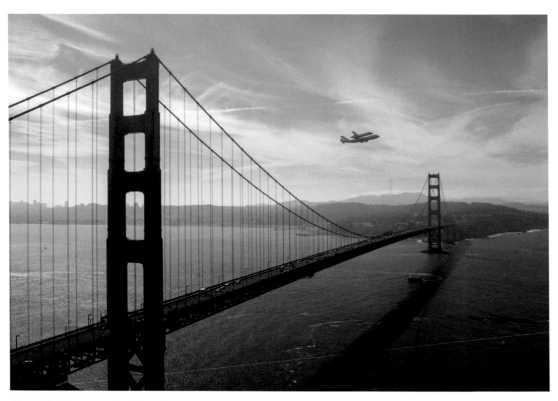

Figure 3.26 Space Shuttle Endeavor makes its final flight past the Golden Gate Bridge.

Figure 3.27). The black-and-white conversion added an important element of drama to the scene. As always, black-and-white has to be about how colors throughout the original photograph are changed into shades of gray and how the monochrome tones then interact with each other. In this image, the dark tones are heavy and a bit muddy, which does not allow the bridge and its shadow to separate cleanly from the bay. Simply doing a little work to brighten the dark tones, though not the blacks, gives more definition to the bay and makes the day look brighter.

The emphasis of this book is not on particular software tools; most of the final fine-tuning of images that were captured in the camera can be achieved with virtually any image editor. However, sometimes specialized tools can be useful. A popular conversion software application for black-and-white adjustments is Silver Efex Pro, part of the Nik suite of plug-ins now owned and distributed by Google. This software offers a great deal of control over how the black-and-white tonalities are converted from color and then how you affect specific tones within the photograph.

Using Silver Efex Pro, I was able to produce a more dramatic sky while keeping the bay still looking like water. That allows the image of the bridge to separate from the rest of the image, as well. The airborne craft are then represented in a dramatic silhouette, but the event—the passing of the Space Shuttle and its 747—is still readily apparent. The photographer's original composition is great for showing off the location and setting. However, because the left side of the Golden Gate Bridge is so separated and isolated from the left edge of the composition, the bridge is dominant in the photograph. This creates a competition between the bridge and the aircraft. By cropping the image, the bridge becomes the setting and the aircraft are the stars of the photo. (See Figure 3.28.)

Figure 3.27
A monochrome version produces a silhouette.

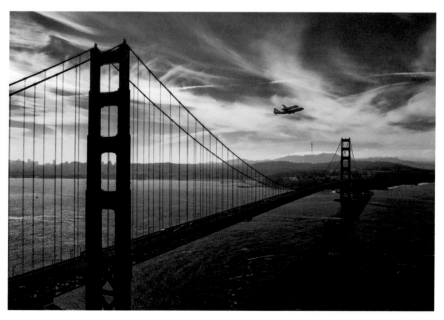

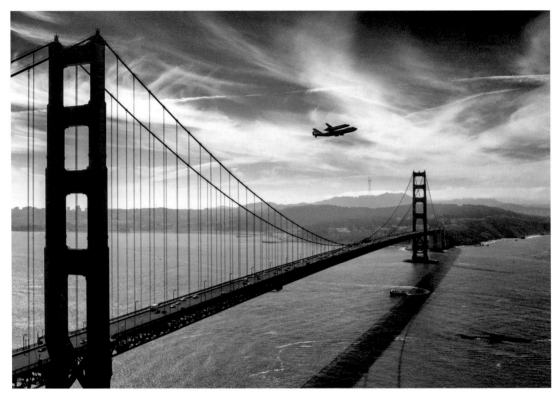

Figure 3.28 Cropping the left side of the bridge and lightening the tones returns the focus to the aircraft.

4

Creative Cropping

Sometimes you shoot a picture that you really like and then, after some reflection, realize that there is another, even better image hidden in the frame. To reveal that image, all that may be necessary is a little judicious cropping. Even the best photographers find that what was seen and evaluated in the viewfinder can be improved by excluding selected portions of the original image.

Some purists have often prided themselves on presenting their original "vision," and, back in the days of film, went so far as to make prints that included the edges or sprocket holes of the negative to prove that nothing framed in the viewfinder was left out. That approach had its merits, particularly if your subject matter happened to fit neatly into, say, the 2:3 proportions of the 35mm film frame. It was particularly challenging 30 or more years ago when non-zooming (*prime)* lenses ruled, and recomposing an image often meant moving closer/farther from your subject, or switching to an entirely different lens.

But, in both the film and digital photo eras, cropping has been a useful tool for helping good images become even better, as you'll see in this chapter.

Cheetah

Photographer: Barbara Pennington

This photo grabs attention because of the intensity of the cheetah's gaze (see Figure 4.1). The photographer did a great job of getting down closer to the ground to shoot at the eye-level of this resting cheetah. The eyes are the focal point of this picture; it's compelling even without any other manipulation.

The photographer did two important things en route to a revised version. The original image was a little underexposed so the photographer made some tonal adjustments to brighten the image, as you can see in Figure 4.2. The increased contrast really makes the color and texture of the animal's fur pop.

Photographer Techniques:
The photographer brightened the original underexposed photo and then cropped it for impact.

Suggested Improvement Techniques:
Maintain whites in the photo and try some alternate crops to affect the appearance of the cheetah.

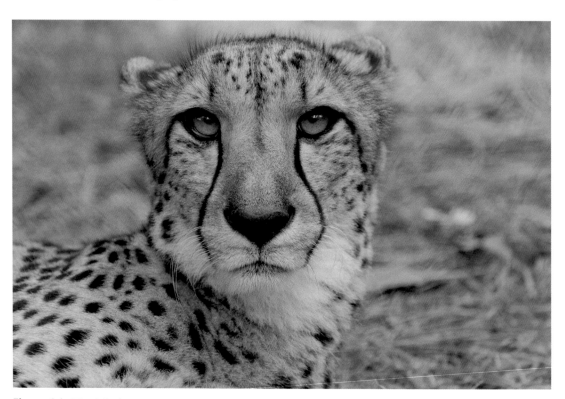

Figure 4.1 Here's looking at you, cat!

Then, Pennington cropped the image to eliminate all details except for the animal's intimidating facial expression. The version shown in Figure 4.3 is a dramatic and impactful portrait of an elegant, but wild animal. The eyes are now even bolder, giving the image a great deal of presence—that is, the viewer is right there with the animal, as if it were just inches away. This presence adds exceptional impact to the photo. Moreover, by cropping so tightly, the photographer has also created an abstract design with the animal's face. Its visage is flattened out visually by the telephoto perspective, into a series of lines, patterns, and textures that are bold and attention-getting.

The photographer did have other options for cropping the photo that could have been almost as interesting. The ears of many animals often reflect their mood and personality. Although the final close-up cropping is excellent, the version shown earlier in Figure 4.2 is also compelling. This particular image fits within a square format, without the static quality that square pictures often assume. It also shows off the cheetah's ears, revealing another side of the cat's personality. The square crop retains the bold look and still retains much of the emphasis on the eyes. Even so, I prefer the heavily cropped image, which is more abstract in the way it affects the animal.

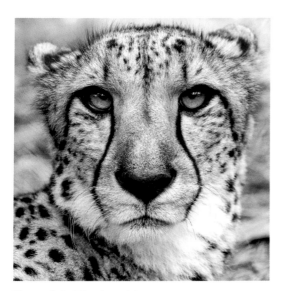

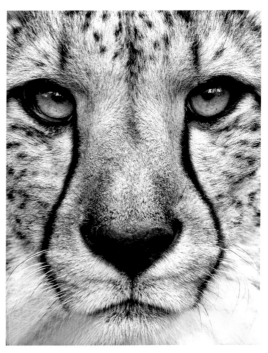

Figure 4.2 The cheetah's piercing gaze is intimidating.

Figure 4.3 A tight close-up is even more frightening.

Waiting for the Battle *Photographer: Eric Wethington*

The photographer caught a pensive moment of a woman dressed for a Civil War reenactment, waiting by a fence for the staged "battle" to begin. There is a lot of potential in the original photo (see Figure 4.4). Something about the empty space around the woman makes her seem very lonely, perhaps echoing the feeling of Civil War brides when their menfolk were far away, engaged in the fighting.

The photographer reduced the exposure to ensure that its detail would not be washed out. Wethington corrected the tonal values and cropped the image from a vertical to a

Photographer Techniques:
The photographer cropped the image to tighten the composition to focus on the woman at the fence.

Suggested Improvement Techniques:
Get adequate exposure when you photograph—make sure whites are actually white. Look for opportunities to get the subject out of the center of the photo as you shoot and as you process and crop the image.

Figure 4.4
A scene at a Civil War re-enactment has extraneous detail.

horizontal composition to produce an improved version (see Figure 4.5). Brightening the image makes the photograph look livelier. It also brings out the color in the woman's dress and face. The greens in the photo are appealing, thanks to a cloudy day that caused no bright shadows.

Cropping removed the vegetable garden at the bottom of the frame in the original image; it didn't add value to the photo so it was a good idea to crop it out. However, even trimmed, the image positions the woman and the fence smack in the middle of the composition. Centered images are generally less interesting to viewers than images that move the subject out of the center, and they are often static compositions.

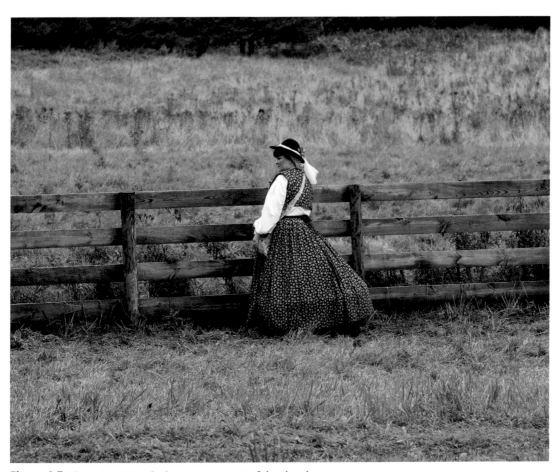

Figure 4.5 Cropping gives the lone woman a wistful or lonely appearance.

There are two additional ways this photo could be cropped. The photographer could have cropped the image to move the woman over to the right and get the fence down lower in the frame (see Figure 4.6). That immediately creates a more dynamic composition and encourages the viewer's eye to wander throughout the picture. Or, the image could have been cropped vertically to add the background area in the distance. (See Figure 4.7.) That creates another interesting image, shows more of the environment around the woman, and emphasizes the feeling of loneliness or wistfulness.

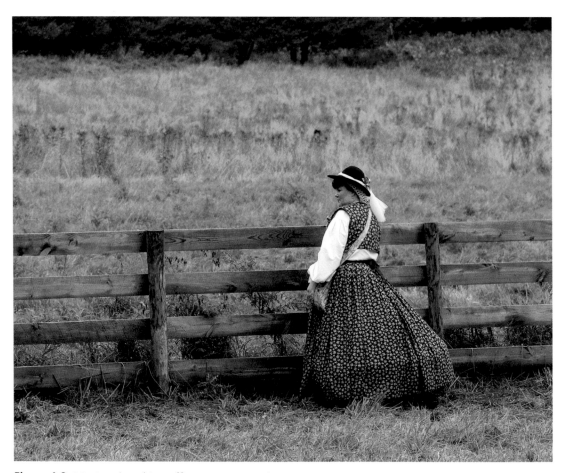

Figure 4.6 Moving the subject off-center improves the composition.

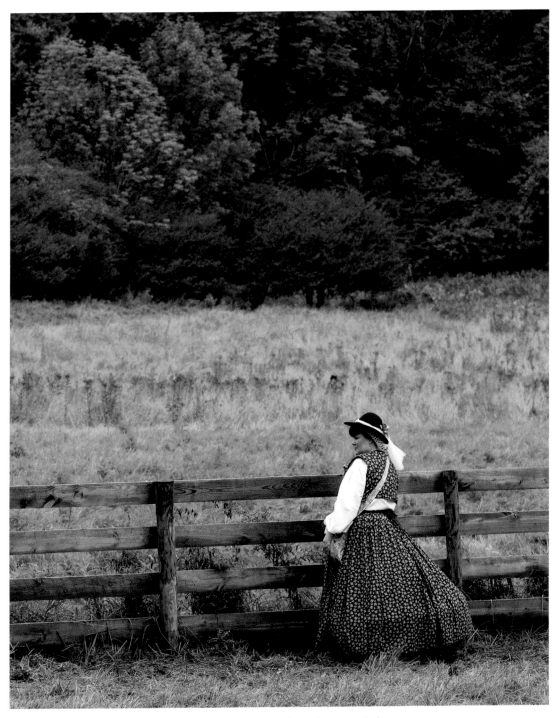

Figure 4.7 An interesting vertical shot can be extracted from the original photo, too.

99% *Photographer: Eric Wethington*

Here's another image by photographer Eric Wethington. In his original shot, he captured an interesting street scene. The posterboard flag, the posters on the ground, the accoutrements at the feet of a musician, all at the base of a statue give the viewer a sense of the environment, time, and event as it's taking place. The original image is a good example of traditional street photography such as that refined by the New York photographers of the 1960s and featured in publications of the time, such as *LIFE* magazine. (See Figure 4.8.) The title of the image—99%—reveals that the viewer is looking at one of the so-called 99 percent of Americans, as reflected by the "99" embedded in the field of the flag plastered onto the base of the statue.

Photographer Techniques:
The photographer cropped into the photo to emphasize the man.

Suggested Improvement Techniques:
Digital sensors do not always capture sufficient detail in dark areas and you may need to enhance those areas; trust your instincts and work with your image to end up with the picture as you originally saw it.

Wethington decided to emphasize the man and eliminate some of the other, less important parts of the picture. Figure 4.9 is an alternate version, brightened, and cropped to include only the man, flag, and musical instruments. However, this cropping loses some of its focus. Without access to the entire original image, the viewer may wonder exactly what this picture is about. That's always an essential question for street photographers and photojournalists to answer. The original image was definitely a candid street scene. Cropped, there's less information to help the viewer understand the intent of the photographer.

If the picture is really about the man and the flag, does the viewer need to see the rest of his body and his surroundings? I tried two alternate croppings just to see what they might look like. A tight crop I made for Figure 4.10 shows the man and the flag; it is both quite dramatic and in the tradition of this type of street portrait. Alternatively, the original overall scene is also an excellent street photograph. A different way to crop the image would be to tighten the composition and then lighten the dark areas (see Figure 4.11), resulting in an interesting scene that tells a story in its own way.

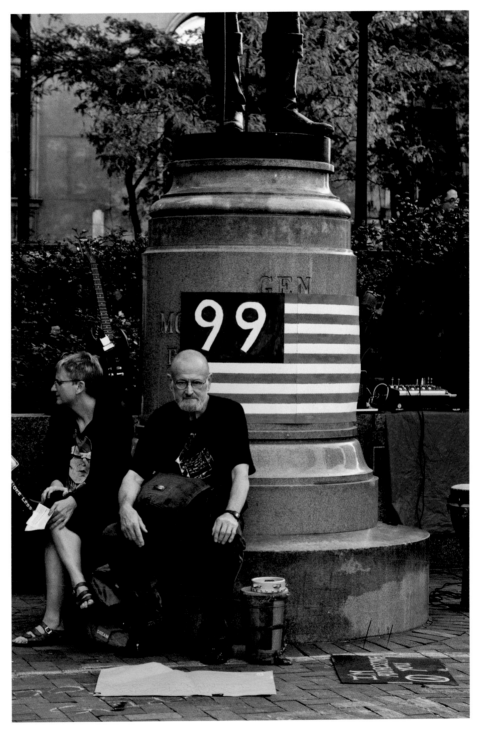

Figure 4.8 Street photography captures people and tells a story.

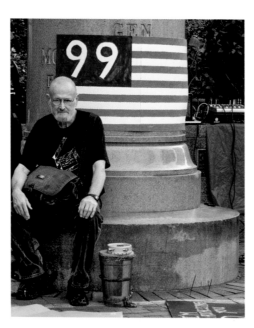

Figure 4.9
Cropping down to
the man adds
emphasis to him.

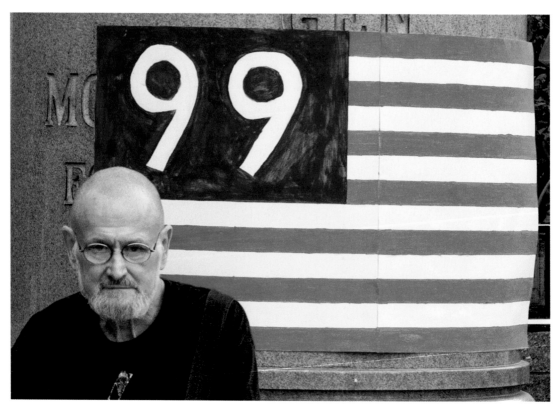

Figure 4.10 Even tighter cropping tells a story about the 99-percenter.

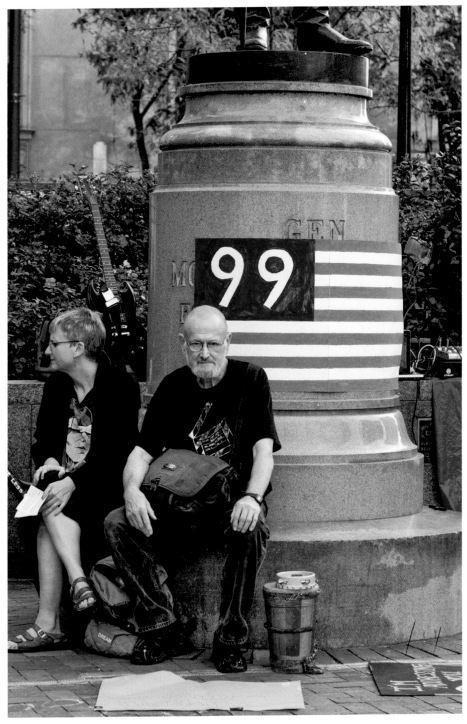

Figure 4.11 An alternate crop shows the man at the base of a statue.

Plates

The original image is simply a shot of an interesting piece of artwork, composed of a collage built of license plates arranged in the shape of the state of Ohio. It's a clever work, especially since the individual plates roughly approximate the shape of Ohio's 88 individual counties. Of course, the original image (see Figure 4.12) is just a snapshot: underexposed and with an excessively warm color balance.

Of course, photographing someone else's artwork doesn't make you a creative photographer.

> **Photographer Techniques:**
> The photographer cropped a mundane photo to create an appealing abstract design.

> **Suggested Improvement Techniques:**
> Watch white balance; try different processing and cropping techniques to make the abstract more of your own.

That's why Hilinski decided to make this image his own by transforming the design of the plates into an abstract design using imaginative cropping. His re-imagining of the artwork, with some color correction to remove the warm color cast, is shown in Figure 4.13. By cropping tightly, he found an interesting design within the collage of license plates. The photo now has an abstract look, assembled from a collection of numbers, shapes, and colors.

When you are trying to take an original scene like the artwork shown in Figure 4.13, and transform it into your own visual expression, think about other things that you can do to expand on the artistry the original creator used. For example, by rotating the image, as I've done for Figure 4.14, the license plates take on a very different look. The odd angles intensify the design, and add some vitality to the composition.

Figure 4.12 This interesting artwork was captured in a snapshot.

Figure 4.13 The photographer put his stamp on the imagery by cropping tightly.

Figure 4.14 Rotated, the image has even more of an abstract look.

At Street Fair

Photographer: Jan Kocsis

The photographer captured a child in a nice moment at a street fair (see Figure 4.15). The facial expression of the child, along with the child's posture and gesture and bright-colored clothing help the viewer focus on the youngster, even though there are a lot of other things going on in the photograph. The eye-level angle intensifies the connection.

The photographer decided to emphasize the child's cute face, and created an extreme crop of the photo. (See Figure 4.16.)

Photographer Techniques:
The photographer cropped the photo to show only the child's face.

Suggested Improvement Techniques:
Don't use crops that emphasize the limitations of your camera's resolution. Try crops that are less extreme and which show more of the child's personality.

Figure 4.15
A child was captured at a street fair.

Figure 4.16
An extreme crop emphasized the child's face, but important image quality is lost.

The photographer tried to isolate the child's face and avoid the distractions of the background. Yet, those distractions show the viewer where the youngster is toddling around with the balloon. A less severe crop would tighten the composition and allow the photographer to emphasize the child and the setting. That's what I did for my alternate version, seen in Figure 4.17, adding a minor touchup to remove the website lettering on the sign in the background.

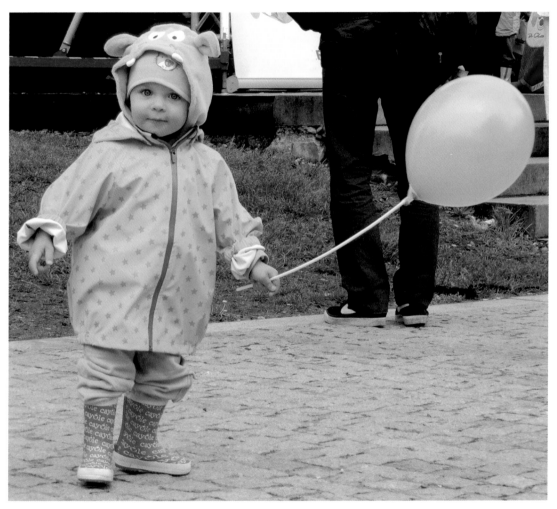

Figure 4.17 Showing the entire child brings personality to the forefront.

Droplets

This sequence starts with a nice fall photograph showing fallen leaves after a rain, which has created some water droplets on the leaves. The photographer enhanced the details of the leaves and increased saturation to enrich the colors. (See Figure 4.18.) Rozin then rotated and cropped the image to emphasize the water droplets on a single maple leaf. (See Figure 4.19.) The tight composition encourages the viewer to look at the detail of the leaf and the water droplets.

> **Photographer Techniques:**
> The photographer cropped the photo to emphasize water droplets on a leaf.

> **Suggested Improvement Techniques:**
> Don't oversaturate individual colors when saturating other colors in an image; try some different crops.

However, the photographer's original image allows the surroundings to provide a little context about the leaf's environment. By trimming the picture to favor the line of three maple leaves that progress from the upper-left corner to the center of the composition, the picture becomes more dynamic, and the water droplets on the trio of leaves contrast sharply with the leaves without pronounced droplets. (See Figure 4.20.)

Figure 4.18
Maple leaves dappled with raindrops make a lovely fall image.

Figure 4.19
A rotated, close-up image makes the droplets pop out.

Figure 4.20
Hidden within the original image is another photo, showing a diagonal "line-up" of rain-drop-covered leaves.

Lighthouse *Photographer: John Earl Brown*

Folks in Cleveland have an abundance of light-houses to photograph along the Lake Erie shore. John Earl Brown got the timing of this shot exactly right for the image shown in Figure 4.21. When the sun gets close to the horizon like this, it soon passes out of sight. The photographer's timing had to be perfect to capture the sun right above the horizon, descending behind the lighthouse. His second version, seen in Figure 4.22, emphasized the sun more, making it a little larger in the frame. Brown also warmed

Photographer Techniques:
The photographer cropped the photo to emphasize the lighthouse and sunset.

Suggested Improvement Techniques:
Emphasize either the water or the sky, then use the stark quality of the silhouette. Try to avoid centered horizons and excessive edge darkening.

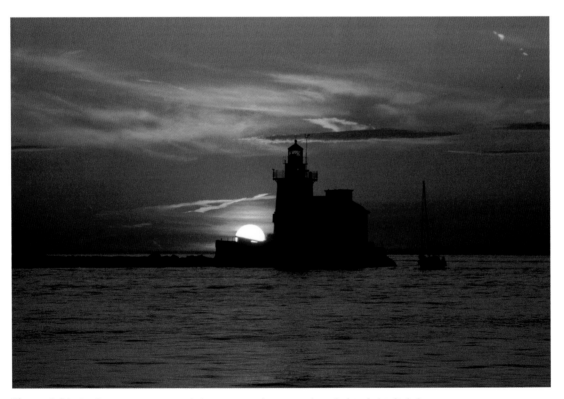

Figure 4.21 Perfect timing was needed to capture the sun sinking behind this lighthouse.

the colors slightly, enhanced detail in the lighthouse, and darkened the corners of the image to emphasize the middle portion of the photograph.

Although the lighthouse and sun were moved out of the center of the composition, the horizon is still right in the middle of the frame. A centered horizon looks best when there is a mirror image between the upper and lower halves of the photo, but that is not the case here. The water is not as interesting as the sky. Showing so much water potentially weakens the visual relationship of the lighthouse and sun to the space, color, and pattern of the sky.

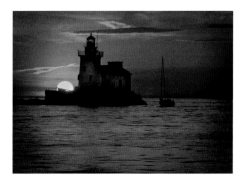

Figure 4.22 Darkening the corners put the emphasis on the lighthouse and sunset.

Even though edge darkening is a great technique for finishing an image, if it's too obvious, it can create a distraction for the viewer. Although Brown's artistic interpretation is great, for an alternative, consider cropping the original image to emphasize the sky and then process the photo to enhance this beautiful silhouette. (See Figure 4.23.) Then, finish off the image by darkening the outer parts of the photo, but blend it so that it isn't obvious to the viewer.

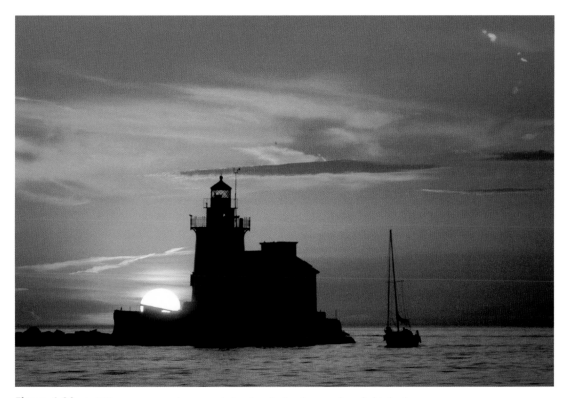

Figure 4.23 A different crop and more subtle edge darkening produced this look.

Entrance *Photographer: Ed Rynes*

The entrance to this Memorial to President James A. Garfield has a massive feel to it—the heavy and dark stonework, along with the sweeping effect of the railings going up the steps. It's not a bad angle for the image. There are some nice textural and color contrasts that are interesting. The white triangles at the upper left and right are distractions, but are also easy to remove. (See Figure 4.24.)

Rynes cropped the image to produce a bolder look (see Figure 4.25). By cropping the photo to just the doorway and some of the stairs, he simplified the image. In addition, he added

Photographer Techniques:
The photographer cropped the image to emphasize the doors of the church, then added the child for scale.

Suggested Improvement Techniques:
Don't be afraid of the tonalities of your image; use them for contrast and impact. Work with your original instincts about the composition by experimenting with contrast and color.

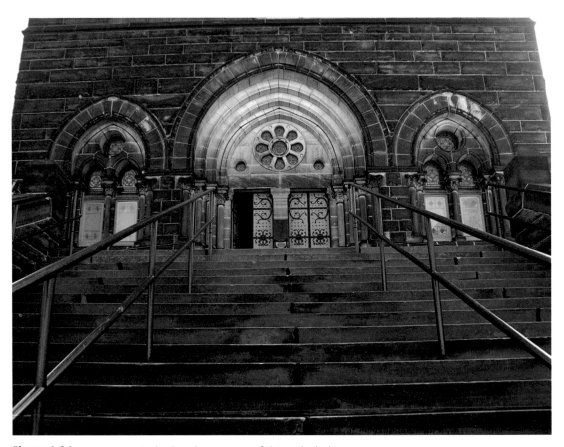

Figure 4.24 Dramatic stairs lead to the entrance of this cathedral.

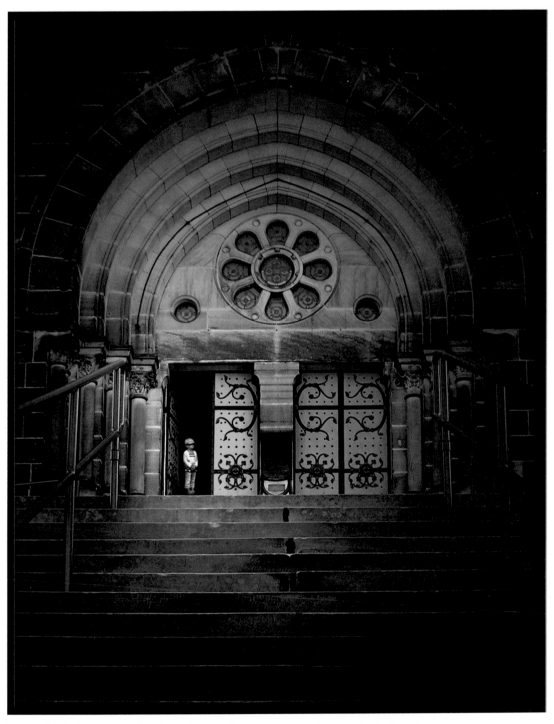

Figure 4.25 Cropping and adding a human figure produced a different look altogether.

contrast and darkened the light stonework over the doors while giving the doors more color. Using an image editor, he added a child to the scene for scale. All of these things definitely give the photo a fine-art look and create a dark mood.

The grayness of the light in the original photo does dull the stairs and railings somewhat, but they can be intensified in an image editor, as I did for Figure 4.26. Finally, if you really want to add some movement to the image, consider shooting or cropping at an angle, as shown in Figure 4.27. This is a technique that is used to create drama and impact in movies. You can certainly use that technique with still photography, though if you do it, be sure to do it in such a way that the viewer *knows* that this is an intentional effect and not simply the result of accidentally tilting the camera.

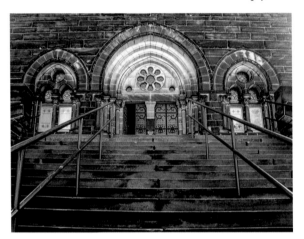

Figure 4.26 This alternate version highlights the stairs.

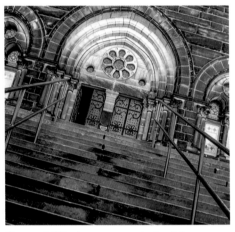

Figure 4.27 An intentional tilt of the image introduces some drama and impact.

Stairwell Looking Down *Photographer: Martin Shook*

Circular stairwells have long interested photographers. There is a classic image of the Beatles looking down a stairwell at the photographer, for example, used on the covers of their *Red* and *Blue* albums. Photographer Martin Shook found an interesting stairwell with a squarish shape and positioned his camera to capture a photograph that shows off its looping spiral. The original image (see Figure 4.28) includes extraneous detail that doesn't emphasize the pattern of the stairwell. Shook then rotated and cropped the image to add a more dynamic quality, improving the color and sharpening detail

Photographer Techniques:
The photographer cropped the photo and rotated it to emphasize the abstract design of the stairwell.

Suggested Improvement Techniques:
Brighten the photo to get rid of a dingy look to tonality and color; selectively brighten the dark stairs to balance out tonalities. Try some stronger processing techniques to capture more of an abstract image.

in an image editor (see Figure 4.29). The second version of the image is more abstract. The lines of the steps draw your eyes around the composition in concert with the spiraling stair rails.

The intensity of the available light receded as the stairwell descended, making the stairs darker. Brightening the dark stairs to even out the tones better reveals the interesting abstract design.

It was this fascinating design that attracted the photographer to this location. In Figure 4.30, I took it further and converted the image to a high contrast, black-and-white photo that became almost a pure abstract design.

Figure 4.28
Spiraling staircases always make interesting subjects.

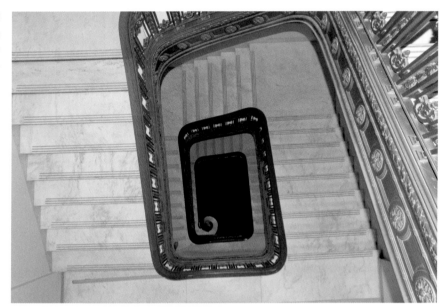

Figure 4.29
Tight cropping reduces the stairs to an abstract design.

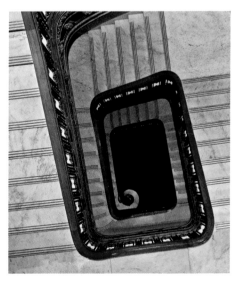

Figure 4.30 In black-and-white the image turns into an interesting pattern of lines.

5

Composition

The elements of good composition involve much more than just setting the boundaries of an image effectively through cropping, as discussed in the previous chapter. There are eight more important rules to keep in mind, and we'll look at them in this chapter:

- **Simplicity.** Reduce your picture to nothing more than the elements that are needed to illustrate your idea. Avoid extraneous subject matter to eliminate potential confusion and draw attention to the most important part of your picture.
- **Choosing a center.** Always have one main subject that captures the eye.
- **The Rule of Thirds.** Place interesting objects at positions located about one-third from the top, bottom, or either side of your picture. Although this is not a hard-and-fast rule, it makes most types of images more interesting than ones that lock the center of attention in the middle of the frame.
- **Lines.** Use straight or curving lines that lead the eye to the center of interest in appealing ways.
- **Balance.** Evenly balance the content of your images with interesting objects on both sides. This can be done while still maintaining the center of interest at a fixed point of your choosing.
- **Framing.** Use elements *within* a photograph to create a frame-within-the-frame and highlight the center of interest.
- **Fusion/separation.** Ensure that two unrelated objects don't merge in a way you didn't intend, as in the classic example of the tree growing out of the top of someone's head.
- **Color and texture.** Work with the hues, contrasts between light and dark, and textures of an image as elements of your composition. The eye can be attracted to bright colors, lulled by muted tones, and excited by vivid contrasts.

Setup for Surprise *Photographer: Rick Wetterau*

Shooting from within a refrigerator is an amus-
ing and unusual idea for a photograph.
Photographer Rick Wetterau might have been
inspired by some of the cooking shows that
place the camera behind a stove or refrigerator,
but even so, the image shown in Figure 5.1 is an
unusual approach for a still photo. My thought
is that the photographer could take this even
further, with a series of images taken over time
of many people looking into the refrigerator,
especially as the contents inside change from
day to day.

Photographer Techniques:
The photographer set up a camera inside a
refrigerator to capture people opening and
looking inside the refrigerator.

Suggested Improvement Techniques:
Clean up distracting "antennae" coming
from young woman's head.

The image uses framing (discussed in the introduction to this chapter) to enclose the young woman
perfectly, surrounded by all of the bottles on the shelf of the refrigerator. Seeing some of the kitchen
in the background also gives a sense of the location.

In this case, the woman is centered in the composition. Usually, the center is not a good place for
the main subject; however, in this case it works. All of the lines of the bottles lead right toward her.
The strong perspective provided by the wide-angle lens creates a feeling of depth (see Figure 5.2).

The title of the image implies that this setup was designed to surprise the subject. Although this
young woman may have opened the refrigerator without expecting to be captured by a camera, her

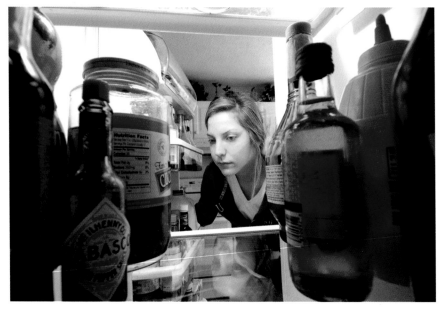

Figure 5.1
Photographing from
inside a refrigerator
is an unusual
approach.

facial expression isn't surprise. Instead, she appears to be looking for something and completely unaware of a camera. That gives the photo an interesting, informal look.

The camera's white balance settings are balanced for the warm color of the refrigerator light. The background appears to be daylight, which is, in comparison, much bluer than the illumination in the refrigerator. This disparity actually increases the feeling of space and dimension for the photograph (warm foreground and blue background) and helps define the refrigerator and young woman against the surroundings.

Figure 5.2 A wide-angle lens creates a feeling of depth.

My only suggested change would be to use an image editor to remove some objects on top of the cabinets. They are perfectly aligned with the woman's head and look like antennae sticking out of her head, producing the "fusion/separation" effect mentioned in the introduction. Removing them cleans up the image (see Figure 5.3).

Figure 5.3 In the final image, antennae are removed from the top of her head.

9/11 Flag Memorial *Photographer: Dennis Wert*

When I am interviewed by the media, a favorite question is "If you could give amateur photographers one piece of advice, what would it be?" I usually respond, "Don't shoot everything at eye-level!" (Although, "Get closer!" is equally relevant for most snapshooters.) Dennis Wert followed both suggestions when capturing this American flag memorial, and transformed a mundane shot into a much more interesting image.

His original image—a large field of flags located in an area next to the Great Lakes Science Center in Cleveland—(see Figure 5.4)

Photographer Techniques:
The photographer changed the angle dramatically, going from standard eye-level to ground level.

Suggested Improvement Techniques:
Watch out for blank skies that can take over an image; getting low is a good idea, but make sure to add definition to the sky.

could have been captured at eye-level (although it might have been taken from a somewhat higher vantage point). It's an effective storytelling photograph, as is.

The contrast of the color of the flags with the green of the grass is compelling. Wert eliminated most of the blank and featureless sky so that it is not an important part of the picture. The photograph is filled with flags and grass, which means it is also filled with color. He deliberately used the edges of the frame to crop the field of flags, which makes them seem to go on forever.

Figure 5.4
An eye-level view, but not the ideal perspective.

The photographer then decided that this view was not dramatic enough, so he placed the camera closer to the ground (see Figure 5.5). This viewpoint provides a more dramatic angle, giving the flags strength and stature. In this version, the flags in the foreground are slightly out of focus and the building in the background is sharp. The flags in the foreground are so visually dominant that they need to be sharp. The revised image now has a bright gray sky that fills up most of the image, muting the colors.

Figure 5.5 Shooting from a low angle is more dramatic.

The photographer's presentation certainly conveys a solemn, somber tune, emphasized by the gray skies. In an effort to add a little more drama to the image, I darkened the sky, as seen in Figure 5.6, which helps balance the sky with the flags, adds some interest to the flags and grass, and even gives an interesting somber mood appropriate to the event.

Figure 5.6 Darkening the sky adds an appropriate somber mood.

Ravenna Balloon A-Fair *Photographer: Roger Moore*

My hometown was once the heart of a thriving subset of the rubber industry that flourished in nearby Akron, and housed the headquarters of the world's largest toy balloon manufacturer. The rubber companies have since gone away, but their legacy lives on with the town's annual Balloon A-Fair, featuring hot air balloon lift-offs that attract photographers from all over Northeast Ohio. Such events are photo favorites because they are colorful and always offer interesting opportunities for attractive compositions.

Photographer Techniques:
The photographer moved from a standard angle outside of an inflating balloon to inside the balloon to capture an abstract colorful design.

Suggested Improvement Techniques:
Use an image editor to balance out tonalities and color.

Roger Moore's first image captured an inflating balloon (see Figure 5.7). He got close to the balloon to show off its bright colors and the activity surrounding it. It's a good picture with a photojournalistic feel, and it's relatively straightforward.

Figure 5.7
Capturing the balloon as it inflates provides a photojournalistic view.

In the second image, Moore photographed the inside of the balloon and captured the dramatic colors of its panels (see Figure 5.8). This view creates a dramatic and effective composition of color and design. The image has become abstract in its use of hues and a combination of straight and curving lines. By placing the center of the balloon to the left side of the image frame, the photographer created a dynamic composition that offers visual movement in a ripple effect going from left to right.

One thing that affects this image is the imbalance caused by the much brighter illumination on the left. Sometimes photographers need to use image-editing software to equalize light imbalances, so that the final image is much closer to what we actually saw. This type of effort forms the basis for much of Ansel Adams' work. Look at his how-to books, such as *The Print*, and you will see he spent a lot of time in the darkroom, balancing bright and dark areas to make the image better fit how he saw the scene.

The dark circle of balloon panels contrasts with the bright colors of the center of this balloon. It does have color in it, but, as captured in the photo, it appears nearly black, creating an interesting contrast with that center pattern. An alternate option would be to brighten that darkness to show off the color, as I did for Figure 5.9. The composition then gains a design based more on the radiating spokes than simply concentrating on radiating ripples of color.

Figure 5.8
The dramatic colors make a more appealing, abstract image.

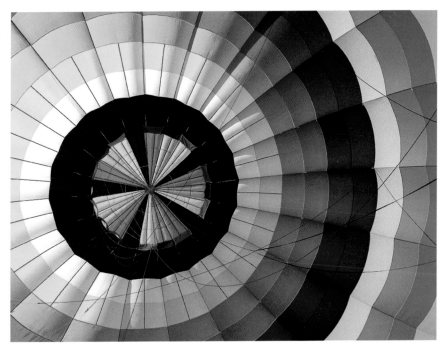

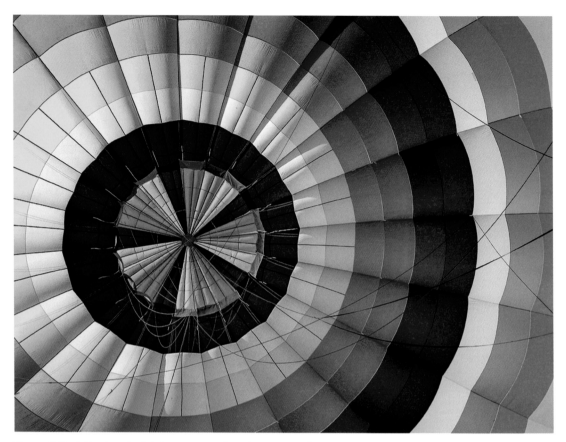

Figure 5.9 Adjusting the brightness gives the colors more richness.

B&O Railyard *Photographer: Roger Moore*

Here is another set of images from Roger Moore, taken at the B&O Roundhouse in Cleveland, a project of the Midwest Railway Preservation Society. Both of his photos are striking compositions that clearly show how a photographer can work with a subject to provide a variety of compelling pictures. Both use a very wide-angle lens and a close-up perspective to provide a dramatic view that creates a strong graphic design for the pair of images.

Photographer Techniques:
The photographer explored an old railroad box car to capture unique photographs.

Suggested Improvement Techniques:
None.

The first image (see Figure 5.10) revealed a wonderful application of shape and color. The hues are extremely dramatic, especially as they progress from foreground to background. This use of a wide-angle lens up close produced an especially intense transition. The extended depth-of-field created a strong feeling of texture and pattern on the train that contrasts with the sky and ground.

Figure 5.10
This view of a rail car is a wonderful application of lines, shape, and colors.

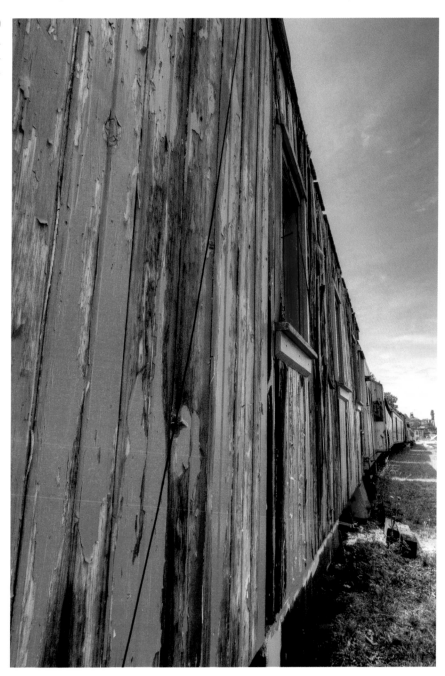

When photographers refer to "working a subject," they mean going beyond the first shot or impression to look for additional images of the same subject, usually by moving around it and trying different approaches. That's exactly what Moore did here to capture the second image (see Figure 5.11). He literally crawled under the carriage of the rail car and found a fascinating design. Once again, the wide-angle lens and the depth-of-field enhanced the design, pattern, and textures, and high dynamic range (HDR) processing enhanced every tone and detail. Both of the photographer's images are dramatic and bold ways of looking at a rail car, showing us something very different in each.

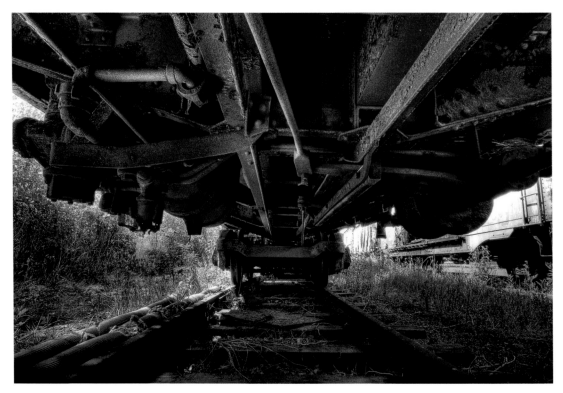

Figure 5.11 But exploring underneath provides another powerful view of the same subject.

4 Strings *Photographer: Dan Sandy*

As the former bass player of The Babylonian Disaster Squad, and still a dabbler with the instrument, this set of images by photographer Dan Sandy is close to my heart. However, you don't have to be a failed musician to have a fascination with the strings of a guitar or related instrument. Here, Sandy found two interesting views within the mystic confines of Eat All Dead Gophers. (Musicians will appreciate the mnemonic.)

Photographer Techniques:
The photographer found two distinctly different ways of photographing a bass electric guitar.

Suggested Improvement Techniques:
Darken areas that are too bright to balance the overall picture.

Both images are fairly abstract. Neither allows us to see much of the instrument other than the strings and bridge/saddle area. This creates a very simple and direct set of compositions. In the first image (Figure 5.12, left), the strings were captured from nearly directly above at a fairly straight-on angle. This view really shows off the intricate

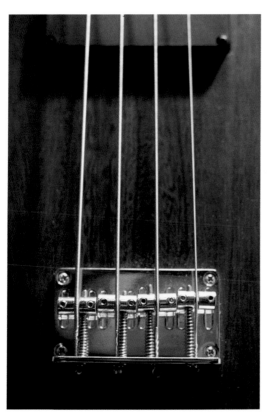
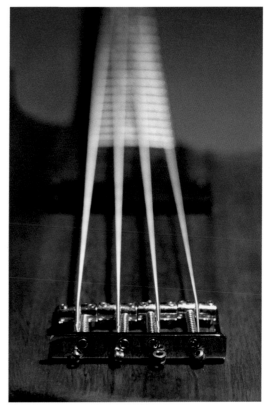

Figure 5.12 A straight-on view of a bass guitar (left). An image shot from an angle (right).

design of the mechanical pieces. The second image (Figure 5.12, right) gives us a very different and dramatic perspective, producing a bolder composition because of the dynamic quality of the lines of the nickel-wound strings. It also creates a very interesting interplay of sharp foreground to out-of-focus background. These things give this image more impact as a photograph.

There are some things that could be done in the first image to make it a little stronger. One challenge of this image is that the light is brighter on the right side than on the left, especially at the top right. The composition is balanced from left to right, but the brighter light at the right, especially the upper-right corner, unbalances the composition. By darkening the upper-right part of the picture, you allow the essentially balanced nature of the composition to show through.

In addition, the photographer's angle was not quite symmetrical from left to right. This makes the bridge and saddle look crooked, and since that portion is the sharpest part of the picture, it looks a little better when it is straightened. (See Figure 5.13.)

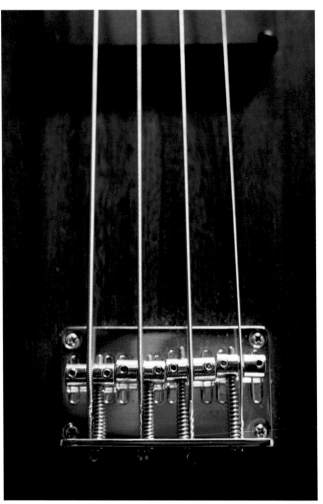

Figure 5.13
A little straightening and darkening at the edges produces the finished version.

Safety Deposit Cleveland Trust *Photographer: Debra Rozin*

The photographer's first image, taken at a historic downtown Cleveland bank, is quite unusual (see Figure 5.14). The bright glare of light at the upper left is a big distraction, but the composition offers strong visual movement from foreground right to background left.

Rozin's second image (see Figure 5.15) was shot from a lower angle. The light on the boxes offered a dramatic, striking view. The

Photographer Techniques:
The photographer captured an interesting pattern and then changed angles to create a more dynamic photograph.

Suggested Improvement Techniques:
Darken some small over-bright areas.

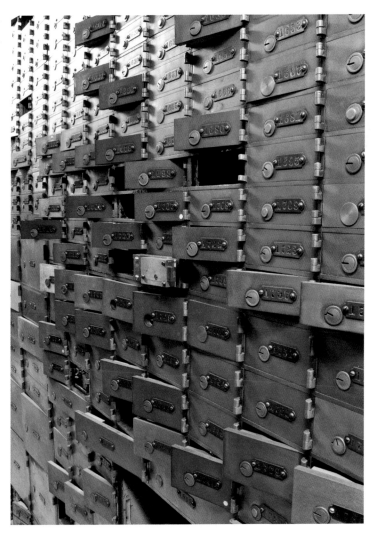

Figure 5.14
No, this isn't a bank heist—it's a photographic opportunity.

photographer's use of a wide-angle lens created a dynamic composition as the perspective changed from bottom foreground to top background.

The contrasty light extracted the texture of the boxes and highlighted the box numbers. In addition, the lighting created contrast between the closed and open boxes. A band of brighter light going through the middle of the image defined and structured the overall composition.

I don't have a lot of suggestions for the second photo. It's very well done. Consider darkening the over bright areas to balance out the composition and add some sheen to the brass.

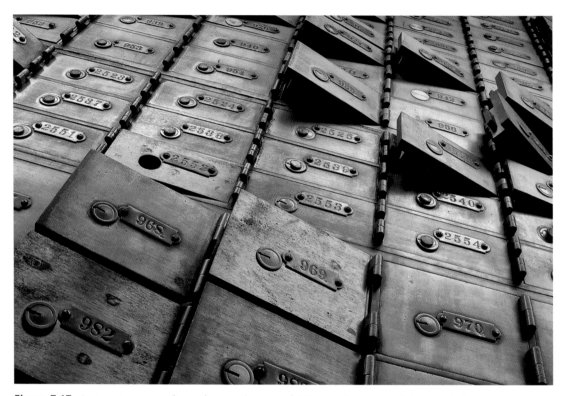

Figure 5.15 An imaginative angle emphasizes the powerful lines and textures of the deposit boxes.

Party Project

Photographer: Debra Rozin

Here's another effort from photographer Debra Rozin. The original image shows a straightforward snapshot of marshmallow snowmen. Light from the flash on the camera doesn't do much other than illuminate the subject. (See Figure 5.16.)

The second image offers a totally different look. The camera is now lowered, close to the subject matter, and shows the snowmen from a striking, eye-catching angle. The light looks natural. (See Figure 5.17.) The photograph takes on abstract qualities as compared to the first image.

Photographer Techniques:
The photographer found a unique angle from which to photograph the tasty subjects.

Suggested Improvement Techniques:
Darken the upper corner to keep emphasis on the color and arrangement; crop the photo slightly to place emphasis on the snowmen.

Figure 5.16 An overhead view of these marshmallow snowmen lacks drama.

This photo is not "about" the snowmen as much as it is about the color, design, and pattern of the image. In fact, because of the way the image is composed, the most emphasis is actually on the strawberries, which form a diagonal line through the middle of the picture from the upper-left corner to the lower-right corner.

Figure 5.17 A low angle is more effective.

Given the abstract flavor, I darkened the upper-right corner to place more emphasis on the snowmen, and less on some details that could be seen in the background. I also cropped out some of the snowmen from the left and some of that blank foreground (see Figure 5.18).

Figure 5.18 Slight tonal adjustments and a crop produced this alternative version.

Letchworth State Park

Photographer: Zach Bright

These two images show how dramatically different the same scene can appear at various times of day. The changing lighting conditions alter both the mood and the appearance of these two landscape shots. Neither is "better" than the other; rather, the two combine to provide variations on the same scene.

While the overall composition is set up to frame the scene in a similar way, the two compositions differ in what is emphasized and what is de-emphasized simply because of the way the light falls. Composition is not simply about the framing of the scene, but also about how the light affects pictorial elements within the image.

> **Photographer Techniques:**
> The photographer shot the same location at two very different times of day—morning and afternoon.

> **Suggested Improvement Techniques:**
> Try using some selective, local adjustments to affect parts of the photos to strengthen the composition.

Photographer Zach Bright says that the first version (Figure 5.19, left) was taken at 7 a.m. The lighting was fairly evenly distributed throughout the scene and allowed fine details of the canyon and water to show up clearly. The viewer's eyes move freely within the composition. The second image was taken at 5 p.m. the same day (Figure 5.19, right), and at that time of day the illumination is much harsher and more distinctive. Under this light the viewer is unable to see as much of the canyon in the composition. This produces a more dramatic mood for the photo.

The overall composition of both images is excellent. There are some things that can be done in the processing of the images to enhance that composition and give it more strength. For example, the bright yellow tree in the 7 a.m. version is a distraction amidst the more gentle lighting and muted colors of the overall image. It draws the viewer's attention away from the mighty river.

In relatively soft lighting like this, the overall scene can appear rather flat visually, because there is no strong contrast between the elements in the front and back of the image. For Figure 5.20, left, I darkened the left and right edges and bottom half of the image, but kept the river bright and glowing. For the 5 p.m. version, the lighting is so strong that the viewer can't see the deep, dramatic canyon. So, for Figure 5.20, right, I brightened the dark tones to "reveal" the canyon more clearly while retaining the drama of the lighting effects.

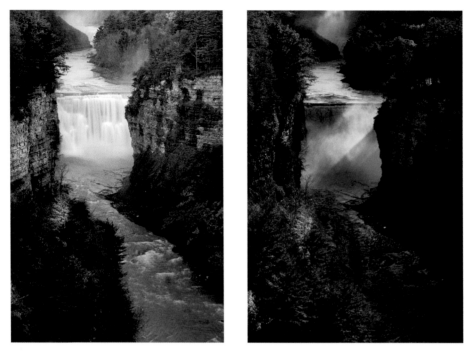

Figure 5.19 An interesting scene captured at 7 a.m (left) and 5 p.m. (right). Both are excellent images.

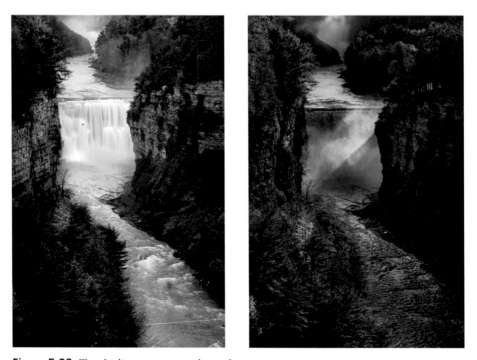

Figure 5.20 Tonal adjustments provide an alternative presentation.

Roaring Fork

Photographer: Donna Schneider

Because digital cameras capture images using a rectangular format (usually with 2:3 or 3:4 proportions), photographers have to decide whether to shoot in portrait or landscape (vertical/horizontal) orientation. And, just as portraits don't always have to be shot in vertical orientation, landscape images don't necessarily have to be shot in a horizontal orientation.

For these two images of a swift-flowing stream, photographer Donna Schneider tried both orientations. Running water is a favorite subject of photographers, because, as you've seen in some of the previous images in this book, a slow shutter speed captures lovely flow patterns of the

> **Photographer Techniques:**
> The photographer shot the same stream with horizontal and vertical compositions.

> **Suggested Improvement Techniques:**
> Be aware of how much sharpness is affected by camera movement during exposure and is lost to diffraction when using very small f/stops; monitor white balance and watch the edges for distractions.

water and creates a gentle, silky look in a stream like this one. The photographer started with a horizontal image with an appealing composition (see Figure 5.21), but then wisely decided to capture a vertical composition (see Figure 5.22). The vertical orientation directs the eye from the background

Figure 5.21 The horizontal view of this stream is interesting…

Figure 5.22 …but a vertical orientation is even better.

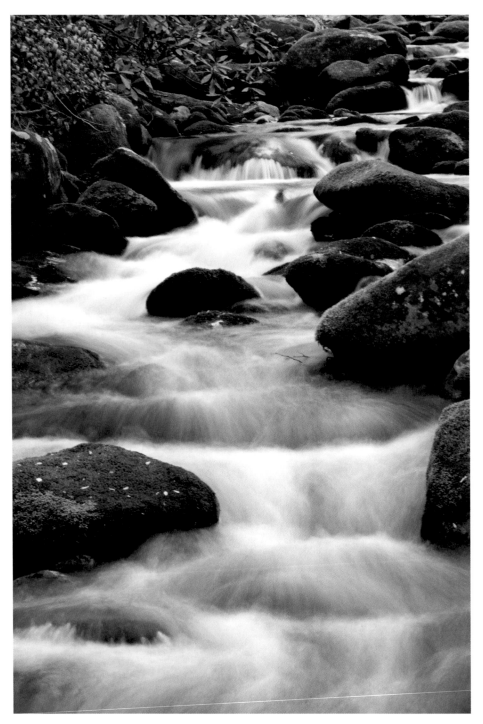

Figure 5.23 Adding a little contrast and removing a distracting rock from lower right improves the final image.

to the foreground along the line of the stream. The composition is tight and effective, except for the distraction of an intruding rock at the lower-right corner that does not fit the rest of the scene. It can be cropped or cloned out of the picture, as I did for Figure 5.23. I also added some brightening and contrast and slightly warmed the color rendition from its initial bluish tone.

When using a long shutter speed (typically one-half to a full second or more) to add a laminar flow appearance to water, it's important that the rest of the image is very sharp to provide a more dramatic contrast. In this image, the moss and rocks should be as sharp as possible, but, as you can see from the enlargement in Figure 5.24, they are not tack sharp. It's possible that there was some camera movement caused by the mirror flipping up and shutter opening to capture the image. Some cameras have a mirror lockup feature that can be used when taking a photo (and not just for sensor cleaning). A few recent cameras have something called an *electronic front shutter*; the physical shutter opens completely, but the actual exposure doesn't begin until a fraction of a second later, when all internal camera movement has ceased. To maximize sharpness for images captured with a tripod-mounted camera, use a cable release, remote control, or the self-timer to minimize vibrations. Also, position the tripod so it doesn't pick up vibrations from the water.

Figure 5.24 Internal camera motion and diffraction effects can reduce the sharpness even of shots taken with the camera mounted on a tripod.

Praying Mantis *Photographer: Maria Kaiser*

Whenever you find a skittish subject like this praying mantis, take photos as you approach so that you at least get some sort of shot before the subject moves or flees entirely. Maria Kaiser's initial photo is fairly straightforward, but the multitude of lines, shadows, and textures in this snapshot make it difficult to fully understand (see Figure 5.25).

For her next attempt, she moved in very close and used a macro lens to capture the insect's head and a dramatic shadow behind it (see Figure 5.26). This composition is an unusual arrangement in the way she has placed the head. It's perfect for playing the subject against its

Photographer Techniques:
The photographer found a praying mantis on a wooden deck, shot one image to capture the insect in a snapshot, then moved in for a dramatic close-up.

Suggested Improvement Techniques:
Brighten the image to get rid of the gray feeling; be aware of diffraction that results from very small apertures and avoid using them unless maximum depth-of-field is needed.

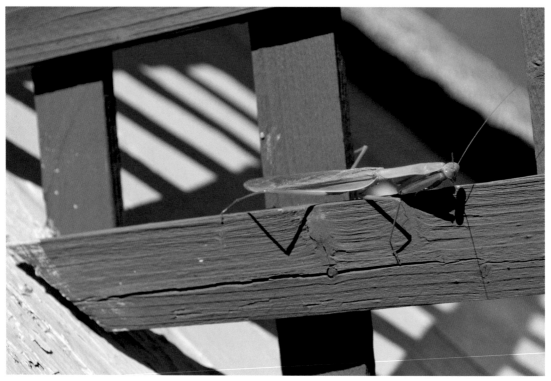

Figure 5.25 It's often wise to grab a shot of an interesting insect before it flees.

shadow within the space of the square. I brightened the image a bit, eliminating a slightly gray overtone.

Like the last image of the stream, this photograph was captured using an f/32 aperture. In this case, depth-of-field was more of a concern. The small f/stop was appropriate, and, with this particular macro lens, did not cause a significant reduction in sharpness. For close-ups like this one, it's often necessary to accept the trade-off that a tiny aperture offers, sacrificing a bit of definition to produce an image that shows both the insect and the texture of the wood on which it rests in great detail.

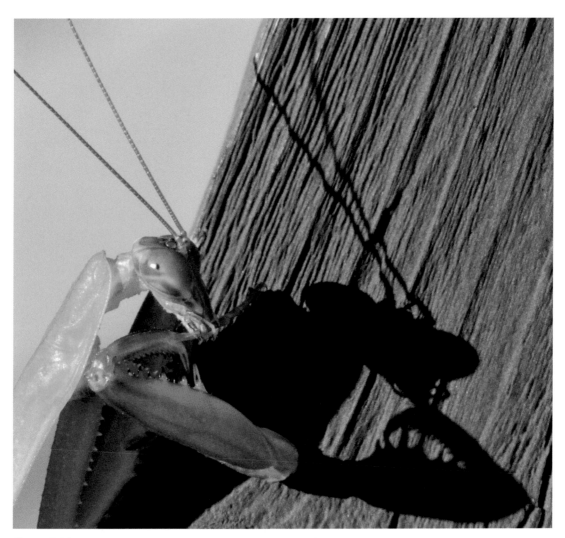

Figure 5.26 Then, if you have time, go for a more dramatic close-up image.

Tell Me Your Story *Photographer: Jerry Hilinski*

This is an interesting sculpture, located outside of the main entrance of a public library. Photographer Jerry Hilinski's first effort takes advantage of soft lighting that highlights the shiny metallic texture of the figures. (See Figure 5.27.) The soft light from the sky also highlights the three-dimensional qualities of this sculpture. However, this first image has some rather dull, uninteresting space behind and below the sculpture, which doesn't help the composition. So, the photographer got in closer for a more intimate look. He's moved enough to separate

Photographer Techniques:
The photographer shot statues at a slight distance, then moved in closer.

Suggested Improvement Techniques:
Watch out for distractions that create odd things appearing to emerge from your subject.

Figure 5.27 These two metallic sculptures reside outside a public library.

the girl figure's head from the panel behind her, helping her stand out more distinctly within the composition. The image has also been brightened to eliminate the muted gray look (see Figure 5.28).

Unfortunately, when the photographer changed his perspective, a line in the wall behind the figure on the right appeared to protrude out of the top of the boy's hat. Because that line is the same color as the statue, it appears to be part of the figure. Luckily, this merger can be easily corrected in an image editor, as I've done for Figure 5.29. I also brightened up the image even more. While Hilinski's composition is good, it does look as if the boy figure's foot is resting on the bottom of the frame as a foot rest. That

Figure 5.28 Changing the angle separates the left sculpture from the panel behind, but creates a merger between the right figure and the background.

visually ties the figure to that edge and doesn't give as clean a look at the statue. Including some extra space under the foot produces a charming look at two engaging figures.

Figure 5.29 A little space added below the right figure's foot improves the framing of the final image.

Jag-A

Photographer: Ed Rynes

As I noted in the critique of the 9/11 Flag Memorial earlier in this chapter, your first instinct to shoot a subject at your own eye-level is usually wrong. Yet, if you visit any location where many photographers are shooting, you'll notice that almost all of them are shooting from their eye-level.

Admittedly, it is easier to shoot while standing, but you'll almost always find a better image using a different point of view. Photographer Ed Rynes reports he was dissatisfied with his first shot of this vintage Jaguar XK 120 roadster,

Photographer Techniques:
The photographer first approached the car from a standard eye-level point of view, but then got down low to create a dramatic angle.

Suggested Improvement Techniques:
Minimal; watch colors as they may be affected by white balance.

Figure 5.30 Photographers typically photograph from eye-level.

because he found the car had a "feminine" appearance when captured from the angle shown in Figure 5.30. While the motor car is attractively portrayed and well-separated from its background, Rynes wanted a more aggressive look for this high-performance sports car.

So, he dropped down to a low vantage point and captured the dramatic view seen in Figure 5.31. This view, which Rynes calls "a road-kill perspective," gives an appearance of power and strength to the car. Indeed, low angles often have that effect. This image grabs our attention simply because it is different. The low angle also simplifies the background and even adds drama by including an intense sky, which Rynes intensified in an image editor. The effect is subtle, and does not overpower the car itself, yet its appearance also adds a touch of the theatrical to the image.

Sometimes photographers complain that they cannot easily position themselves lower or higher. Yet, digital cameras give you the opportunity to change angles without any body distortions as you shoot. With live view, and especially with cameras that have a tilting LCD, you can move the camera lower or higher while remaining in a comfortable position. Even if your camera's LCD doesn't tilt, you can always hold a camera low or high and try a grab shot. Check it on the LCD to see if you got the shot you wanted, and if you didn't, try again until you do.

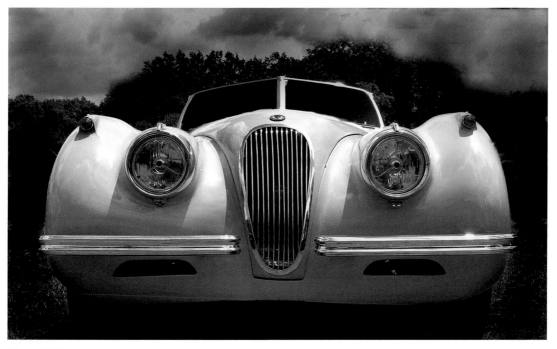

Figure 5.31 A lower view shows more of the area below the bumper and adds a dramatic sky.

India Crowds *Photographer: Susan Onysko*

In photographer Susan Onysko's first image (see Figure 5.32), she captured a scene at the Taj Mahal. She found a great reflection in the foreground that shows off the location, and yet the viewer still sees the crowd of people. The photographer avoided potential problems with the hazy sky or a cluttered background by excluding them entirely.

The first image actually has a lot of potential. But Onysko went a step further and found an extremely creative way to approach this world treasure. She uncovered timeless perspective simply by flipping the image over and cropping it to emphasize the reflections of the people walking in front of the reflection of this crown jewel of Muslim art. The photographer simplified the scene, while giving it a wonderful, mysterious look. (See Figure 5.33.)

> **Photographer Techniques:**
> After photographing the overall scene in front of the Taj Mahal, the photographer found a great reflection to focus on and "extract" from the scene in a new image.

> **Suggested Improvement Techniques:**
> Remove the distracting post; consider a tighter square crop.

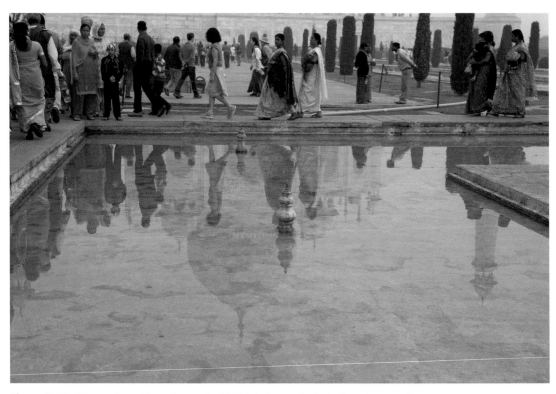

Figure 5.32 You can't avoid tourists at the Taj Mahal—so, include them in your shot.

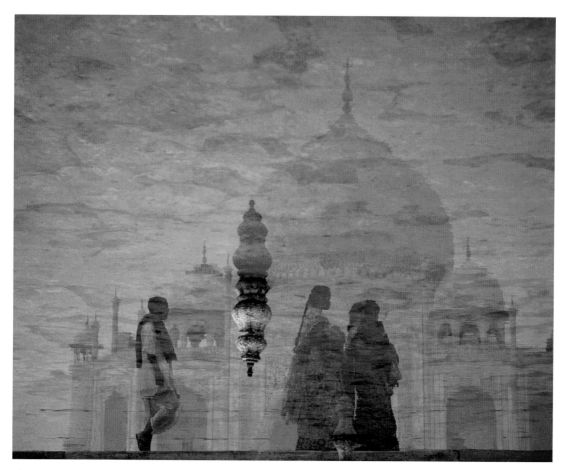

Figure 5.33 Inverting the image produces an image that appears timeless.

The white balance is exactly right for the scene, too. It gives the overall scene a very warm look that creates what seems to be a timeless photo. Moreover, it combines with the pattern on the bottom of this reflecting pool to create a unique effect.

Onysko was careful to make sure that the crowd did not overlap the pillar-like object in the water. However, the pillar itself is a bit distracting because it doesn't entirely fit with the rest of the photo, and the strange floating object calls attention to the fact that the image is a reflection. So, I experimented with an image editor to see what the photo would look like without the pillar. (See Figure 5.34.) I also tried out a square cropping, and added a little more of the edge of the pool at the bottom of the frame, so that the people appear to be walking on a more solid base.

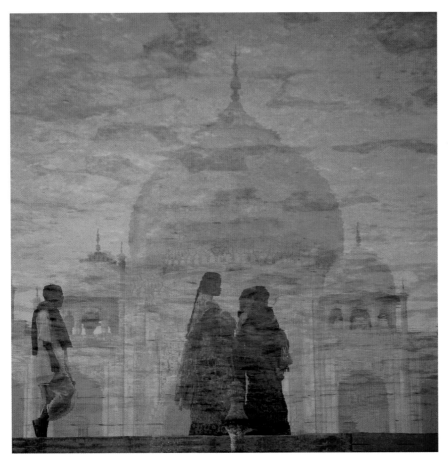

Figure 5.34
The distracting pillar has been removed from the pool.

Slide

Photographer: Debra Rozin

This is a remarkable pair of photos. Both use similar compositions: one shot looking straight down on the descending curve of the structure, and the second looking straight up at the underside and sky. Both views create an abstract design.

The first image (Figure 5.35, left) is a rather dark and moody sort of photo, except for the bright, overexposed part of the slide on the right side of the image. Because of the shininess and contrast of the slide, it would have been almost

> **Photographer Techniques:**
> The photographer found two totally different points of view on a kids' slide that completely change its look.

> **Suggested Improvement Techniques:**
> Overall, none; watch the space at the edges of the composition.

Figure 5.35 Views of a playground slide from above (left) and below (right).

impossible to capture tones in such a bright area—as well as within the rest of the slide—without using something like high dynamic range (HDR) photography techniques. The strong curved line around the outside of the slide holds our attention on the shape of the slide, but the bright area of the image still competes for our attention. The light area creates a dominant visual element in the photo and changes how the viewer looks at the rest of the composition.

That's why the second image is even better. (See Figure 5.35, right.) It is more appealing because of the strong design elements used in the composition, including the vivid colors and curving lines. In this version there are no distractions from the shape and design of the underside of this slide. Although the bottom of the picture is very bright, the strong visual contrast of the supporting structures for the slide and the slide itself are strong enough to maintain the viewer's interest in the entire photograph. Indeed, the contrast is so robust that it makes the composition bold and effective and keeps the clouds and trees at the edges from being distractions.

The only change I made in the final image was to add a bit of space to the right of the slide. The photographer gave this structure sufficient space at the top and bottom to allow it to float within the composition. But, at the right side, it's close enough that the slide starts to "tie" itself to that edge, taking away from the overall design. A little more space there cleans up the composition (see Figure 5.36).

Figure 5.36 A little space was added to the right of the slide to give the image room to breathe.

Tetons Fence *Photographer: Don Keller*

Photographer Don Keller definitely had some challenges to contend with, particularly the quality of light and a relatively blank sky, in these photos of a ranch located along the eastern border of Grand Teton National Park (see Figure 5.37). He handled both quite competently. The grasses have some interesting colors, but, overall, from the initial photograph, you would not think this scene offers a great opportunity for an effective composition.

Nevertheless, Keller found an interesting detail in this landscape and went after it (see Figure

Photographer Techniques:
The photographer captured an interesting fence in an old field, then looked around for an angle to emphasize the fence's pattern. He also made some adjustments to enhance contrast and color.

Suggested Improvement Techniques:
None.

5.38). He moved in closer to some of the fences and used them as a strong visual accent for the rest of the picture. He found an angle that paired the lines of the fence retreating into the distance with the tire tracks that also extend to the same vanishing point. The leading lines (seen in Figure 5.39) make the composition especially effective.

Figure 5.37 Ranches border the Grand Teton National Park on the east.

He then cropped the image, transforming the hills in the background into "sky," and creating a panorama that works extremely well. The strong colors, from the browns of the vegetation to the contrasting blue of the background, add something of an attractive abstract and mysterious quality that is more intense than what we might expect to find in nature.

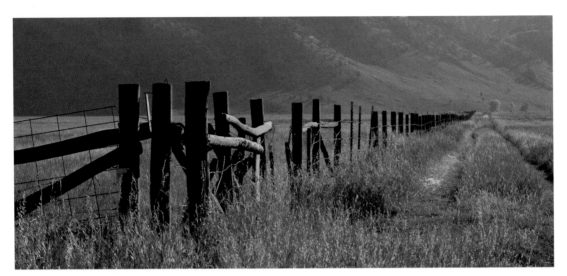

Figure 5.38 A close view of a fence can be used to create a panorama.

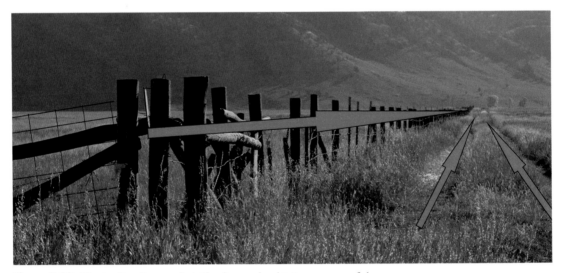

Figure 5.39 The leading lines and vivid colors make this image powerful.

6

Exposure

Exposure can make or break a photo. Correct exposure brings out detail in the areas you want to emphasize, producing the full, rich range of tones and hues that create the image. In contrast, poor exposure can cloak important details in shadow, or wash them out in glare-filled featureless expanses of white. However, getting the perfect exposure requires some intelligence, whether it's the smarts built into the camera's metering system, or the experience of the photographer. If the dynamic range (span of tones) in an image is broad, the creative photographer must calculate an exposure that renders the most desired tones in a way that best matches his or her creative vision.

Given a particular scene, you may have to decide that you *want* to underexpose the subject, to produce a silhouette effect, or, perhaps, use an external flash unit to fill in the inky shadows. This chapter shows you some examples of how other photographers have tackled these situations, demonstrating that exposure is one of the foundations of good photography, along with accurate focus and sharpness, appropriate color balance, freedom from unwanted noise and excessive contrast, as well as pleasing composition.

Blitzkrieg Bikers

Photographer: Erik Heinrich

Historical re-creations often benefit from imparting an old-timey look to photos captured during an event. But, sometimes, the action at these events happen quickly, so even the most alert photographer may have to grab a shot. Even so, as you can see from Erik Heinrich's set of photos, it's possible to learn something from a grab shot, and then follow up with an improved image.

The photographer's first shot (see Figure 6.1) was not exposed properly, so he adjusted the exposure and captured a much better looking

Photographer Techniques:
The photographer took a quick grab shot of a moving motorcycle, then corrected exposure to enhance detail.

Suggested Improvement Techniques:
Don't crop an image so tightly to the subject that it looks like it's in a box. Use a sepia tone to brighten the dark areas.

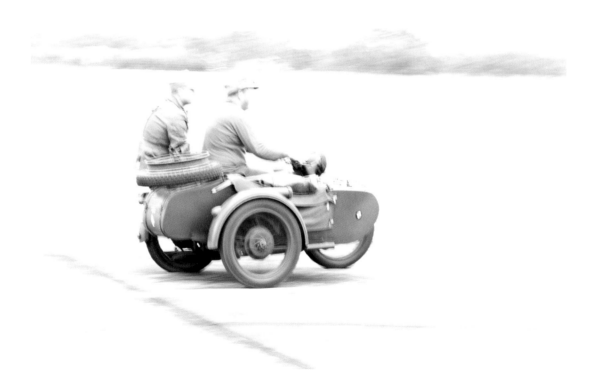

Figure 6.1 This grab shot is overexposed, but the panning effect adds movement.

image, as seen in Figure 6.2. The improvement comes not only from the corrected exposure, but from the driver's face, which is turned more toward the camera in the second shot. Panning the camera during the exposure produced an excellent motion blur effect. Only the intrusion of the non-vintage photographer at upper right spoiled the illusion that this might be an actual World War II image.

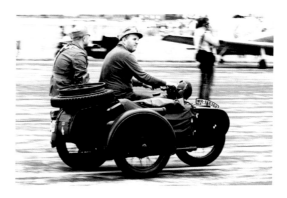

Figure 6.2 More exposure and the driver turning his head more toward the camera makes a better picture.

The black-and-white rendition is an interesting interpretation of the scene and gives it an aged look. Because the dark areas were missing some detail, I tried balancing the exposure to add detail. I added a bit of sepia toning to the image to enhance the feeling of age, which the black-and-white is doing anyway. (See Figure 6.3.)

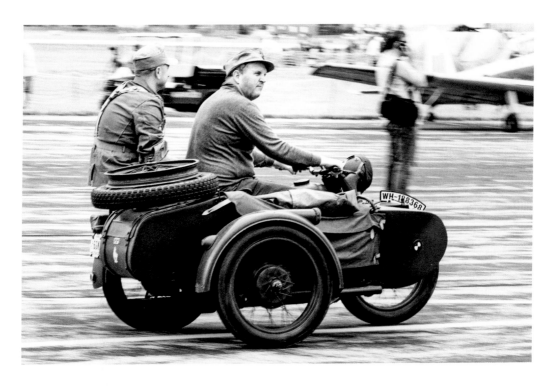

Figure 6.3 A sepia tone is appropriate for this vintage look.

Balloon Glow

Photographer: Roger Moore

A night glow is a spectacular photographic opportunity, often conducted as a climax to a hot air balloon festival, or as a special event during the festivities. The balloons are inflated as if they were going to ascend, but are instead kept tethered to the ground while their propane burners are ignited to keep them filled with hot air. The giant orbs blossom with light, like huge Chinese lanterns, displaying vivid colors and unearthly glows. The best time to capture the balloons is during the inflation process, when all the burners are fired up at the same time.

Photographer Techniques:
The photographer captured hot air balloons as they inflated. The first shot didn't capture the glow and was underexposed. The second shot resulted from patience and good exposure.

Suggested Improvement Techniques:
Nothing. An alternative might be a panoramic crop.

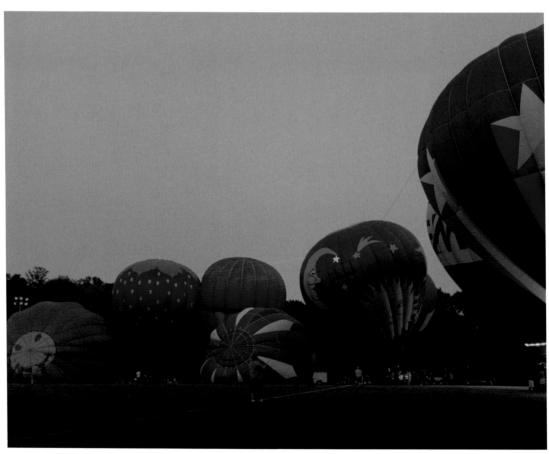

Figure 6.4 Underexposure at dusk doesn't show off the inflating balloons.

Roger Moore, whose daytime photography at the Ravenna (Ohio) Balloon A-Fair was featured in the last chapter, stayed for the evening event, capturing the initial, underexposed image at dusk, as seen in Figure 6.4. Minutes later, the photographer adjusted his exposure for the inflating balloons, and captured a dramatic image of the glowing in contrast to the dark foreground and deep blue nighttime sky. He fine-tuned the exposure for the panels of the balloons, allowing the areas around the burners to wash out. The hot areas of the propane burners aren't important to the images, and, with their hot spots, remind the viewer of the source of the balloons' uplifting thermal support. (See Figure 6.5.)

There's not much to do to this image to make it better. You could crop it to a more panoramic format, as I did for Figure 6.6. That cropping provides a pleasing composition that emphasizes the lineup of colorful balloons.

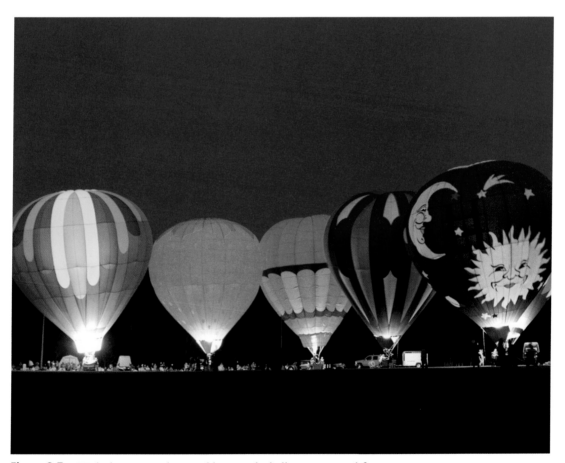

Figure 6.5 With the propane burners blasting, the balloons come to life.

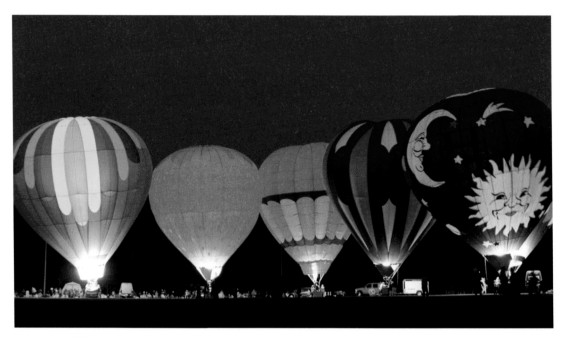

Figure 6.6 This image also makes an excellent panorama image.

McWay Falls

Photographer: Matthew Kuhns

Each leg of the classic "exposure triangle" (ISO, shutter speed, and aperture) affects an image in different ways, and each can be adjusted proportionally to produce the exact same exposure, but with the tradeoffs associated with each leg. ISO can be increased to enhance the sensitivity of the sensor at the cost of additional visual noise; or reduced to minimize noise. Shutter speeds can cut an exposure into smaller slices, freezing movement, or extended to increase blur from camera or subject movement. The aperture selected affects the amount of depth-of-field, with a small f/stop producing a broad range of sharpness, and a large f/stop isolating a subject through selective focus within a smaller range.

Photographer Techniques:
The photographer tried different exposures, varying shutter speeds to change how the movement of the water was captured.

Suggested Improvement Techniques:
None.

Photographer Matthew Kuhns varied the shutter speed, and compensated by adjusting the aperture to produce these two images of McWay Falls, a classic location along the Pacific coast in northern California. McWay Falls is in Julia Pfeiffer Burns State Park, near Monterey. This location has limited viewpoints available for shooting. As Kuhns discovered, the photographer's options are basically what focal length to use, time of day, and what exposure to use. The limitations make it challenging for photographers who want to create a distinctive image, and many of the photographs I've seen from this location look the same.

Kuhns was up to the challenge. He shot at sunset, on a day when the sky was filled with dramatic clouds. The two images (Figures 6.7 and 6.8) were captured at the same location at roughly the same time, and are essentially variations of each other. As such, one can't be arbitrarily labeled as better or worse than the other; each has its own distinctive attributes. In the first image, he used a faster shutter speed of about three seconds, compared to the second image, exposed for 30 seconds. The choice of shutter speeds had a big impact on the appearance of the waves, while the rocks and other non-moving parts of the image are similar in both versions.

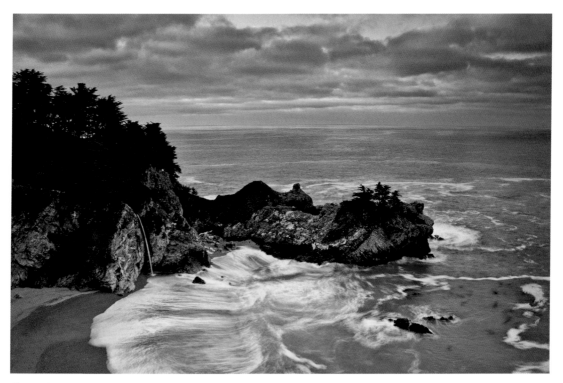

Figure 6.7 McWay Falls with a three-second exposure.

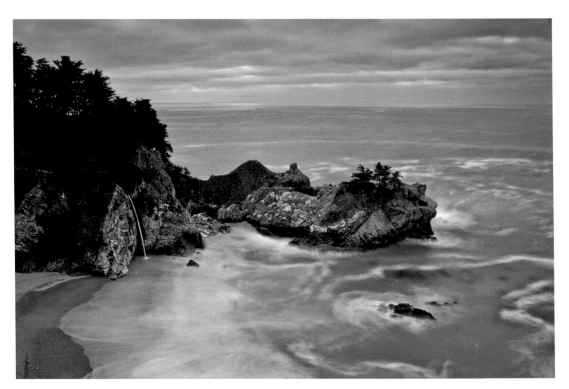

Figure 6.8 A longer 30-second exposure provides a different look of the water and sky.

The three-second exposure creates a more defined look to the waves as well as the ocean and the clouds, as I've highlighted in Figure 6.9. Sometimes photographers think more about the application of a particular technique, such as an extra-slow shutter speed, than about which rendition is better suited for a particular shutter. While both of Kuhns' images are excellent, my personal preference is for the shorter shutter speed, because the three-second exposure produces a defined and more structured look that matches the rugged character of the rocky shoreline. The water complements its surroundings. In addition, the clouds and their reflections have a more distinctive quality.

The longer, 30-second exposure is excellent as well. The softer look of the blurred water created a contrast with the sharper-edged rocks, but the long exposure blended together the ocean in the background, making it a blander gray. That said, some people may prefer one over the other because they like the different moods that are produced from these two images.

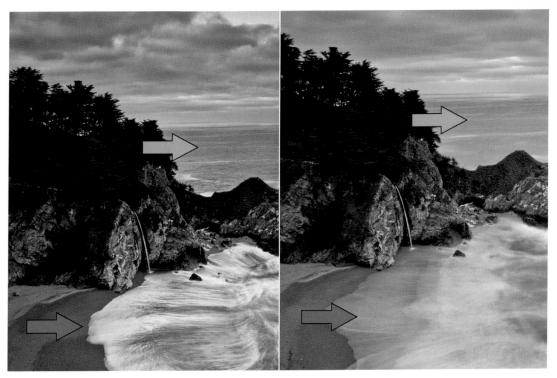

Figure 6.9 You can compare the rendition of the sky and sea in this figure.

South River Vineyard Star Trails *Photographer: Anita Orenick*

Back in the film era, nighttime photography was a great deal more complicated than it is now. Selecting the correct exposure can be problematic, but with a digital camera you can view your results while out in the field, make an adjustment, and then continue. When using film, photographers never knew what they had until the film was processed. Results could vary, because films suffered from a phenomenon called *reciprocity failure,* which resulted in a loss of apparent sensitivity with longer (and shorter) exposures. That is, an exposure at f/4 for 30 seconds wasn't exactly the same ("reciprocal") as one at f/16 for 8 minutes (480 seconds).

Photographer Techniques:
The photographer captured different photos of the star trails.

Suggested Improvement Techniques:
Use the processing power of the computer to bring out details that are not fully revealed by the camera. Sometimes shooting at an angle to the subject can offer a more dynamic composition.

Today, even digital photographers can jump right in and experiment with night shooting, confident that they can adjust their exposures to get good results over the course of an evening. That's exactly what photographer Anita Orenick did for the initial image shown in Figure 6.10, left. Her initial exposure was not long enough for the stars to create trails across the night sky, and the review image showed that clearly.

For the second exposure (Figure 6.10, right) she was able to capture an interesting pattern of star trails circling around the North Star. This circular star trail effect is a fascinating aspect of the night sky, but impossible to see with the naked eye. In the second shot, however, the bright building is a distraction. Some adjustment of the exposure in an image editor allows the stars to really pop and become the most important aspect of the composition, as you can see in Orenick's adjusted exposure in Figure 6.11. That diagonal white line in the middle is probably the lights of an airplane or UFO.

 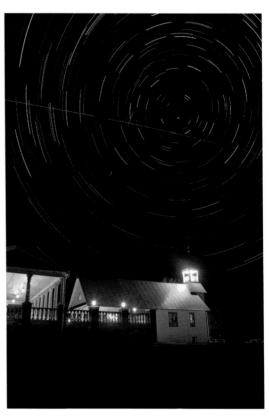

Figure 6.10 Increasing the exposure makes the star trails more visible.

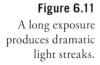

Figure 6.11
A long exposure
produces dramatic
light streaks.

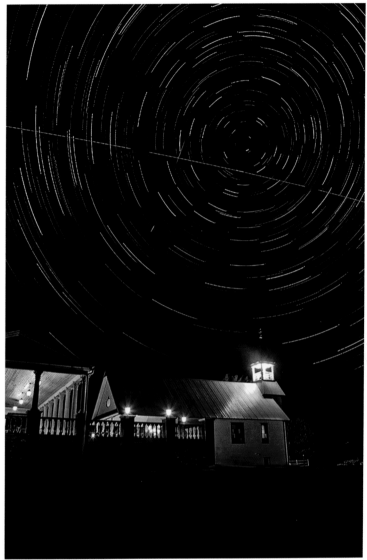

In the first image, the photographer oriented the building at an angle, but in the second image, she made sure the building was aligned vertically. Sometimes shooting an object at an angle can make for a more dynamic composition. The classic film *The Third Man* with Orson Welles is renowned for its use of these strong angles (called Dutch angles in the film industry). They are often used to create tension or drama in a photograph. Notice what happens to the photograph when the building from the first picture is composited into the second version (see Figure 6.12). This perspective adds to the drama and dynamic quality of this already interesting image.

Figure 6.12 The building provides scale, but it might look better at a slight angle.

Sunny Day in Antarctica *Photographer: Susan Onysko*

Antarctica has become a dream destination for many photographers, but the remote location is unachievable for most. Photographer Susan Onysko made the most of the opportunity and came home with this interesting scene that is a sumptuous and compelling landscape of birds, ice, water, and sky.

> **Photographer Techniques:**
> The photographer shot into the sun for dramatic light and tried different f/stops to affect the sun burst pattern.

> **Suggested Improvement Techniques:**
> None.

By shooting into the sun and exposing with a small f/stop, the lens's aperture created a strong sunburst pattern around the sun (see Figure 6.13). This effect comes from the light diffracting along the diaphragm blades of the lens's aperture; it occurs when shooting with a small f/stop at a bright light against a dark background such as the sun against the deep blue sky seen here. It makes for a very dramatic effect.

The photographer changed the aperture to an f/22 stop to emphasize the sunburst effect (see Figure 6.14). In the first image, she positioned the sun off to the left, which is a more dynamic placement of the sun compared to simply putting it in the middle of the picture, as in the second version.

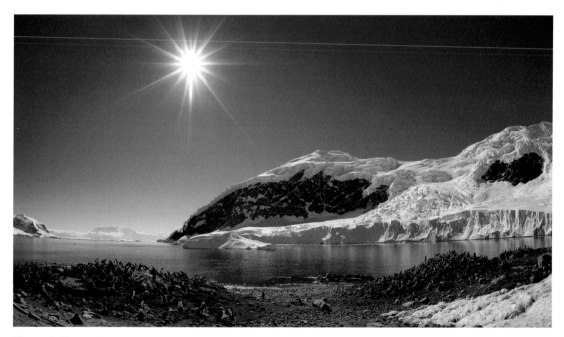

Figure 6.13 A relatively small f/stop produces a star effect in the sun.

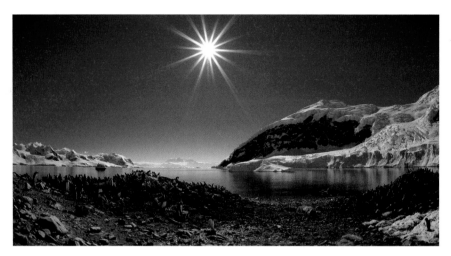

Figure 6.14
An aperture of f/22 increases the star effect.

The photographer recognized that the penguins are an important part of the photograph and the composition, especially in the second photograph in which they cover quite a bit of space. Because of the exposure needed for the scene, they are rendered dark in both photographs. I used an image editor to brighten Figure 6.15. However, my edit does make an otherworldly location look even more alien and garish. Although some might like the change, which I've presented here as an example, a less aggressive boost to the brightness of the foreground would be more realistic and less jarring.

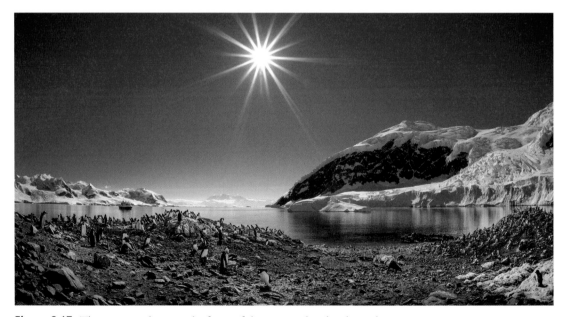

Figure 6.15 The penguins become the focus of the image when brightened.

7

Getting Up Close

I particularly like close-up photography because it is a photographic pursuit you can enjoy all year long. As you'll see from the examples in this chapter, opportunities abound in spring, summer, and fall for capturing images of emerging blossoms, mature plant life, and skittish animals. Earlier chapters have included tight shots of autumn leaves, a praying mantis, and other close-up subjects.

But those of us who reside in wintry climes don't have to shut down our macro efforts in winter. We can go beyond the subjects presented in this chapter and set up macro tabletops to shoot pictures of anything that captures our fancy. Close-up photography lets you discover whole new worlds in a water drop, teeming life under any bush or tree, and fascinating patterns in common household objects.

Turn Left on Red
Photographer: Jerry Hilinski

The photographer found a beautiful tulip in its full glory. (See Figure 7.1.) The overhead angle shows off the color pattern of the flower exceptionally well. However, this initial image is somewhat underexposed—the white edges of the tulip are not white, but gray (Figure 7.2, left). In addition, the image has a slight blue cast, which is typical when using auto white balance. When blue cast is corrected (Figure 7.2, right), the color saturation of the red and yellow is much improved because that blue cast will always dilute warm colors, such as the red in the blossom.

Photographer Techniques:
The photographer shot a tulip from directly above to show off its color and pattern, then cropped the image to emphasize its center.

Suggested Improvement Techniques:
Be wary of auto white balance when shooting outdoors. Darkening the outer parts of the picture and cropping less produces a dynamic picture.

Hilinski's cropped second version highlights the color of the flower even more (Figure 7.3). His adjustments make the red and yellow very dramatic and emphasizes the internal structure of the flower. The photo is bold and colorful and the centered composition works with these colors.

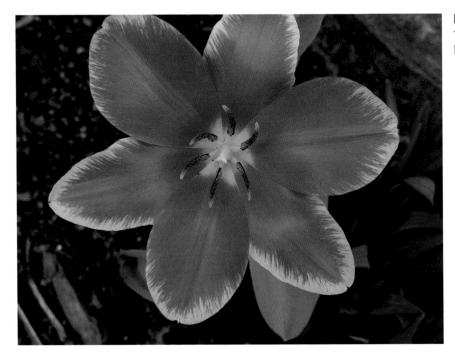

Figure 7.1
This tulip is beautiful.

Figure 7.2
The right side of the image shows how dramatically the photographer improved the contrast and colors.

Figure 7.3 A tight crop provides a great close-up of the center of the flower.

The photographer got the cropping and depth-of-field correct to create a stunning and vibrant image. This tight framing is an interesting abstract design, but it does lose some of the details of the flower that attracted the photographer to this particular flower in the first place. By simply darkening the outside edges of the photo, it's possible to add some pop to the original image and still emphasize the other interesting aspects of the flower (Figure 7.4). My modified version moves the center of the flower out of the middle of the picture, which can make for a more dynamic composition.

Figure 7.4 My alternate cropping shows it's still possible to retain interest while showing more of the blossom.

Thorn Branch

Photographer: Eric Wethington

Photographer Eric Wethington used shallow depth-of-field and powerful selective focus effects to capture this close-up. (See Figure 7.5.) Often, photographers stop the lens down to a small aperture to achieve abundant depth-of-field. Here, the photographer showed that one can find fascinating images that explore the possibilities of shallow depth-of-field.

By necessity, there is a tendency to consistently center close-up and macro images. Such photos usually concentrate on a single subject, and placing that subject in the middle of the frame is the most logical and, often, the best way of creating an eye-catching composition. In this pair of images, the thorny centers of attention are almost dead center in their compositions (Figure 7.6). The eye is immediately drawn to the main subjects, but the images aren't as dynamic as they could be. If it's possible to move the dominant pictorial element out of the center, it will encourage the eye to explore the photograph, adding dramatic and dynamic qualities to the composition (Figure 7.7).

Photographer Techniques:
The photographer used selective focus techniques to emphasize the thorns and create two moody and interesting close-ups.

Suggested Improvement Techniques:
Look for ways to get key pictorial elements out of the center of the composition to get a more dynamic image. Consider using black-and-white for these photos.

In the second image (Figure 7.5, right), there is a bright spot at the lower left causing a distraction, and the lighter area at upper left also attracts the eye away from the thorn. As I've noted before, anytime you have a bright area that contrasts with its surroundings, especially near the edges, the eye wanders from the center of image. For Figure 7.8, I cropped the picture a little to make it slightly less centered, and to remove or de-emphasize the two bright areas.

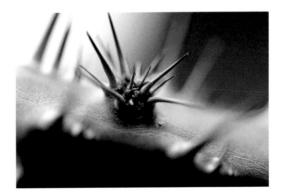

Figure 7.5 Two views of a thorny branch.

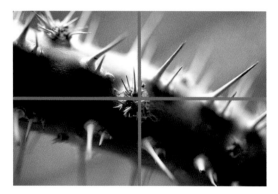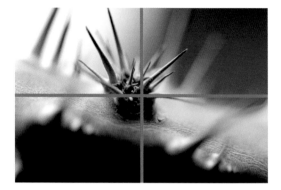

Figure 7.6 The main subject is centered in each.

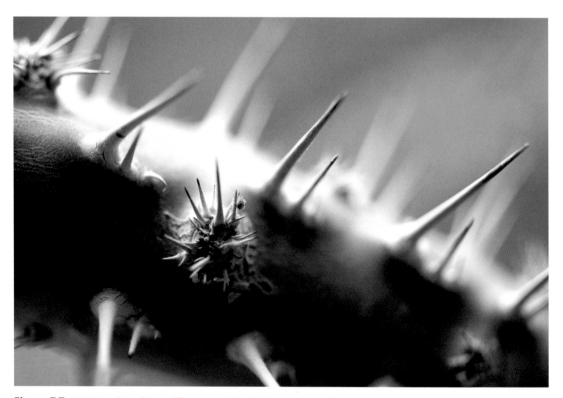

Figure 7.7 Moving the subject off-center makes the image more dynamic.

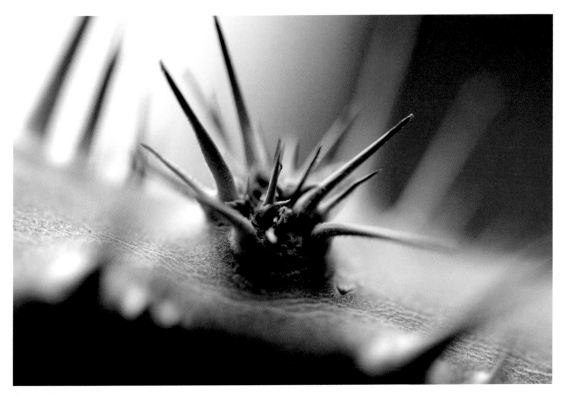

Figure 7.8 This image can be centered using a little judicious cropping

Both these images have very minimal color, and would look quite good in black-and-white. (Figure 7.9.) Black-and-white has become something of a novelty these days, and offers an elegant approach even to macro photography.

Figure 7.9 Both look very good in black-and-white, too.

Dahlia *Photographer: Mawele Shamalia*

The original shot is a lovely photograph of a dahlia (Figure 7.10). The lighting accentuates the flower's form and shows off the color without making the texture or hues harsh or garish. The contrast adds dimensional qualities to the flower. The photographer's angle from the side of the blossom provided a great look at the flower's details, much better than an overhead view.

Photographer Techniques:
The photographer found a beautiful dahlia flower then cropped to a square composition to emphasize the color and pattern.

Suggested Improvement Techniques:
None.

Shamalia then cropped in tighter to eliminate the outer parts of the photo (Figure 7.11). The background was a little distracting in the original photo because of the change from green to gray. The contrast of the upper part of the flower with the green is quite attractive, but the lower bright gray background—not so much.

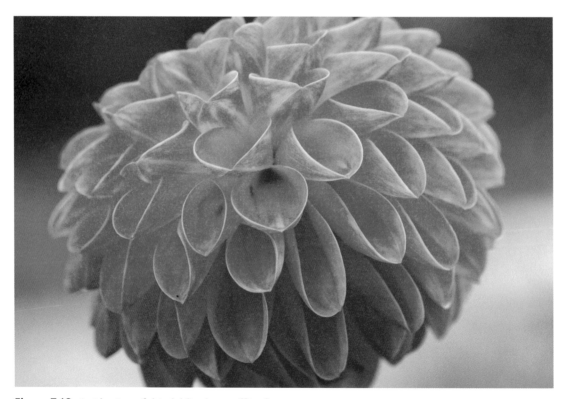

Figure 7.10 A side view of this dahlia shows off its features.

So, the photographer cropped to a square, which works very well with the petals. The brighter petals are kept toward the top of the picture and not centered. This adds an interesting cascading gradation effect to the composition. Shamalia created a beautiful photograph. The photographer's final square composition is a beautiful and bold design of color and pattern that is nicely emphasized by the light and angle to the flower.

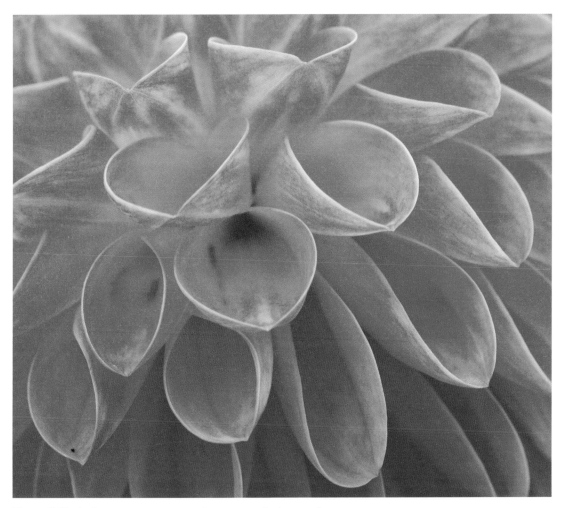

Figure 7.11 A close-up version cropped to a square looks even better.

Sunflower
Photographer: Nancy Balluck

Lensbaby specialist Nancy Balluck focused (or de-focused) her optics on an emerging sunflower, with interesting results (see Figure 7.12). Too often photographers wait for a flower to open before attempting to capture the blossom in close-up. But here the photographer found a great subject in this sunflower bud that was just starting to open. The photographer's use of limited depth-of-field helped isolate it within the photograph.

Photographer Techniques:
The photographer captured an image of a sunflower bud with shallow focus. She then cropped the shot to emphasize the bud and changed the photo to black-and-white.

Suggested Improvement Techniques:
Brighten the center of the flower bud.

The original image definitely had potential, but the original illumination made the photo look flat, plus there were distracting out-of-focus shapes in the background that were not contributing to the image. So, Balluck cropped the image and

Figure 7.12 Not many photographers would think to photograph a sunflower before it unfolds.

converted it to black-and-white (see Figure 7.13). The black-and-white also added contrast to the photo, making the final image much more dramatic. The contrast is bold and works well with the texture of the bud.

The photographer also used an image editor to clone the distractions out of the image and darken the surrounding areas. The photographer's use of edge darkening for the entire photo added dimension and emphasis to the flower.

Black-and-white images, because they have been converted from a full-color scene, always involve some degree of interpretation and the photographer's interpretation here is certainly valid and effective. The image has a strong contrast that works well with the opening sunflower bud. Consider brightening only the center of the bud to bring out extra detail, which would change the emphasis of the photo slightly by allowing the viewer to see inside the flower bud. (See Figure 7.14.)

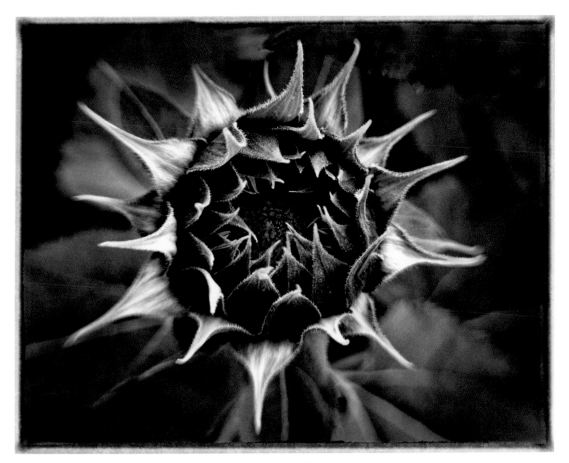

Figure 7.13 A black-and-white version has a stark, artsy look.

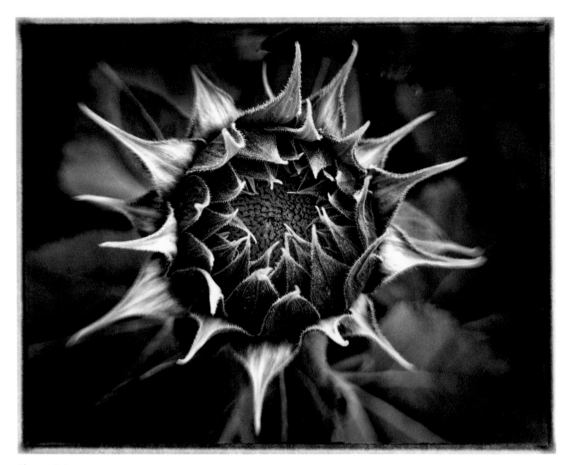

Figure 7.14 Brightening the center of the bud provides another look.

Unfolding Fern

Photographer: Michelle Schneider

Here's another great "unfolding" image. The fiddlehead of a new fern frond is a harbinger of spring, and a great subject for a close-up image like the one seen in Figure 7.15. Photographer Michelle Schneider did an excellent job of getting in close and emphasizing the frond using shallow depth-of-field. But, while capturing this particular shot, she also caught distracting details along the right edge.

To get rid of those distractions on the right, Schneider cropped the image to the fern

Photographer Techniques:
The photographer captured a fiddlehead, then cropped and processed it to improve color and contrast.

Suggested Improvement Techniques:
Avoid using strong saturation adjustments that create garish colors. Try an edge-darkening technique to add more dimension.

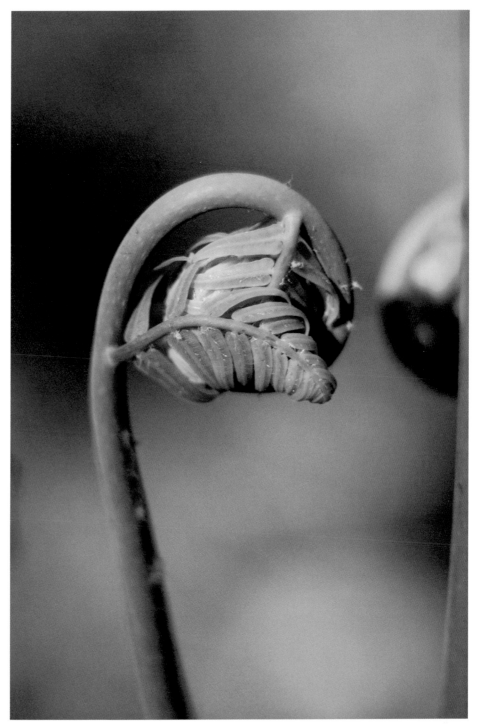

Figure 7.15 This photo of a fern fiddlehead has some distracting details at right.

(Figure 7.16). The original image did not have a lot of color, but the photographer processed the image to increase the saturation and boost contrast.

When applying saturation adjustments, add them quickly so that you can see what happens to the quality of the color. If your image editor has a Vibrance control, try using it instead. Vibrance boosts the colors selectively, enriching only those hues that aren't already fully saturated. That allows you to add some saturation to muted colors without oversaturating colors that are already rich.

Reducing the colors slightly results in a much more natural-looking photograph (Figure 7.17).

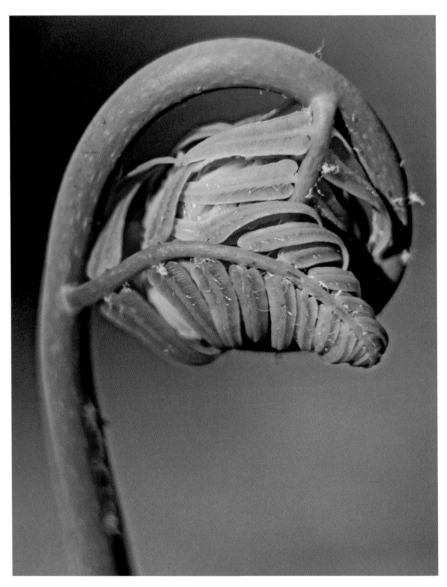

Figure 7.16
Increasing saturation makes the colors pop.

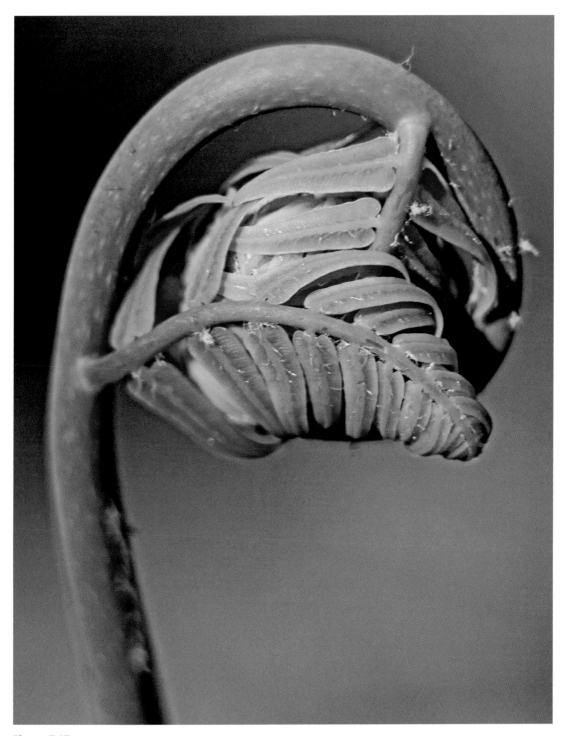

Figure 7.17 However, a slightly muted version looks more realistic.

Dew Drop Refraction

Photographer: Debbie DiCarlo

The photographer used shallow depth-of-field in both photographs to contrast the sharp droplets in the foreground with the blurry, out-of-focus background portions of the image.

The first image (Figure 7.18) uses space and color in some interesting ways. The descending tendril with a water droplet at its tip stands out in sharp relief from the softly blurred background, an out-of-focus flower. This initial image is simple, direct, and catches the eye with its stark minimalism. It is a beautiful photo.

Photographer Techniques:
The photographer captured water droplets and used shallow depth-of-field to experiment with the relationships between the foreground droplets and the background.

Suggested Improvement Techniques:
Out-of-focus objects in the background can still draw the viewer's eye.

Figure 7.18
The purple out-of-focus blossom in the back makes this frond stand out.

The second image is a completely different look at water drops glistening on the fronds of a plant. (Figure 7.19). This visually stunning photo presents a delightful world of cropping options in addition to the initial presentation.

Photographer DiCarlo spent a great deal of time creating a unique image within an image that shows off a snowflake decoration on the plant reflected by the water droplets so that it appears that the snowflake is actually inside the droplets.

One possible alternate framing would be to simply crop the image in closer to what should be the center of attention in this photograph—the droplets (Figure 7.20). That visual redirection immediately helps focus our eyes on the water droplets. Another option is to darken the areas *outside* the water droplets enough to create an emphasis on the areas where the tiny orbs of liquid reside. Finally, as you can see in my version shown in Figure 7.21, a combination of cropping and darkening might be successful, making the main liquid subject at center right even more apparent to the viewer.

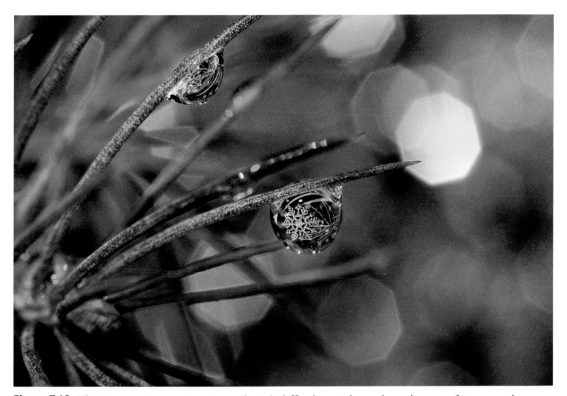

Figure 7.19 This is a more interesting picture, but it's difficult to pick out the real center of interest—the water droplets.

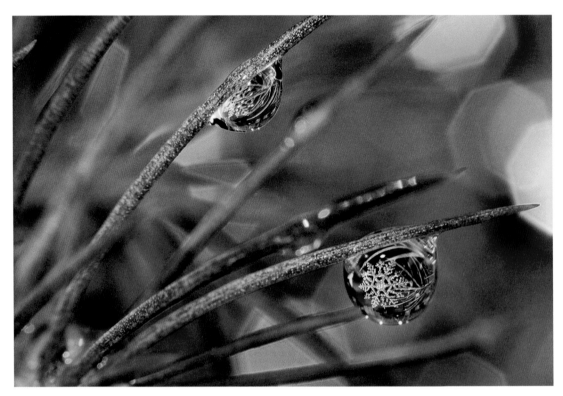

Figure 7.20 Cropping the image brings us closer to the water droplets.

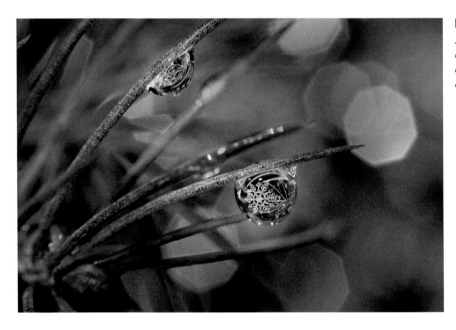

Figure 7.21
A combination of
cropping and
darkening offers a
different view.

This is the kind of work that Ansel Adams used to call "directing the viewer's eye." When you have an image that is this complex in terms of tones scattered throughout the photo, it's sometimes necessary to help the viewer know what they are really supposed to be looking for. If you fail to do that, you're making the photograph a lot of work for the viewer and the viewer may move on to a different image without discovering the cool little snowflake reflections inside the water droplets.

The Redhead *Photographer: Dan Sandy*

These two images are a fascinating exploration of the possibilities of focus using a Lensbaby optic. The photographer created a unique focus on this flower. (See Figure 7.22.) Part of the flower looks like a face or head and the red petals look like red hair growing out of that head. The effect is an interesting approach to photographing this particular subject.

The photographer created two different versions shown here, one a vertical shot and the other a horizontal orientation (see Figure 7.23).

Photographer Techniques:
The photographer used a Lensbaby to photograph a flower with red petals.

Suggested Improvement Techniques:
Brighten up the underexposed photo and enhance the sharp areas to contrast with the rest of the photo.

Figure 7.22 The vertical capture resembles a red-headed person.

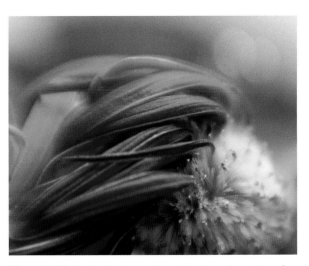

Figure 7.23 In the horizontal version, the red portion of the image still stands out dramatically.

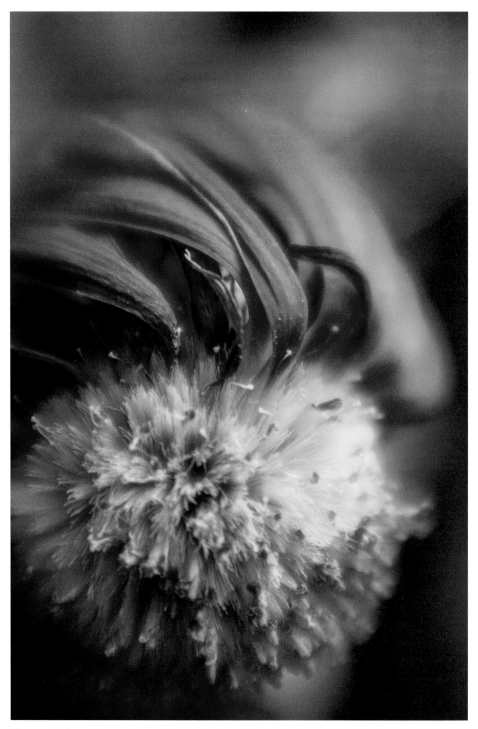

Figure 7.24 A little brightening and sharpening produces this result.

When you're experimenting with approaches to a subject, it often helps to work with both the horizontal and vertical perspectives. Often, you will see more possibilities than if you stuck with just one or the other. It is always interesting to see how a photographer's vision may be changed by an adjustment in orientation.

Both of Sandy's images have a shallow plane of focus. This creates some lovely blurred backgrounds and colors, yet also focuses the emphasis on parts of the flower. The Lensbaby lens captures a unique soft-focus look and creates a quality to the image that you won't see with other lenses.

A little processing could improve the photo. The vertical image is slightly underexposed, making the photograph look a little dull. Brightening that photo and then tweaking the sharp areas with a bit of local sharpening and clarity enhances the photo (see Figure 7.24).

The horizontal image is perfectly exposed. Although it might seem counterintuitive to sharpen an image taken with a soft-focus lens, the second shot might benefit from enhancing the sharp areas to give them greater emphasis (see Figure 7.25). The right side of the flower is a little bright so it could also be toned down slightly to make it more in balance with the rest of the picture. The bright areas at the top left and right fit with the image to create a frame and to encourage some visual movement from foreground to background.

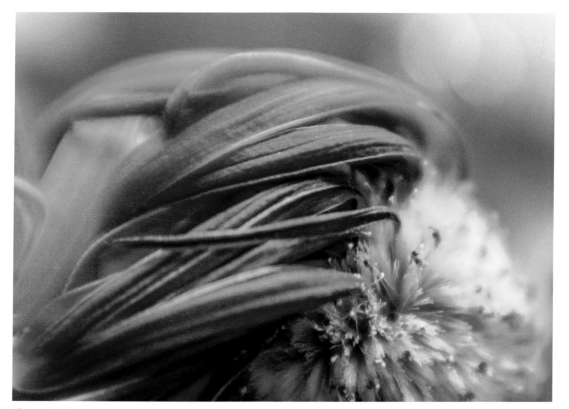

Figure 7.25 The same treatment can be given to the horizontal image.

Sally Lightfoot Crab

Photographer: Vicki Wert

This is a terrific example of a photographer paying attention to the subject's surroundings. Cameras have no way of knowing what the subject matter is; they see only dark and light objects. That can mean big problems when the subject and the background are similar in tone, texture, and/or color.

This is a great example of how a simple, dark background really sets off colors. In the first image (see Figure 7.26), the background is full of texture and variations in tonality and color. The crab shows up, but not dramatically. In the second image (Figure 7.27), photographer Vicki Wert found a different crab poised on a background that really shows off the crab and its colors. Now the crab is definitely the star of the photograph. These two photographs demonstrate how important the surroundings can be in portraying a particular subject.

Photographer Techniques:
The photographer captured Sally Lightfoot crabs on a dark background.

Suggested Improvement Techniques:
None.

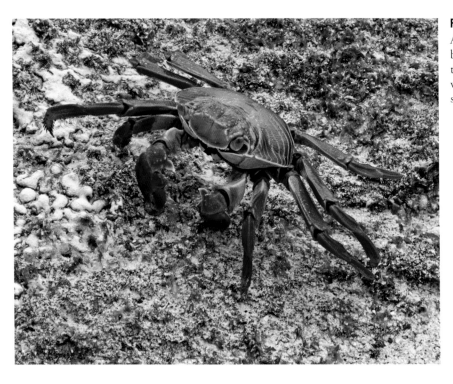

Figure 7.26
A highly textured background helps the crab blend in with its surroundings.

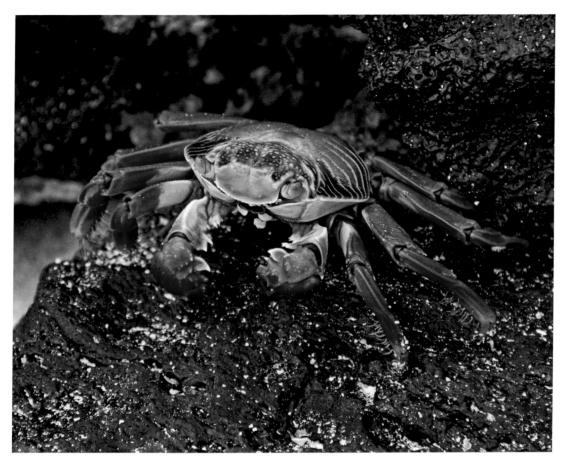

Figure 7.27 The darker background makes the crab stand out sharply.

Orchid Mania *Photographer: Vicki Wert*

Here's another set of images by photographer Vicki Wert that shows how backgrounds can be used to emphasize the most important elements of a photograph. Orchids are a wonderful subject for photographers. They come in so many different shapes and sizes, and their colors and patterns can be fascinating as well. The photographer found a very attractive orchid in soft, gentle illumination that emphasizes the flower's color and patterns. (See Figure 7.28.)

Photographer Techniques:
The photographer found a beautiful orchid in a general light, then processed the image to emphasize just that flower.

Suggested Improvement Techniques:
None.

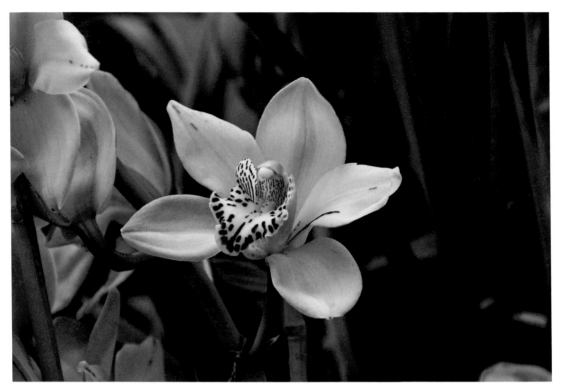

Figure 7.28 An orchid amidst other orchids.

The photographer cropped the image to an interesting square format then used an image editor to simplify the composition. (See Figure 7.29.)

Wert darkened the edges of the image and areas of the orchid itself to provide a lush lavender hue that is more interesting than pure white petals (see Figure 7.30).

I cropped the photo to move the flower out of the center but still show its connection with its surroundings, including the other flowers, as shown in Figure 7.31. I darkened the areas surrounding the orchid to keep visual focus on the flower itself. Now you have an additional version that reflects the setting for the blossom, producing another interesting image from the same original shot.

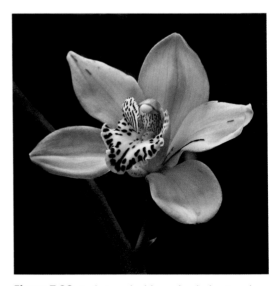

Figure 7.29 Isolating the bloom by darkening the areas around it highlights the orchid.

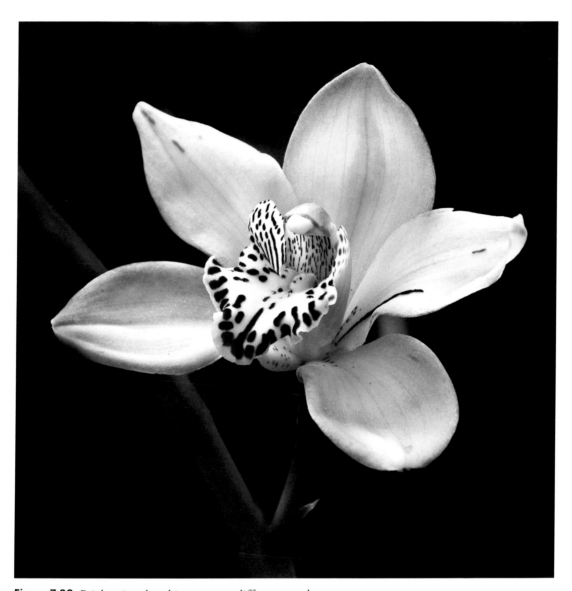

Figure 7.30 Brightening the whites creates a different mood.

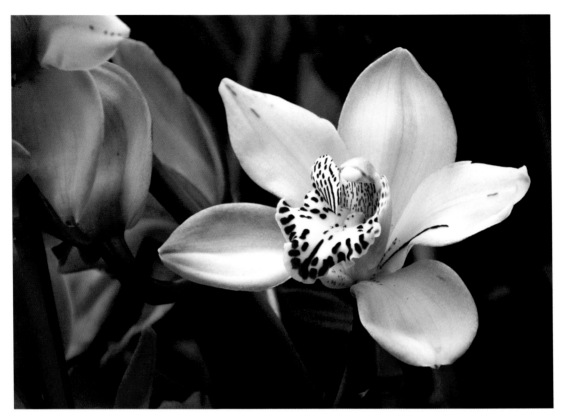

Figure 7.31 Judicious cropping can be used to show the original orchid among its surroundings.

Orange Orchid *Photographer: Anita Orenick*

Here's another great orchid capture, this time from photographer Anita Orenick. It is always interesting to see a photographer shoot two verticals (Figure 7.32) of the same subject. Many photographers forget about portrait orientation entirely, because digital cameras (like their film counterparts of the dark ages) are set up to be used horizontally. And, in today's HDTV and computer age, one of the most common ways of viewing a photographic image is on a screen, and most display devices are oriented horizontally. So, vertical compositions offer something unusual and oftentimes rewarding.

Photographer Techniques:
The photographer focused on a small, orange orchid to discover different ways of showing it off.

Suggested Improvement Techniques:
Consider unique compositions so that the subjects aren't always in the center of the image.

Figure 7.32 Two vertical shots from different angles.

The image at left has an interesting color contrast between the orange-yellow flowers and the green of the background. The bright areas in the background are attractive with the sharp flower. It almost looks like the flower is reaching up toward those lights and that creates a dynamic compositional relationship. In the second image, there is a contrast between the in- and out-of-focus colors, thanks to the use of soft-focus optics.

The images are excellent as is, particularly the right-hand version, in Figure 7.32. But, there are other options for the first version. Cropping some of the image at the bottom while retaining the open area at the top of the photo creates an interesting look. Framing in this way adds drama and actually emphasizes the sharp flower (Figure 7.33, left). The composition creates interesting relationships between the sharp flower and the space around it. Figure 7.33, right, shows an additional alternate cropping I made which places the focus, so to speak, more directly on the subject matter in the middle, by eliminating some of the image at bottom right side, and top.

Figure 7.33 These alternate croppings move the center of interest out of the middle.

8

Effective Lens FX

I've tried to place the emphasis of this book on techniques for creating great photographs *in the camera,* using choice of angles and perspective, composition, exposure, and other shooting techniques. This chapter deals with how your choice of lens and lens accessories can contribute to compelling photographs.

While many of the images throughout the book do involve a bit of fine-tuning in an image editor, I think you'll find that the most enjoyable part of photography is when you're out shooting, not seated in front of a computer screen.

Tunnel View *Photographer: Zach Bright*

Tunnel View is a classic location in Yosemite National Park that's always a great place to visit and shoot, and has been photographed by some of the legendary greats, including Ansel Adams. The challenge to a photographer is to look for the best light. In this case, photographer Zach Bright's original image had the typical blue haze that results from shooting through miles of dense air in midday. (See Figure 8.1.)

So, Bright wisely decided to use a polarizing filter. That gave the image more contrast, removed the blue haze, and improved color saturation in

Photographer Techniques:
The photographer shot an expansive landscape scene first without a polarizer, then used a polarizer to improve color and contrast.

Suggested Improvement Techniques:
The photographer's use of a polarizing filter and tiny adjustments in an image editor brought this image to life.

the trees and the rocks. The scene looks much better in his second version. (See Figure 8.2.) When using a polarizer, keep in mind that the polarizing effect is strongest at a 90-degree angle from the sun; that is, with the sun located to your immediate left or right. Any other angle, especially with the sun behind you or toward the lens, produces less of an effect. When working with extreme wide-angle lenses, you may notice that the difference in sun angle from one side to the other is great enough to produce noticeably different polarizing effects at each end.

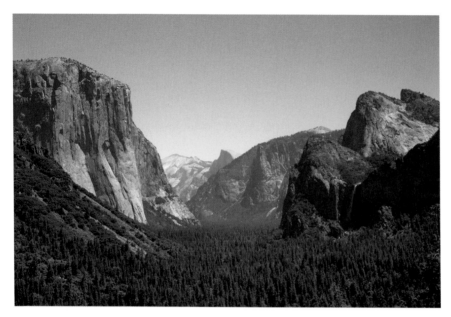

Figure 8.1
Haze cloaks details of this distant vista.

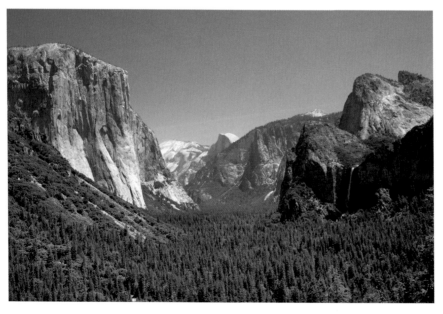

Figure 8.2
The photographer used a polarizing filter to remove the haze

Of course, even with a polarizing filter, the haze may not be reduced sufficiently to give you the pure blacks needed for a full range of tones from white to black. Despite the goal of getting the best shot possible in the camera, it may be necessary to do further tonal adjustments in an image editor. By performing some local adjustments in an image editor, it's possible to balance out the lighting by brightening the falls and cliff on the right while darkening the very bright rocks on the left. (See Figure 8.3.)

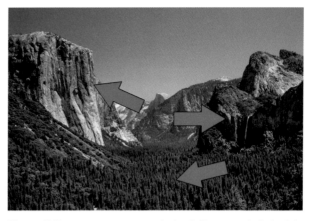

Figure 8.3 Some areas are too light (left) or too dark (right).

However, the polarizing filter was all that was really needed to achieve the stellar landscape seen in Figure 8.4.

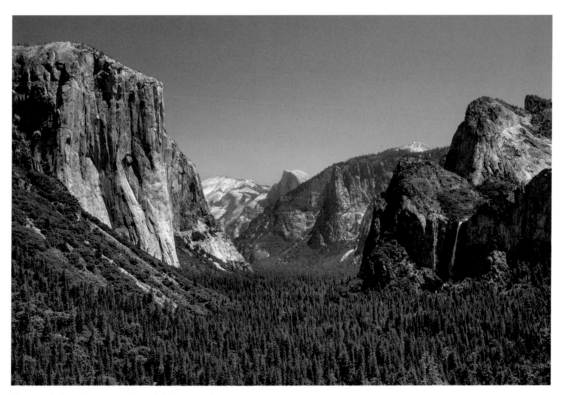

Figure 8.4 The image has a full range of tones.

Ricketts

Photographer: Zach Bright

Here's another photo of a flowing stream, but the important technique in this case is not the use of a long shutter speed (which has been covered in previous chapters), but in photographer Zach Bright's application of a polarizing filter. Unlike his photo at Tunnel View, in this case Bright used the polarizer to reduce reflections on the fast-moving water.

Here he's found a beautiful section of the small stream with multiple little waterfalls and the attractive rocks that create a fetching shoreline. (See Figure 8.5.) The diagonal flow of the

Photographer Techniques:
The photographer shot a small stream, first without a polarizer. Then he used a polarizer to get better color and contrast.

Suggested Improvement Techniques:
The photographer adjusted the amount of reflections removed to keep the stream bright and flowing.

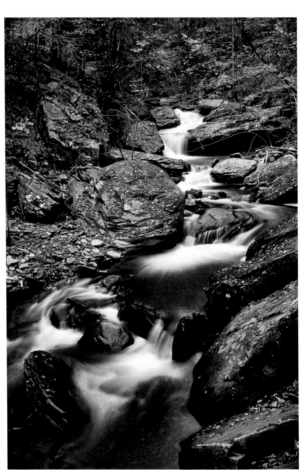

Figure 8.5
Reflections in the water can be distracting.

stream produces an attractive composition, especially with the vivid fall colors along the edges. This initial shot is a good example of using a vertical orientation to provide a visual sense of movement from foreground to background.

After taking a photograph of this scene, Bright decided to work with the polarizer to remove the reflections on the water and other surfaces, such as the rocks. The filter definitely produces a more dramatic-looking photo. (See Figure 8.6.)

A polarizer is a handy tool, because you can control how much of the reflections you remove, simply by rotating the front ring of the filter until you get the effect you want. *Some* reflection is needed for the water to still look like water. When you use a polarizer at its maximum, it's possible to make the water reflections disappear entirely, and again, you start to lose the texture of the stream. My alternate version—a combination of both the original and second image, shown in Figure 8.7— simulates the appearance of the water when the polarizer is rotated to reduce its effect.

Figure 8.6
A polarizer removes the reflections, but now the white water areas seem disconnected.

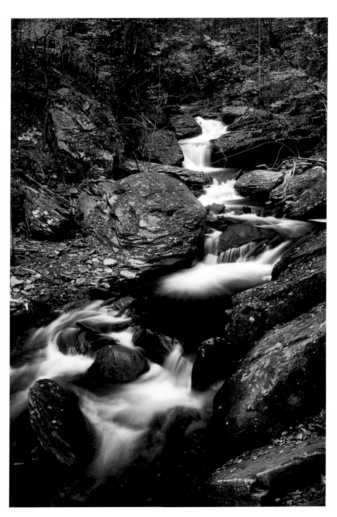

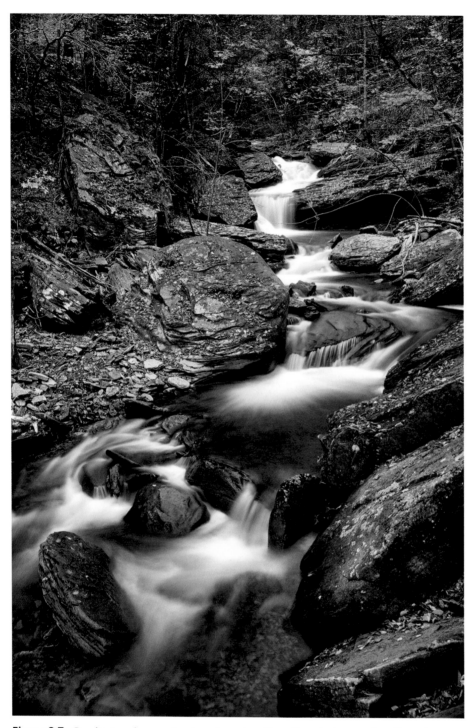

Figure 8.7 Combining the two simulates how the effect of a polarizer can be adjusted to remove some, but not all reflections

Easter Head



Photographer: Zach Bright

Here's another virtually perfect shot from photographer Zach Bright that we can use to illustrate how viewpoint and lens choice can be adjusted to change the perspective in an image. The illumination for this Easter Island head is quite dramatic, and shows off the contours of the face. The photographer captured this image at an ideal time. The first version (see Figure 8.8) uses a longer focal length that compresses the image of the head with its background. Although it's a wonderful photograph as is, the background blends in with the head itself,

Photographer Techniques:
The photographer captured a photograph of an interesting statue and changed the perspective of the shot for a more dramatic image.

Suggested Improvement Techniques:
For an alternate view, try shooting with a wide-angle lens from a lower angle to lower the horizon in the frame.

Figure 8.8
In a telephoto view, the background appears close to the sculpture.

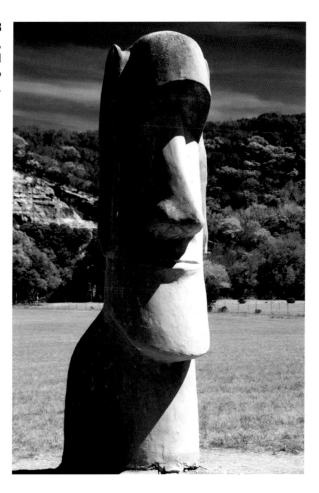

particularly in black-and-white, where there are no color differences to provide contrast.

So, photographer Bright took a second shot, using a wide-angle lens. (See Figure 8.9.) Even though the size of the head is the same in both images, the wide-angle perspective makes the background look much smaller. The second image creates some additional drama by isolating the sculpture. Both images look great in black-and-white, too.

The photographer has done something that most photographers today don't think to do. (Most will see a subject, put on the zoom lens, and then zoom in and out until their subject fills the frame. There's nothing wrong with that; it is essentially cropping the view that is in front of you.) But here, the photographer adjusted the focal length *and* changed the camera position to modify the perspective of the image. He positioned the camera until the subject was essentially the same size in both photos. But the different focal lengths changed how the perspective of the scene looks. With a telephoto lens, the image is flattened out, making the background appear larger and closer behind the subject. With a wide-angle lens at a closer distance, the background appears smaller and more distant.

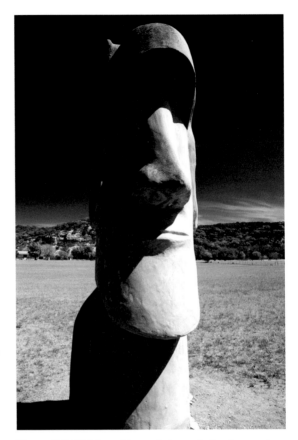

Figure 8.9 With a wide-angle lens, the background retreats.

The photographer used a polarizing filter for this series of shots. This makes the sky very dark, so that there is not much separation between the figure and the sky on the left side in the wide-angle shot. That does make the image quite dramatic, but I wanted to see what it would look like with some brightening of the dark areas on the statue. (See Figure 8.10.)

Shooting from a lower angle would have given this image a different perspective. The camera height used caused the horizon to fall into the middle of the photograph and cross behind the head at lip height. I took the liberty of playing with the image a little to simulate that lower angle, and you can see in Figure 8.11 how it would look if the background were located below the chin.

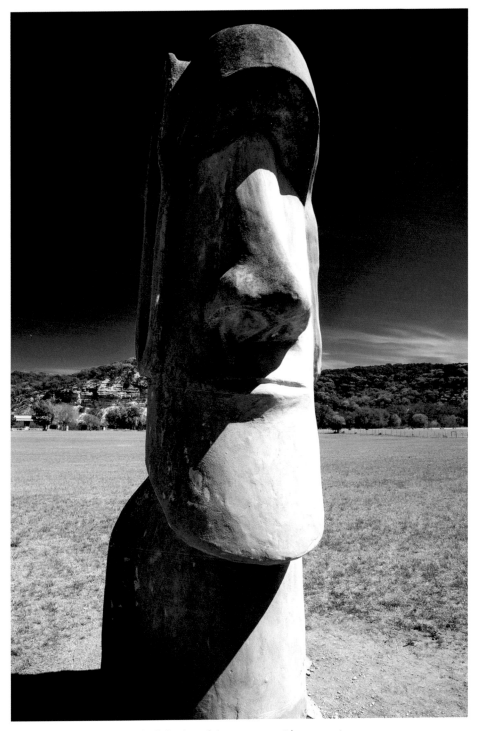

Figure 8.10 Brightening the left edge of the statue provides separation.

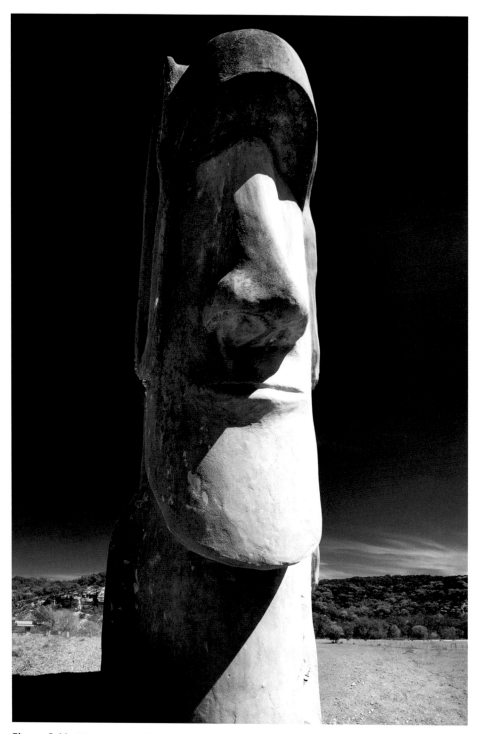

Figure 8.11 This simulated lower viewpoint provides a different perspective.

Mobius Arch

Photographer: Matthew Kuhns

This arch is one of the most photographed locations in Alabama Hills, near Lone Pine, California. It offers a perfect framing of Mount Whitney, especially at sunrise, as emphasized in the first image from photographer Matthew Kuhns (see Figure 8.12). The color image works well because of the contrast of the grays around the color of the early morning light on the mountain in the background. The timing is superb—that strip of color in that specific location lasts only a short time. This creates an almost abstract design. Kuhns also used a telephoto focal length and backed up somewhat to bring that mountain visually closer to the frame of the arch.

Photographer Techniques:
The photographer captured a well-known arch in Alabama Hills, California, highlighting mountains in the background and using two different focal lengths and distances.

Suggested Improvement Techniques:
Create contrast in the mountains of the black-and-white image to make them stand out more.

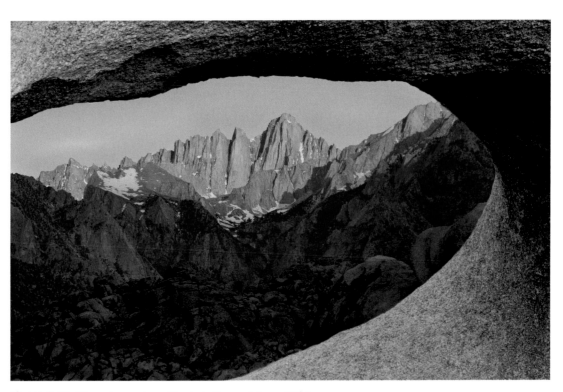

Figure 8.12 The color version effectively frames Mount Whitney.

The black-and-white image is also excellent (Figure 8.13) and shows the value of moving to a different location when lighting conditions change dramatically. The sunrise shot has little in the way of clouds, and lacks the dramatic sky seen in the second photo. By using a wide-angle lens and coming in a little closer, the photographer makes the mountains look farther away, and the sky fills the upper half of the frame. The black-and-white rendition emphasizes the contrast range of the scene.

Although both photos are terrific, an image editor could be used to brighten and intensify the dark and muddy areas around the mountain without affecting the rest of the photo. The rest of the photo already looks great and should not have the same intensification as the area around the mountain.

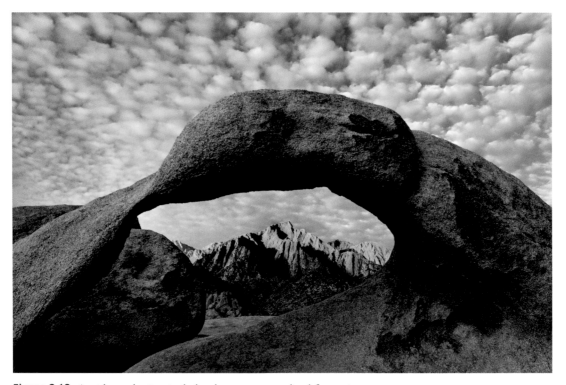

Figure 8.13 A wide-angle view includes the sumptuous cloud formations.

9

HDR Effects

High dynamic range (HDR) photography is a popular technique that is often used to overcome the inability of digital camera sensors to capture the full range of tones that our eyes can see. Because of the sensor's limitations, we often must choose an exposure that will record all the detail in the shadow portions of an image (while overexposing the highlights), or expose for the highlights and allow the shadows to become too dark. HDR photography provides a remedy for this constraint by merging two or more images that are virtually identical, except for the exposure. A version that contains well-exposed shadows is combined with a second image that reveals rich details in the highlights, resulting in a single image with a much broader range of tones.

Many recent camera models offer HDR processing internally. Such cameras usually take two pictures in succession, and save a combined image to your memory card. You can also create an HDR image manually by bracketing exposures and combining the different photos in an image editor. There are also specialized utility programs that can automate combining these multiple exposures, or are capable of using special techniques to extract shadow and highlight detail from a single image to generate an HDR photograph. In this chapter, I'll offer some tips on using HDR effectively.

Hale Farm Sheep

Photographer: Daniel Kozminski

This image is a lovely farm scene, complete with animals, fence, and farmhouse. (See Figure 9.1.) It reflects backlighting and the early morning atmosphere, catching the two sheep roughly in the center of the frame at a perfect moment. The composition focuses on what is important without showing extraneous detail, such as a blank sky.

In his second image, photographer Daniel Kozminski created a different interpretation of the scene using high dynamic range (HDR) and other processing techniques. (See Figure 9.2.) This interpretation produces a bold and interesting photograph.

Photographer Techniques:
The photographer captured a beautiful early morning farm scene and then used some strong processing techniques, including HDR and Nik Software, to create a dramatic interpretation of the image.

Suggested Improvement Techniques:
The original image has a great atmosphere, and alternate processing can create a whole new photo that retains the crisp, misty feeling

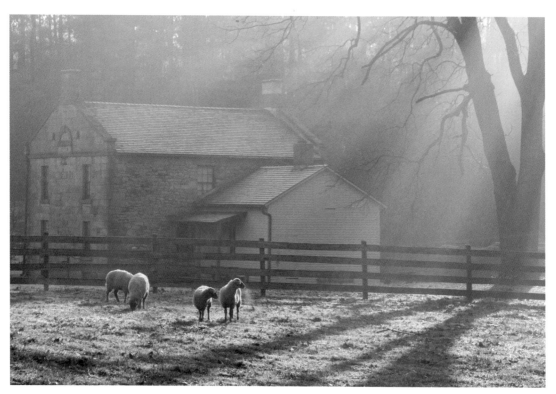

Figure 9.1 This low-contrast morning scene has a wonderful pastoral look.

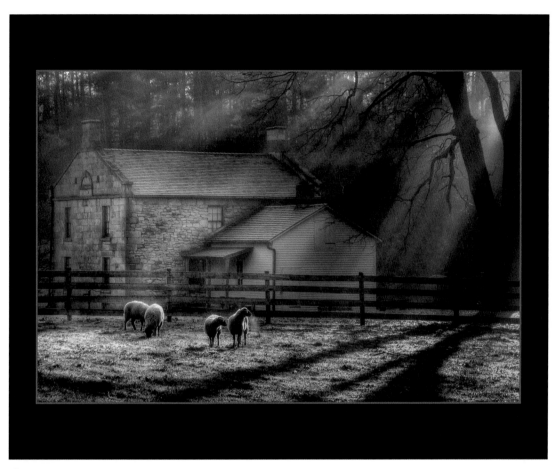

Figure 9.2 HDR made the colors more vivid while enhancing the contrast.

The original image has some beautiful aspects to it—early morning on a foggy, frosty day (note the sheep's breath and frost on the ground). There is nothing wrong with creating a dramatic image, but the processing does change the atmosphere of the original scene. It's possible to process the image differently to create an entirely new image with charm of its own.

Pine Mountain

Photographer: Matthew Kuhns

Photographer Matthew Kuhns captured this image of Pine Mountain at dawn. The brightness of the rising sun threatened to overpower the rich texture of the rocky foreground. (See Figure 9.3.) Unfortunately, the tonal range between the bright sky and the foreground was beyond the ability of the digital sensor to capture.

So, Kuhns shot multiple exposures and then combined them in an image editor to achieve the HDR effect shown in Figure 9.4. He did an excellent job of creating an image that looks very naturalistic, despite the processing, and which reflects more closely what was actually

> **Photographer Techniques:**
> The photographer discovered a beautiful scene that had too high of a contrast range for his camera, so he shot multiple exposures of the scene and combined them in an image editor.

> **Suggested Improvement Techniques:**
> Be aware of overly bright and contrasty parts of a photograph that can be a distraction; make sure the photograph retains its natural look during processing.

Figure 9.3 The dynamic range of this scene is impossible to record with a digital camera sensor.

seen by the eye. There is definitely an HDR flavor to this photo, but it doesn't have the cartoonish look that screams "HDR!" to everyone who sees it for the first time.

The second image makes the rocks more contrasty; the lower contrast of the rocks in the original scene had a nice feel to it. The increased contrast made the rock at the lower left bright and harsh. By toning down the contrast of the image slightly by brightening some of the dark areas and darkening that rock, the picture has an even more natural feel to it (see Figure 9.5). I also toned down the yellow a bit and darkened the blue sky to see what that interpretation would look like.

Figure 9.4 HDR photography allows including both the dramatic sky and well-exposed foreground.

Figure 9.5 Some minor adjustments can produce a more realistic image.

Fall Back Road

Photographer: Jamie Umlauf

This image is nicely balanced, with the trees on the left and right sides. The diagonal line of the road moves the eye through the picture. The small amount of sky defines the size of the scene and balances the road, although in the original exposure, its relative brightness does tend to dominate the image. (See Figure 9.6.)

Umlauf's HDR technique reduces the contrast between the sky and the trees, creating a darker sky and showing more detail in the colorful fall leaves. (See Figure 9.7.)

Photographer Techniques:
The photographer found a beautiful early fall scene along a dirt road then used HDR techniques to change the interpretation of the image.

Suggested Improvement Techniques:
Modern software such as Lightroom can do a great job in bringing out the full range of tonalities of a scene like this.

Figure 9.6 The bright sky is an important part of the image.

In my version (see Figure 9.8), the sky is less dark. If your image editor has a Vibrance control, it can be used to increase the richness of the colors without oversaturating those that are already bright. The road is a very important part of the composition, too, and should be selectively brightened. Some images lend themselves to conventional adjustments that work just as well as HDR effects. Here, the photographer did an excellent job using HDR photography techniques. However, other possibilities include using Lightroom, or possibly coming back at a different time of day. Capturing the beautiful colors of this scenic location is well worth trying additional techniques.

Figure 9.7 HDR creates a more balanced look.

Figure 9.8 Sometimes conventional processing can work well.

Warner & Swasey Observatory *Photographer: Erik Heinrich*

Photographer Erik Heinrich shows how HDR photography can extract details from an image to transform a rather ordinary-looking, abandoned scene into a great photo. His original image looks like a bunch of junk in an abandoned building with trash and debris on the floor. Even so, Heinrich obviously saw some potential in this mundane subject because of the differences in textures, shapes, and forms. (See Figure 9.9.)

Photographer Techniques:
The photographer used HDR techniques to transform an ordinary-looking image into something unique and remarkable.

Suggested Improvement Techniques:
No suggested improvements to this image, though you might want to consider an alternate crop as another possibility.

Figure 9.9 A seemingly abandoned area.

By using HDR techniques, he crafted a photo that has a great deal of color and texture. (See Figure 9.10.) These enhancements make this photo come alive. The image is not realistic and has that HDR look that makes it appear to be more like a painting than a photograph. But in this case, the point of the photograph is not to present a realistic view of a stark scene; the intent is to create a semi-abstract design of texture and form. He's created an image that catches the eye because it is unusual in subject matter and treatment and so richly textured.

I thought that this particular image also lent itself to an interesting square composition. (See Figure 9.11.) My version is not necessarily an improvement over Heinrich's second version, but, rather, it is an alternative that adds a bit of extra structure in the composition. The original composition deals with some rather random placement of objects in this location, and the photographer had little control over that placement. A tight square composition brings the viewer in to emphasize more specific details of the scene.

Figure 9.10 HDR transforms an eyesore into an interesting composition.

Figure 9.11 An alternate version works well in a square composition.

Volvo Graveyard

Photographer: Mawele Shamaila

Mawele Shamaila found an interesting group of old automobiles in a used parts lot just outside my hometown. Locals have dubbed it the "Volvo Graveyard" because of the large number of Volvos that have been collected there. The autos span a broad range of conditions, and the photographer found one that has particular character because of the way its paint has faded and its body has rusted. He then composed an image that focuses on that particular car, using the automobiles behind it to make up the background. (See Figure 9.12.)

Shamaila felt the image needed more intensity, so he enhanced the color and contrast with

Photographer Techniques:
The photographer found an interesting group of old cars, focused on one with strong color, then used HDR techniques to enhance the color and contrast.

Suggested Improvement Techniques:
Intensify the effect to add even more drama, plus consider shooting at an angle to create a more dynamic composition.

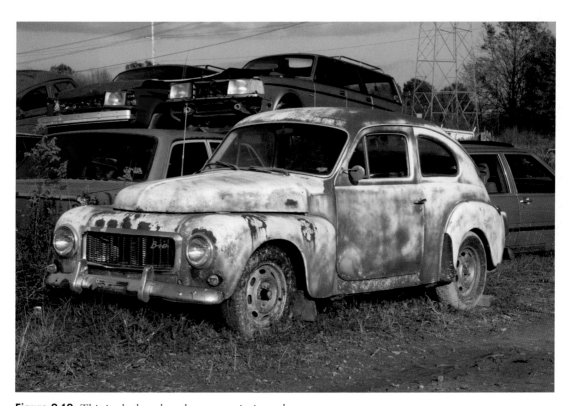

Figure 9.12 This junked car has character as it sits and rusts.

HDR techniques. (See Figure 9.13.) The procedure strengthened the colors and intensified the contrast among the variations of paint splotches on the foreground car. The photographer also refined his image by darkening the edges of the image. This makes for a boldly colored automobile that stands out from the rest. However, if going after a strong HDR effect that exceeds reality, it's often best to go all in with the effect. Increase the intensity of the contrast to give the photo more of an edge, as I've done in Figure 9.14. The modification also enlivens the foreground car more dramatically compared to the cars in the background.

Figure 9.13 HDR brings out the vivid colors of the flaking paint, mud, and rust.

Of course, shooting at eye-level from a typical 45-degree angle works fine for this subject, but a stronger image might be obtained by shooting from a different angle. (See Figure 9.14.) From that slightly skewed perspective, the image becomes more active and dynamic, as if the old car was headed uphill and on its way out of the picture.

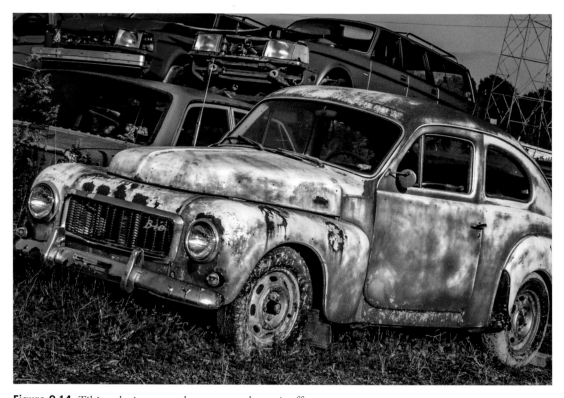

Figure 9.14 Tilting the image produces a more dynamic effect.

Hall of Fame Museum

Photographer: Michelle Schneider

Northeast Ohio has a rich history; it's the birthplace of rock n' roll, the rubber industry, Superman, Alcoholics Anonymous, and Halle Berry. And Canton, which spawned one of the earliest professional football teams, is the home of the Pro Football Hall of Fame. Area resident Michelle Schneider was attracted to the imposing façade of the entrance to the Hall, seen in Figure 9.15. However, the extreme tonal range, which included bright sky and the darker structure, were beyond the normal capture capabilities of a digital camera.

Photographer Techniques:
The photographer saw an interesting façade and moved in tight to capture it with her camera. Then she applied HDR techniques to bring out a wide range of color and detail.

Suggested Improvement Techniques:
None.

Figure 9.15 Façade of the Pro Football Hall of Fame on a cloudy day.

So, Schneider used HDR techniques to bring out the rich color and detail in the building and balance it with the sky. (See Figure 9.16.) In addition, she straightened up the lines of the building to correct the perspective. Indeed, it's not unusual to see photographs of tall buildings that have been shot from eye-level that appear to be leaning backward. The effect is produced when the photographer tilts the camera up to include the upper reaches of the building in the photograph. The "falling back" effect makes the structure look less substantial, so corrections of the sort Schneider applied were needed to restore the drama of the Hall of Fame's entry.

When applying a strong effect, make sure it appears deliberate and intentional, so the viewer will know that the vivid look is what you were trying for, as seen in Figure 9.16.

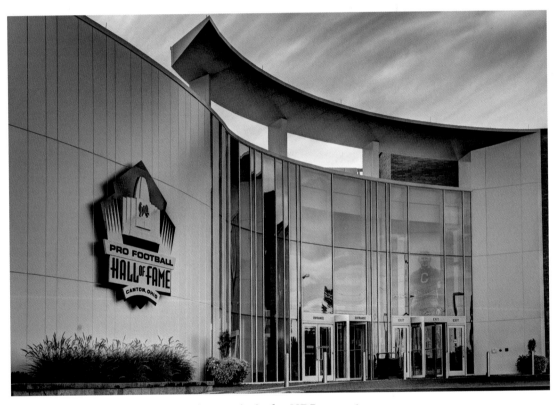

Figure 9.16 The structure takes on a dramatic look after HDR processing.

10

Photoshop Transformations

There is a good reason why I've placed the two chapters that deal with heavy image-editing techniques near the end of this book. In the 175-year (plus) history of photographic art and science, digital manipulation is a very recent capability, dating back no further than the late 1980s if you consider only affordable tools available to the general public. Photoshop was born in 1988, and I've been using it myself only since Photoshop 2.0 debuted in 1991. Prior to that, the vast majority of images were created *right in the camera*. Admittedly, a certain amount of manipulation was done in the darkroom and beyond, and sometimes involved cutting and assembling of film, airbrushing, and other forms of retouching.

Because so many photographers sometimes adopt a "shoot it now; fix it in Photoshop" attitude, I've always tried to emphasize the magic that can happen in the camera through choice of composition, angles, lenses, exposure, and a few in-camera processing techniques. In many cases, image editors are applied to fine-tune an image that's already great—as a tool, rather than as a crutch. That's been the main thrust of the first nine chapters of this book. Once you understand the basics of creative photographic techniques, you can take what you know and expand on it with a program like Photoshop.

So, at this point, you should be ready to learn exactly what imaginative image editing can do to improve your images. The transformation from terrible to terrific, from awful to awesome, starts in your imagination, and not whether you're holding a camera or seated in front of a computer.

Venus

Photographer: John Earl Brown

Photographer John Earl Brown fine-tuned his vision of the original subject, a statue of Venus in a window that was bathed in marvelous lighting. But while the statue was dramatic, there were many distractions in the snapshot-like original photograph. (See Figure 10.1.) So, Brown transformed this image in Photoshop by removing the distractions and toning the image in lovely shades of sepia. He's created an image that in its own way is as timeless as the ancient goddess, and much more beautiful than the statue in its original setting. (See Figure 10.2.)

This is a fascinating image, especially since it is one that many photographers would simply have cropped. Instead, the photographer preserved the proportions of the scene as originally shot, darkening the distracting areas to cover up the problems of the original photo. He actually went far beyond "covering up" to create an image with a great look. Photographers often think they have to either crop or clone things out, when in fact as Brown has shown, the cloning tool may not be necessary. It's often sufficient to simply darken areas to produce a dramatic effect.

He did an excellent job of preserving the tones of the statute so that it almost seems to glow in this environment of darkness. The use of mono-chrome is perfect for this image, and the sepia tone works especially well.

Photographer Techniques:
The photographer captured a statue in a window in an attractive light, but the setting was not optimal, so he transformed the scene by removing the distractions and adding a sepia tone.

Suggested Improvement Techniques:
None.

Figure 10.1 The initial shot shows the beautiful lighting on this statue.

Figure 10.2
Darkening the
surroundings and
converting to mono-
chrome makes it
look like Venus is
poised in a museum.

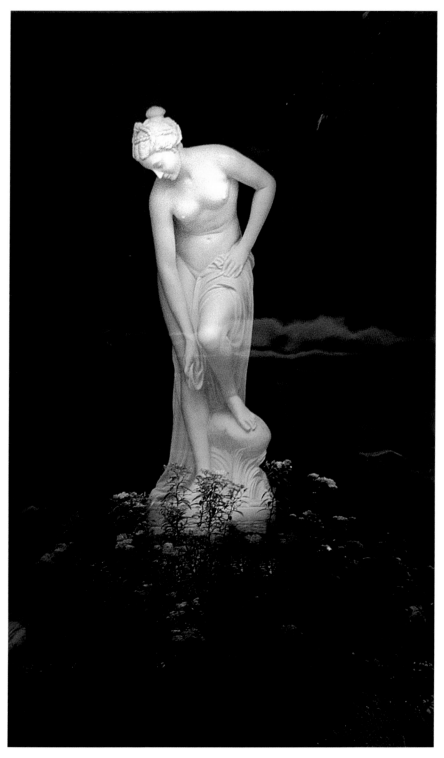

Crow View

The photographer's original image is a rather stark picture of a tree branch and crow against a dark sky. (See Figure 10.3.) The composition is strong and the content interesting, but the blank sky and underexposure keep this image from being anything more than fodder for creative Photoshop manipulation. Indeed, the underexposure made it easier to extract the branch and crow from the image and manufacture an interesting new picture with an entirely different background. Other examples of compositing several images into one fresh photograph are found in Chapter 12.

> **Photographer Techniques:**
> The photographer took a picture of a crow in a tree then highly manipulated the photo in Photoshop, including adding a totally new background.

> **Suggested Improvement Techniques:**
> None.

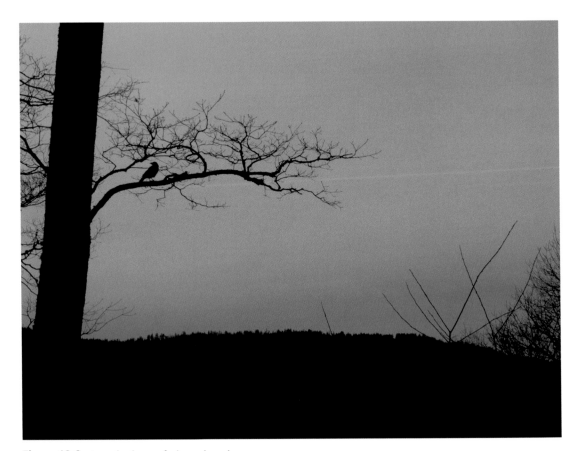

Figure 10.3 A stark photo of a branch and crow.

Photographer George Sipl created a fascinating image that is totally imagined, and entirely assembled in Photoshop without any real relationship to reality. (See Figure 10.4.) His original photograph has become a fine art image with a large black border and thin orange stroke border that gives it an unusual look.

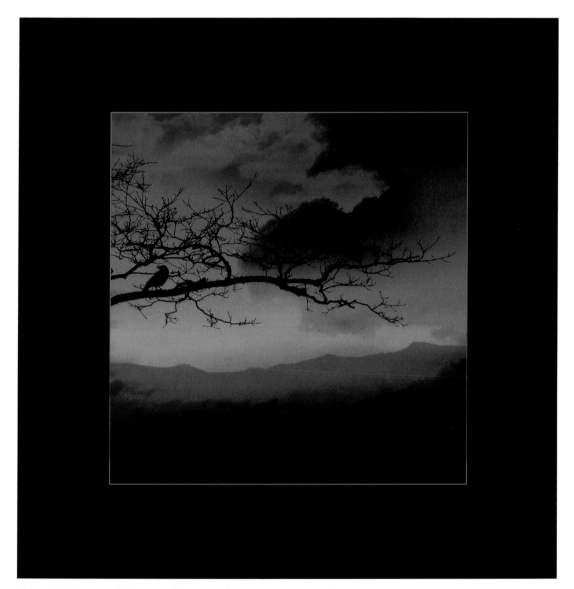

Figure 10.4 A new background converts the image to a piece of art.

The finished photo has rich, unusual colors and vivid contrast. Sipl added a scene behind the tree and crow and a vista with mountains or hills, and he changed colors. The image almost has a feeling of a Japanese tapestry. The composition is simple and works well, including the use of the square proportions.

The image is striking and has impact. The photographer's tree branch would be a little stronger if it didn't merge so much with the dark clouds behind it, as you can see in my minor edit. (See Figure 10.5.) As with many truly excellent pictures, there are other interpretations that are also interesting. I couldn't resist transforming the original image into a stark horizontal black-and-white composition, just to illustrate the rich possibilities in this shot. (See Figure 10.6.)

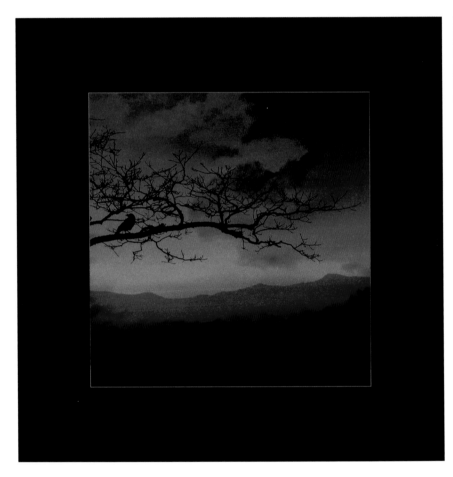

Figure 10.5
Brightening the sky behind the right portion of the branch produces extra separation.

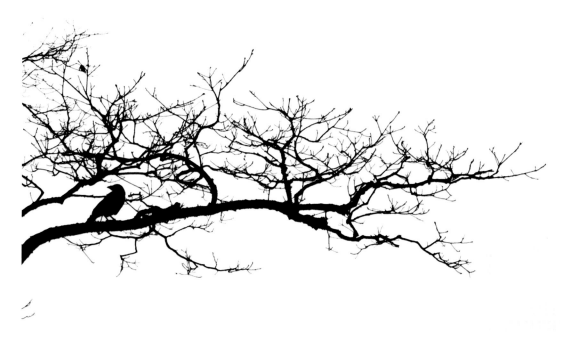

Figure 10.6 The original shot even looks great in black-and-white.

Victorian Home

Photographer: Ed Rynes

Victorian homes have marvelous shapes and architectural details, as you can see in Ed Rynes' unadorned image in Figure 10.7. Unfortunately, this photo opportunity appeared when the day was gray or overcast. Still, Rynes took the picture and decided he could make something of the photo in his image editor.

He didn't simply change the color and contrast to brighten a somewhat dreary day. Instead, the photographer created a whole new image of whimsy and fun. (See Figure 10.8.) He distorted the shape of the house, intensified colors,

> **Photographer Techniques:**
> The photographer shot an interesting Victorian home and then manipulated the image to create a funky and whimsical photo.

> **Suggested Improvement Techniques:**
> Not much. One thing to consider would be to add clouds to the blank sky.

and then added a sports car for a very lively look. The image has some wonderful cartoonlike aspects to it almost reminiscent of the movie *Who Framed Roger Rabbit?*.

The final picture is great just as it is, and I wouldn't suggest changing much. However, the subtle sky doesn't quite fit with the rest of the photo. Filling the sky with some overly dramatic clouds adds to the cartoonish look of the picture and may, in fact, intensify the effect that the photographer was after.

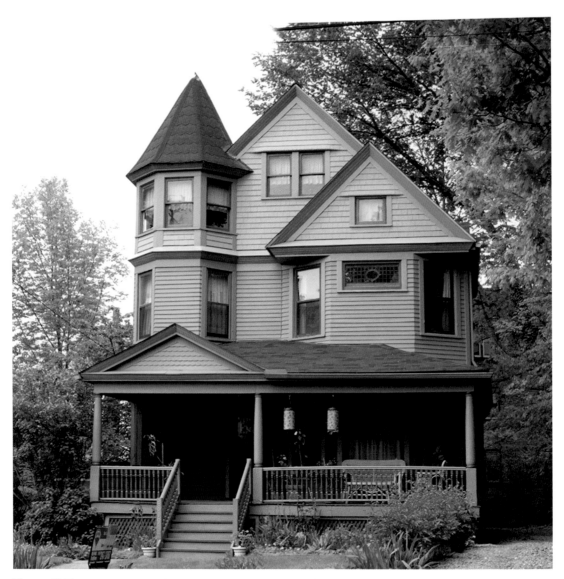

Figure 10.7 A great Victorian home captured on an overcast day.

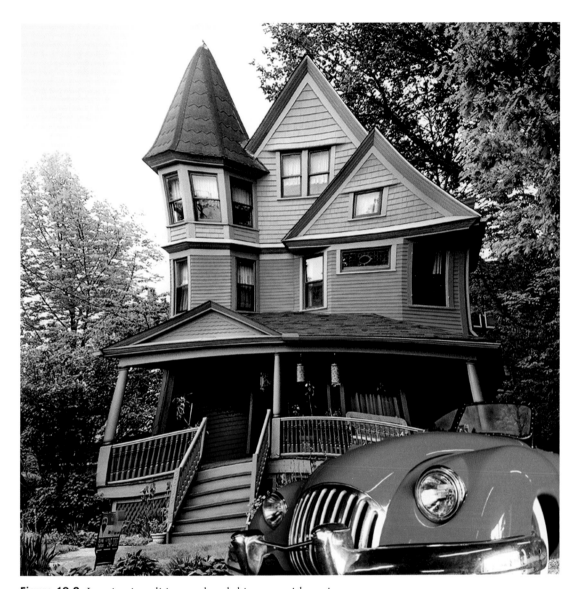

Figure 10.8 Imaginative editing produced this cartoonish version.

Given the Victorian style of this architecture, I wanted to see what a "moody" look would add to the picture, so I changed the contrast and saturation, as seen in Figure 10.9. My version is in no way a better picture than the photographer's original interpretation of color and tonality. It's simply a different take on a highly creative image of an interesting home.

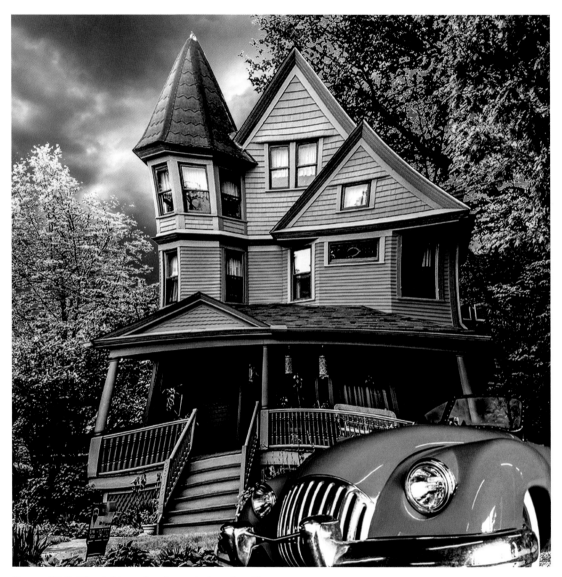

Figure 10.9 The Addams family might have lived here.

Warrior Masks

Photographer: Daniel Kozminski

Here is an example of how you can take a great shot, such as the lineup of warrior masks shown in Figure 10.10, and process it into an entirely different image that's just as good. Photographer Dan Kozminski photographed the grouping of masks with a telephoto lens from an imaginative angle. He could have simply cropped out the orange Gatorade bottles at far left and, perhaps a bit of the top of the image to produce a striking photograph with no further manipulation.

Instead, he implemented a fascinating interpretation of his original subject matter. (See Figure 10.11.) By converting to monochrome, with a

Photographer Techniques:
The photographer captured a group of African warrior masks in a neat row then manipulated the image in Photoshop to create a dramatic image.

Suggested Improvement Techniques:
Be aware of the edge position relative to important visual elements in the composition. Make sure that the bright areas that attract the eye are actually important parts of that image.

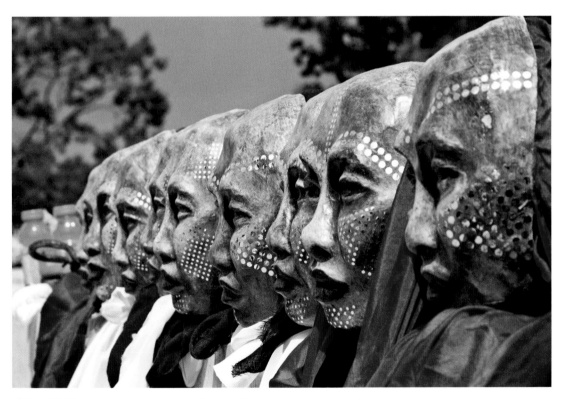

Figure 10.10 Even the original shot of these African masks is a great picture.

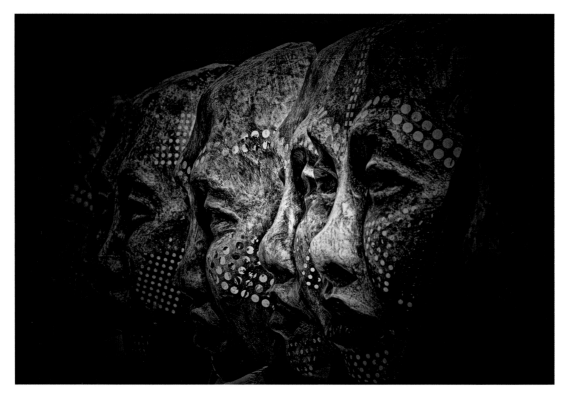

Figure 10.11 Image editing produces a mysterious look.

sepia tone, Kozminski gave the image more of a timeless look. Then, he manipulated the bright areas of the composition, producing an emphasis that achieved almost a spotlight effect. This transformed the mask into a unique image that stands alone.

The resulting image crops the chins of the center masks so they are literally resting on the bottom of the frame. That positioning "ties" the chins to the edge of the image, so they don't have the same visual presence within the photo. The masks are not merged to the top edge because of the way the foreheads of the masks recede into the distance, creating an interesting space going back to the distance at the left. Just giving the chins a little space helps better define the masks within the composition. (See Figure 10.12.)

Of course, bright areas within an image like this always define where the viewer's eye goes first. The brightest part of this image highlights the nose of a mask that is not visible, which could cause confusion. I adjusted my version of the image so the area of brightness is spread over all three masks, drawing the eye to one clearly defined visage that leads the viewer to explore the rest of this excellent photograph.

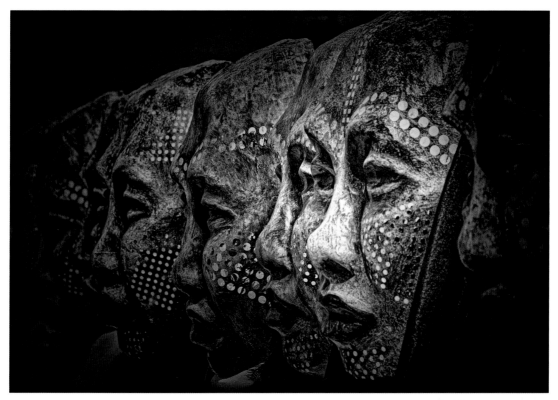

Figure 10.12 Adjusting the brightness of the mask on the right highlights its interesting features.

Mansfield Reformatory *Photographer: Rob Erick*

The 20th anniversary of the release of the film *Shawshank Redemption* in 2014 drew a lot of attention to the Mansfield (Ohio) Reformatory, a former prison where some of the movie was filmed. Photographer Rob Erick participated in several of the photographers-only field trips sponsored by the Cleveland Photographic Society. These were self-guided, and allowed the use of tripods and other photographic paraphernalia not normally welcomed by conventional tours.

Photographer Techniques:
The photographer visited a historic prison and photographed a dramatic hall; then he added light beams in Photoshop.

Suggested Improvement Techniques:
Not much. You may want to correct the lean of the walls.

On this visit to the Reformatory, Erick photographed a towering cell block, capturing the soaring space with windows on the right. (See Figure 10.13.) Even the first version captures the feeling of vastness and decay, with long strips of peeling paint hanging from the ceiling. Row upon row of

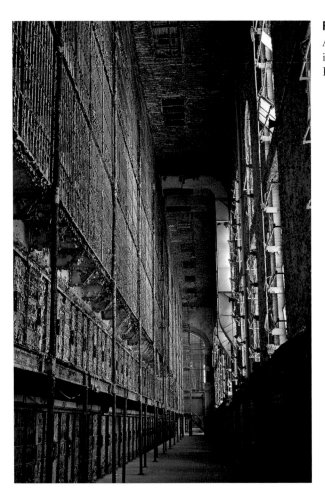

Figure 10.13
A decaying cellblock in the Mansfield Reformatory.

rusting steel cell doors convey a sense of thousands of individual stories and it's easy to become lost in thought as one explores.

Despite the crumbling interior, the image evokes a cathedral-like feeling, and the prison bars add a disturbing beauty. Although Erick's original image is quite interesting, he added some beams of light from the windows that were not captured by the camera, making the image more striking and a bit spooky. He used a polygonal lasso tool to draw a series of diagonal lines from each narrow band of windows to create a realistic pattern. The resulting selection was then feathered heavily, filled with white, and the opacity reduced, allowing the original image to show through the created "rays of light." The resulting mood helped to achieve Erick's goal of attempting to combine the reality of what the prison had become with the promise of its original intent.

The photographer did a nice job. I straightened the walls to add a feeling of height to the photograph. (See Figure 10.15.) Most image editors have controls to correct the perspective that is captured when the camera is pointed upward at an angle like this.

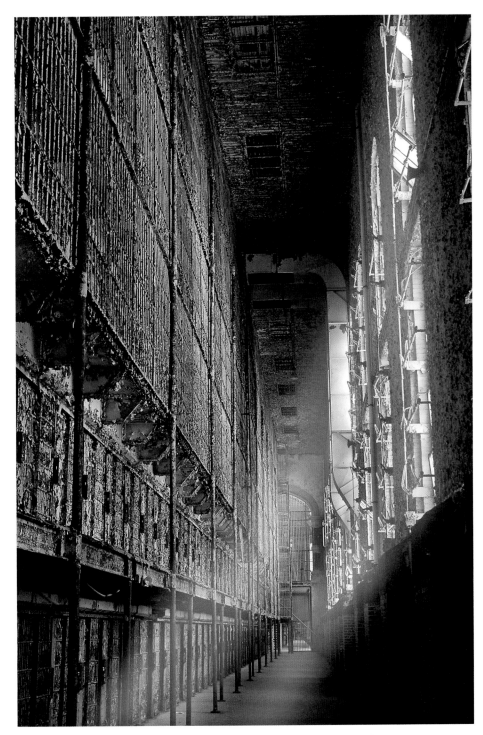

Figure 10.14 Beams of light added in an image processor cast an eerie glow.

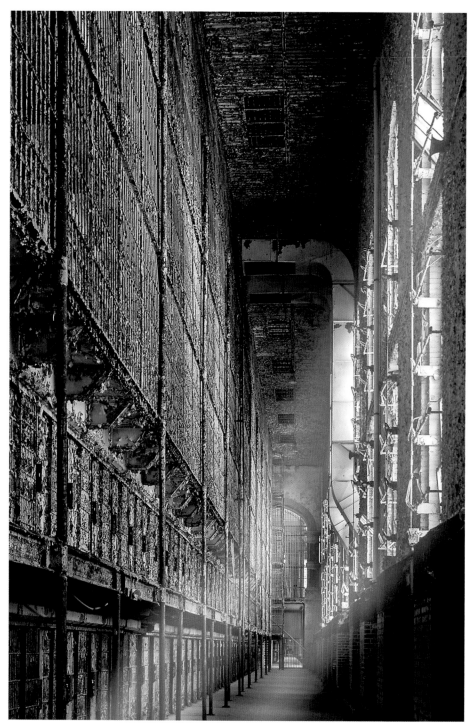

Figure 10.15 Straightening the walls adds a feeling of height.

Snowy Egret

Photographer: Harry Kaulfersch

Snowy egrets have a dramatic mating display, and photographer Harry Kaulfersch caught a male at a peak moment. (See Figure 10.16.) These birds typically display from branches, extending from small trees near water. The bird was bathed in a beautiful soft light, but shafts of sunlight lit up branches behind him that became intrusions into the image.

So, Kaulfersch used his image editor to clean up the image. He removed the background distractions by essentially covering them with black. This added a dramatic look to the photograph. He removed the blue cast that sometimes results from auto white balance, and intensified the look of the feathers.

Photographer Techniques:
The photographer captured a snowy egret displaying mating behavior. He used an image editor to remove the distracting elements in the image.

Suggested Improvement Techniques:
When making a dramatic change to a background ensure it still fits with the rest of the photo. When making adjustments for one aspect, such as enhancing feathers, make sure it doesn't over-intensify other parts of the subject, such as the body of the bird.

Figure 10.16
There are lots of distracting details to draw our attention from this male egret.

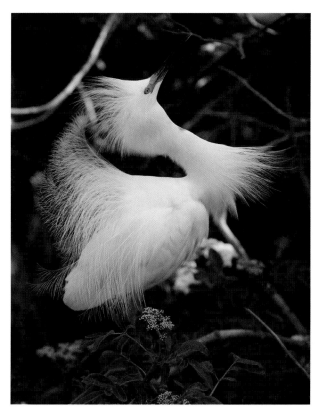

When the photographer created the black background, he cut into a bit of the neck feathers of the bird, which produces an odd notch at the base of his neck. In my version (Figure 10.17) I applied less of an intensifying effect on the feathers on the bird's chest. By reducing the sharpness of the chest, the egret gets a more natural-looking body, and the rest of the feathers actually gain more impact.

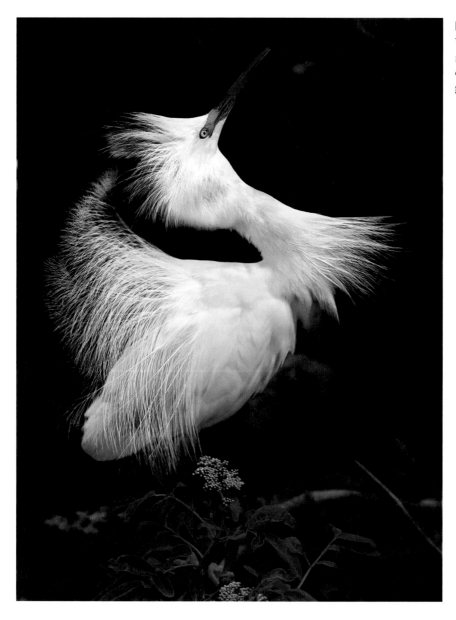

Figure 10.17
With the features restored, the male displays in his full glory.

System 8 *Photographer: George Sipl*

Photographer George Sipl captured an interesting composition and moment with his original beach scene. (See Figure 10.18.) The reflection of the lifeguard chair, its color, and the runner on the beach all combine for an interesting visual relationship. Unfortunately, the sky is gray, which makes the whole image rather dull.

So, Sipl added a new sky with a sunrise or sunset where the sun is at the horizon and the sky is lit up with vivid colors. He incorporated the warm colors into the rest of the photograph so that the overall scene harmonized with the colors and tones of the sky. He also intensified the lifeguard chair by adding a strong red color. (See Figure 10.19.)

Photographer Techniques:
The photographer found an interesting composition at a beach, but the day was gray and overcast, so he changed the sky and added color to match that sky for a more colorful image.

Suggested Improvement Techniques:
Don't over-saturate parts of the picture that normally would not have such intense color under the conditions you are simulating.

Figure 10.18
This seaside shot lacks contrast and color.

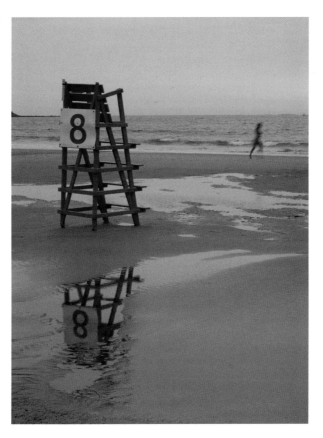

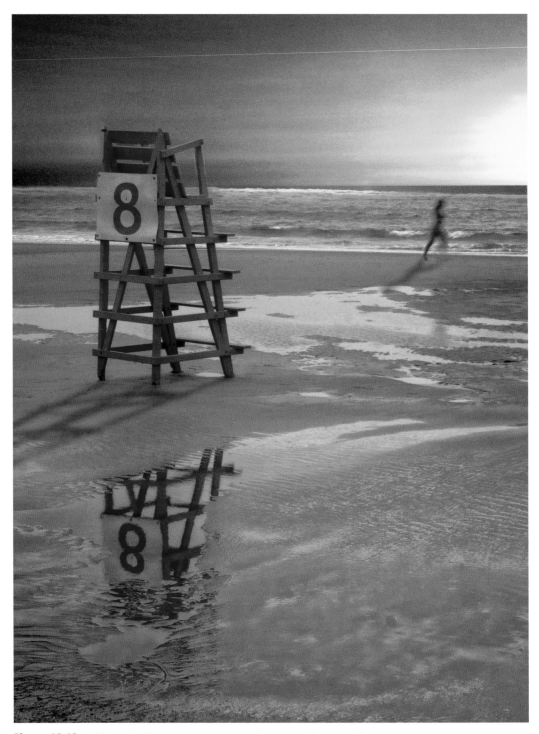

Figure 10.19 Adding a brilliant sunset improves the picture dramatically.

One of the truly remarkable aspects to the second image that is easy to overlook is the photographer's attention to detail, which extended to creating realistic shadows for the runner and lifeguard's chair. It's truly a wonderful transformation of a basic picture into a sublime one.

For my version, I reduced the saturation of the color a little, so the image still has the intense red. I also added a slight blue tone to the darker parts of the picture, while retaining the warm tones in the highlight area. That's a natural look for a scene like this. The darker, shadow areas will typically pick up color from the parts of the sky overhead that are still blue, whereas the bright areas are going to pick up the warm light from the low sun. While my version might be more "realistic," it serves to point out exactly how dramatic and compelling the photographer's modification was.

Figure 10.20
Toning down the highly saturated colors provides an alternate, more realistic view.

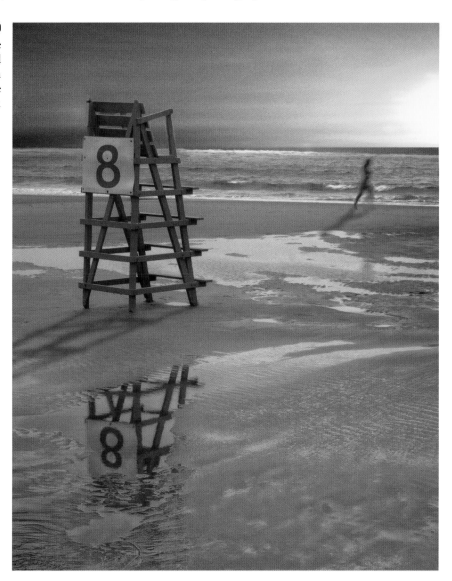

Thunderbirds Crossing *Photographer: Rob Erick*

Although I emphasize capturing the best possible image in the camera, sometimes the weather or other factors work against you. Photographer Rob Erick's timing for the original shot was quite remarkable. (See Figure 10.21.) Unfortunately, the day was gray and the image is underexposed, so while the moment is dramatic, the photograph is not as appealing.

For the original image, Erick was positioned to shoot the two opposing solo aircraft as they flew directly toward each other, panning to follow the jet approaching from the right while shooting continuously. The panning motion captured a reasonably sharp image of the aircraft being followed as it passed to the left side of the image, but the one that was crossing from left to

Photographer Techniques:
The photographer captured an image of the U.S. Air Force Thunderbirds in a dramatic moment during their air show. The sky was a dull gray, so the photographer manipulated the image in Photoshop to create a more attractive image.

Suggested Improvement Techniques:
Be careful when cropping an image. Don't make the subject look like it has been artificially forced into a box. Consider tilting the composition at angle to get a more dynamic quality to it.

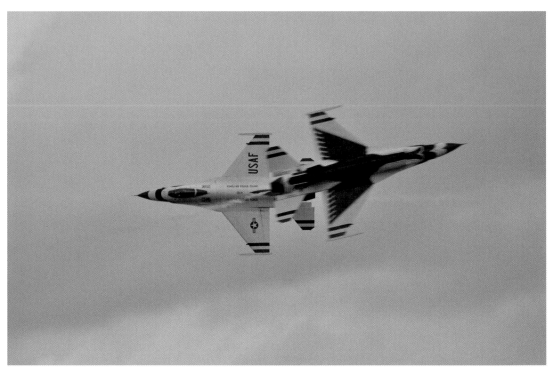

Figure 10.21 A captured moment as two Thunderbirds cross paths.

right was noticeably blurred. In his image editor, he selected the blurred plane and sharpened it to better define its edges, and then darkened the sky to reproduce in his final photograph (Figure 10.22) what he remembered seeing at the event.

The cloud at the bottom of the photo is one of the brightest parts of the picture so it does compete with the jets for the viewer's attention. Tone that down somewhat to balance the photo. The outer parts of the photo can be darkened a bit to create a strong emphasis on the jets.

In Erick's original image, the jets are crossing in a straight path. For my version, I tilted the image slightly to add a more dynamic quality to the composition.

Figure 10.22 Extensive processing in an image editor produced this exciting picture.

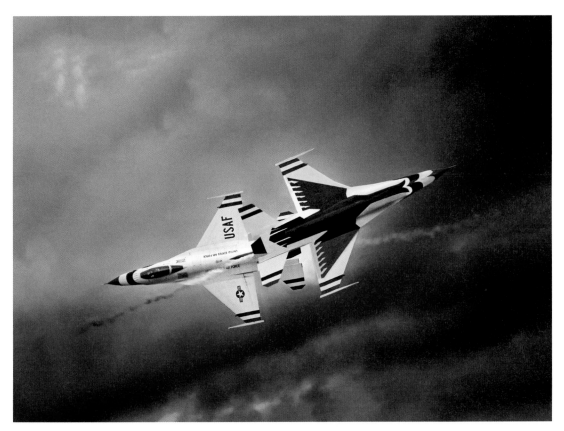

Figure 10.23 Darkening the lower clouds and tilting the image slightly makes it more dynamic.

Paco—CF-18 Pilot

Photographer: Anita Orenick

Here's another Cleveland Air Show image, this one from photographer Anita Orenick. Capturing jets in the sky can be challenging. If you shoot the jets at a fast enough shutter speed to stop movement, they can look very static against the sky. In addition, the texture and colors of the sky can make a big difference, because the sky truly is the background for such images.

The photographer notes that she shot these two images on different days. The conditions are similar, but the sky is different—more overcast

Photographer Techniques:
The photographer captured a jet in the air on two different days and then manipulated the edges of the jet to produce a feeling of speed.

Suggested Improvement Techniques:
Balance the image tones.

in the first image, and a vivid blue in the second. The light appears to be different as well. Orenick processed the image while maintaining the sense of speed. This is most obvious in the first picture where the trailing edges of the wings are blurred. (See Figure 10.24.)

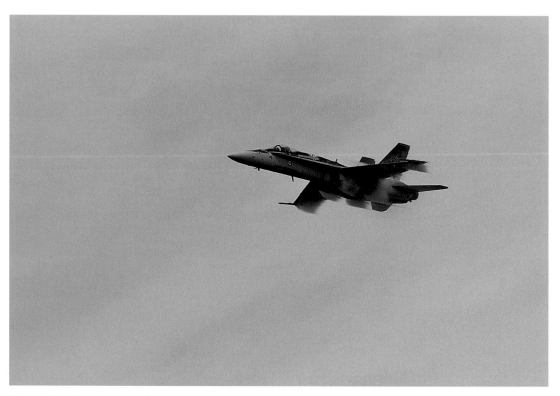

Figure 10.24 A jet captured on an overcast day.

The trailing edges of the wings are blurred in the second photo as well, plus there is a vapor cone, produced when an aircraft breaks the sound barrier surrounding the plane. (See Figure 10.25.) I considered brightening the image so the whites are bright and the blacks dark enough to balance with the midtones (see Figure 10.26), but, in truth, the photographer's image actually does a better job of capturing the colors and tones that were present.

Figure 10.25
The skies were clear and blue the following day.

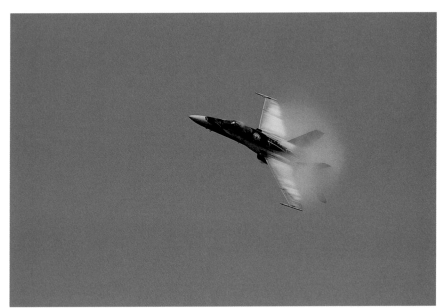

Figure 10.26
This alternate version has adjusted tones, but doesn't actually represent the jet as it appeared during the airshow.

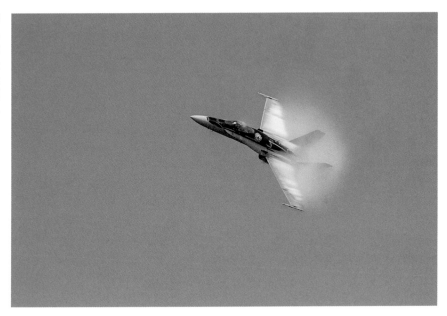

San Juan Hotel

Photographer: Alexander Stulock

Photographer Alexander Stulock found a very interesting night scene at this Miami hotel. (See Figure 10.27.) The bold and colorful sign plus the night colors on the awning, the interesting patterns of movement, and the people sitting under the awning made for an interesting night photograph. Digital cameras today pull out great detail from a night scene like this one.

Stulock processed the image to enhance certain areas and change the balance of brightness within the photo. (See Figure 10.28.) That modification emphasized the area under the awning, which seems to be illuminated by a different, cooler light source.

Photographer Techniques:
The photographer shot a night scene of a hotel and street using a long exposure. He then adjusted it in an image editor to balance tones and colors.

Suggested Improvement Techniques:
When adusting tones in images shot at night, be careful that you don't lose the inherent warmth often found in such images.

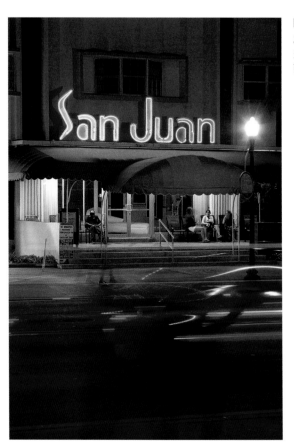

Figure 10.27
Some areas of this image need to be brightened.

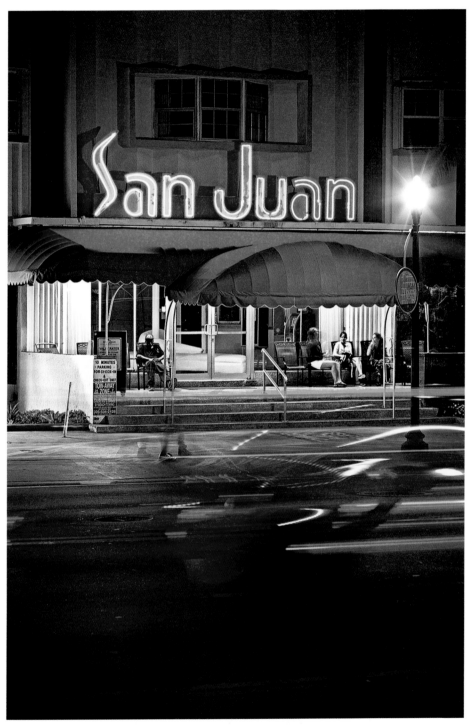

Figure 10.28 Increasing the brightness under the awnings improves the shot.

Viewers tend to prefer scenes with warmer tones and less harsh contrast. The original image could have been adjusted similarly to Figure 10.28 but with the area under the awning maintaining gentler tonality/less contrast and more warmth.

For my version (see Figure 10.29), I cropped the image, made some local adjustments to the bright left side under the awning, the dark area around the man, and the harshness and darkness around the woman at right.

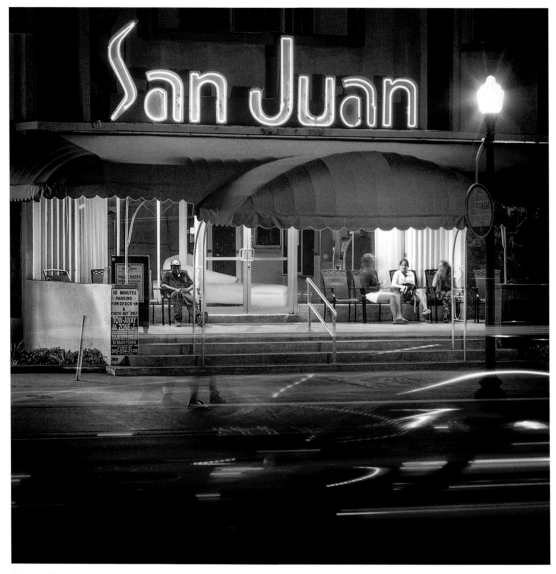

Figure 10.29 A warmer tone and square composition provides another view.

Grumpy's Café

Photographer: Daniel Kozminski

The owners of this café used unique signage to create a façade that photographer Daniel Kozminski captured in the photograph seen in Figure 10.30. He shot this scene from the front, perfectly parallel to the front of the building and at a slight distance so that the photograph became an abstract design of colors and shapes as much as a specific façade. This approach to the building is interesting, but this was only the start for Kozminski.

Photographer Techniques:
The photographer found an interesting and colorful café to capture and then created a remarkable and whimsical image from his photograph of it.

Suggested Improvement Techniques:
None

He considered this café shot as an opportunity to create a whimsical and fun new version of the eatery. (See Figure 10.31.) The photographer manipulated the image to vary tonality across the scene so that it was even in brightness. Then he applied cracks and texture to the image.

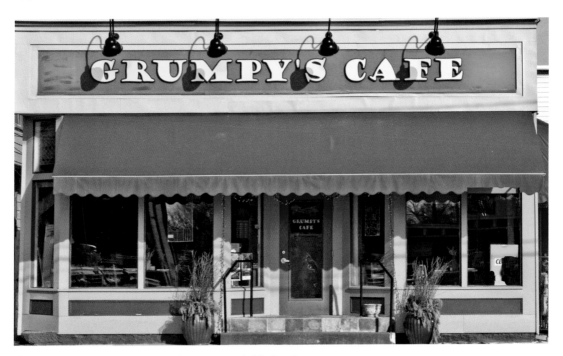

Figure 10.30 This interesting café has a remarkable façade.

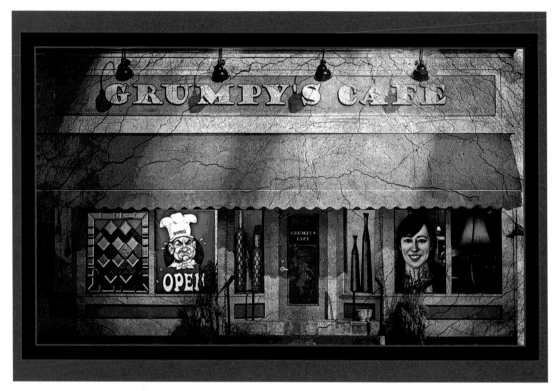

Figure 10.31　The photographer transformed the image into a work of art, adding texture, and faux "posters" to the windows.

Next he replaced the windows with designs and posters. The lamp in the far right window is a little dark to balance the rest of the image, but it is interesting. The photographer combined all these things plus added a few other little touches to create a most unique and unusual photograph.

Finally, Kozminski added some unique border treatments. Generally, areas that look like strongly colored mattes can make an image look dated and fight with the colors of the photograph. However, in this case, they fit with the whimsical, colorful look of the photo. The black border/matte with its red stroke borders and interesting elements fit the actual design of the colors of the original café. The first image of the café front was good; it's been transformed by sophisticated editing techniques into a work of art.

11

Cloning and Compositing

Retouching and compositing are two very different, yet closely related sides of the same image manipulation coin. Retouching generally involves fixing problems with existing photographs, removing dust spots, stains, and artifacts. With compositing, you can *combine* one or more images, or portions of images, to create an entirely new picture. Image editors have enabled us to flip the old saying, "Seeing is believing" on its head.

Until recently, realistic image fakery required either a great deal of planning or monstrous expense. *National Geographic*, for example, employed a gazillion-dollar Scitex laser scanner to nudge two pyramids closer together into a vertical composition for its controversial February 1982 cover. Today, any digital photographer can do the same thing, and probably do a better job of it.

In general, these newfound capabilities are good things. Most of us aren't interested in assembling a photograph that shows Brad Pitt having a conference with Mohandas Gandhi, for nefarious purposes or otherwise. We're more interested in removing bags under the eyes in a portrait of a loved one, or banishing an ex-brother-in-law from a family portrait. We'd like to disguise dust spots, bring back vibrant color to a faded '50s-era snapshot, or remove a telephone pole that seems to be growing out of someone's head.

The goal of simple retouching is often to remove the real or imagined defects from a photograph. A high school senior portrait (male or female) showing less than silky-smooth skin is sometimes viewed as a disaster by those who have just traversed the rocky roads of puberty. On the other hand, removing the character lines from the face of a 60-year-old corporate chief executive would provoke outrage. Emphasizing that steely glint in the eye may be much more important.

Compositing involves combining images, or portions thereof, to create a new image that didn't exist in that form previously. You may want to create a composite that combines the best poses of two family members into a single double portrait. Perhaps you don't like the background in another

image, and would like to replace it with a more attractive setting. If you have a touch of whimsy in your soul, you may even harbor a secret desire to transplant the Eiffel Tower to London. This chapter showcases some ways that creative photographers have taken an image to the next level with image editing.

Inspiration Point *Photographer: Matthew Kuhns*

The opportunity to stand at a spot like this at sunrise or sunset under beautiful conditions like these is indeed inspirational. Photographer Matthew Kuhns discovered an interesting composition of rocks, trees, and mountains at this spot, with the sun just below the horizon. (See Figure 11.1.) There's not much in the way of clouds in the sky, so the photographer added some clouds from another photograph to produce a dramatic and colorful image. Kuhns did an excellent job of merging these clouds into the photo, especially where the edges of the new content merge with the original image. There are virtually no traces that betray the fact that the final photograph (see Figure 11.2) is actually a combination of two different pictures.

Photographer Techniques:
The photographer captured a photo of a pine tree and mountains at sunset then cloned in a new sky.

Suggested Improvement Techniques:
When you add a new element to a photograph, be aware of places that can reflect the color of that element so that the entire photo is tied together. Before you start applying such drastic changes to an image, look at your photo and trust your original instincts.

Figure 11.1
An interesting picture, even without a cloud-filled sky.

Still, snow and other white surfaces, such as the clouds in the middle distance, all reflect the color of ambient light. In the original image, the sky at the top of the picture was blue, and the ruddy hues of the sun appeared only at the horizon. That's why the clouds in the lower middle of the photo have a blue tint. Yet, as we examine the composite image, none of the brilliant crimson sky that's been added is reflected in the areas formerly illuminated by the blue sky of the original shot. (See Figure 11.3.)

Figure 11.2
Adding a layer of clouds makes the image more dramatic.

Figure 11.3
However, the ruddy sky is not casting its glow on some areas of the photo.

Most viewers won't be able to put their finger on exactly what is causing the problem, but some may find the image makes them a little uneasy. When some warmth is added to those areas, the top and bottom of the picture tie together better. (See Figure 11.4.) Inspiration Point is a great location, and both images, as different as they are, provide a compelling look at this picturesque scene.

Figure 11.4 Warming those areas creates a more realistic image.

Cubano Farmer *Photographer: Susan Onysko*

Third world countries offer great opportunities to learn about other cultures and to capture some wonderful photography if you are respectful to the people. Photographer Susan Onysko photographed a farmer and oxen in the field. (See Figure 11.5.) She then cropped the original image to produce a more panoramic format. This helped her get rid of some blank sky and ground that didn't contribute much to the image. (See Figure 11.6.)

For the final version, Onysko removed the power and phone lines/poles as well as the

Photographer Techniques:
The photographer captured a farmer working the fields with oxen, but the original image included many power and phone lines. She removed those wires to simplify the image.

Suggested Improvement Techniques:
None.

building with the bright distracting shapes. She also straightened the image slightly and did some processing to enhance certain details. The photographer must have invested a great deal of time to remove those distractions. The results are definitely worthwhile. The focus is now on the farmer and his oxen rather than the wires and the building in the background.

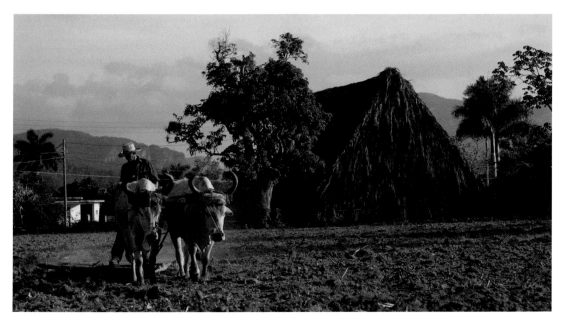

Figure 11.5 A Cuban farmer at work with his oxen, but the power lines in the background are distracting.

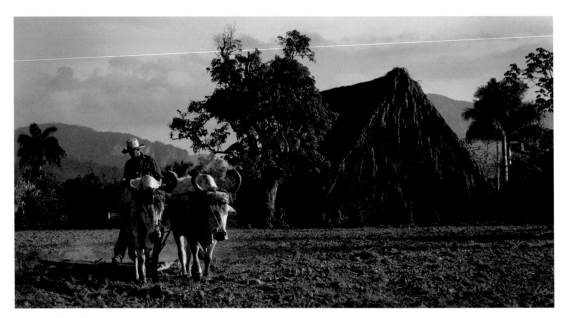

Figure 11.6 Removing the power lines gives the image a timeless quality.

The image has great light, and the photographer darkened some of the midtones, especially in the vicinity of the farmer. For a slightly different look, adjusting the dark areas without simultaneously brightening the lighter areas softens the image, as you can see in my alternate version (Figure 11.7).

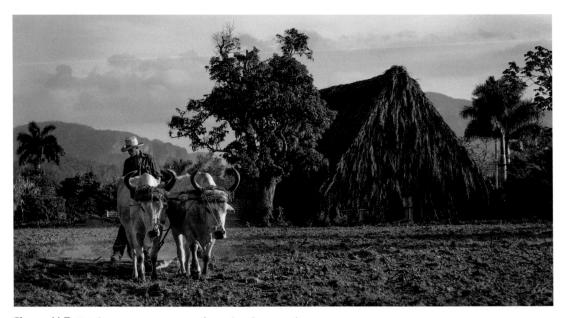

Figure 11.7 Brightening some areas softens the photograph.

AD-5 Skyraider
Photographer: Rob Erick

Nothing beats the sheer speed and chest-pounding presence of modern jet aircraft to get the juices flowing at an air show. But the gallantry and patriotism of those who fought the World Wars and later conflicts and the aircraft they flew also stirs the soul. At a small-scale local air show dedicated to vintage aircraft, photographer Rob Erick had the opportunity to photograph this vintage AD-5 Skyraider. A propeller-driven aircraft that debuted near the dawn of the jet age, the AD-5 saw service from the late 1940s well into the 1980s before being

Photographer Techniques:
The photographer captured a Marine plane, the AD-5 Skyraider, in action, but the sky was bland and gray. He replaced that sky with a new one that is more visually interesting.

Suggested Improvement Techniques:
None.

succeeded by the jet-powered A-10 "Warthog" Thunderbolt. The sky was overcast and even while panning to follow the fast-moving aircraft, the photographer found that his "best" shot positioned the plane at the extreme left edge of the image, which almost makes it appear as if it were about to crash into the side of the frame. (See Figure 11.8.)

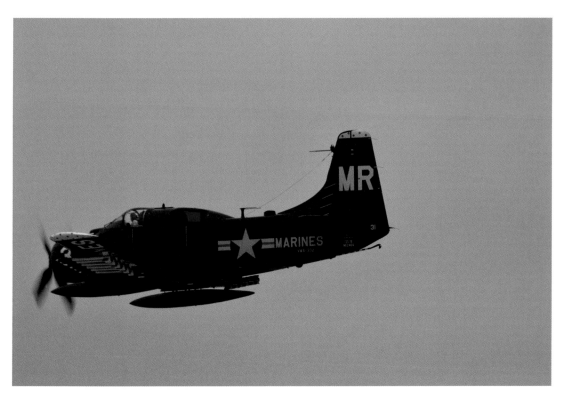

Figure 11.8 The aircraft has almost sped completely out of the frame.

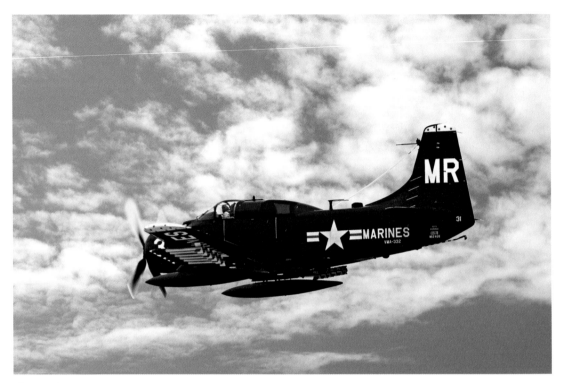

Figure 11.9 The clouds that were added look as if they really could have been the backdrop for this picture.

Fortunately, the image is sharp and has good detail, and the plain sky background is so simple that Erick was able to carefully select the aircraft and drop it into a sky photo taken at a different time and place. (See Figure 11.9.)

The sky image he chose for the background works extremely well, and the lighting and compositing make the two images appear to belong together. Too often we see images that are composited well technically, but the object looks pasted in because there's no visual connection of subject and environment.

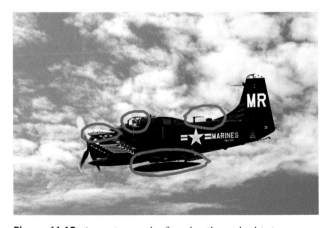

Figure 11.10 Attention to the fine details made this image more realistic.

It's easy to see the attention to detail that the photographer applied while combining the plane with the background. The pilot and the tip of the wing have a brightness that looks appropriate to the sky, and Erick was very careful in the way that he has composited into small areas so that the detail of the plane is retained against the background. (See Figure 11.10.)

Just Blend *Photographer: Barbara Pennington*

Rubber ducks have transcended childhood memories ever since Dutch artist Florentijn Hofman began exhibiting several of his massive (more than 100 feet high) polyvinyl chloride sculptures floating on bodies of water near 18 different cities worldwide (to date), beginning in 2007. Photographer Barb Pennington created her own ducky artwork with the photo of a group of these plastic toys, as seen in Figure 11.11. She then added a picture of a real duck in a gap in the image. (See Figure 11.12.) This is great fun!

Photographer Techniques:
The photographer captured a group of rubber ducks and added a real duck in their midst, resulting in a clever image.

Suggested Improvement Techniques:
When compositing, watch how a composited object interacts with its surroundings. This is key to make the composited object blend with the new background.

Figure 11.11 Some rubber ducks with an empty space crying for a real duckling.

Figure 11.12
The added duck
seems comfortable
among the "decoys."

The challenge, however, is making sure that the real duck fits in with the overall picture. If it looks like it is simply stuck into the picture, the viewer will see this as a paste job in Photoshop and will not find it as interesting. They won't engage with the image. While the compositing job shown in Figure 11.13 is good, this real duck does look pasted into the picture.

As soon as you add shadow under the duck's bill, blur the front of the duck's bill, create a shadow at the lower part of the duck, and soften the top of the head, the duck immediately starts to look like it actually belongs in this group of rubber ducks, as you can see in my quick-and-dirty modification (see Figure 11.14). Adding a little bit of the color of the rubber ducks to the composited duck gives it another environmental connection, because it would not be unusual for the ambient light to pick up reflective color off of the surrounding ducks.

Figure 11.13
However, the surrounding ducks are blurred in places, while the new duck is uniformly sharp.

Figure 11.14
A bit of creative blurring helps him fit right in.

Banana Split in Alaska

Photographer: Joe Polevoi

If you've ever visited Japan, you've probably been amazed by the astounding reproductions of food items on display in restaurants to represent items on their menu. Originally created in wax for a Tokyo department store, after World War II these food replicas began to be produced from resin and were hand-painted by expert craftsmen. They are used to provide a quick reference to what is on a restaurant's menu—especially useful for visitors who don't speak Japanese. Today, in the Kappabashi, or "Kitchen Town" area of Tokyo, food-themed stores offer replicas for purchase by tourists, and even host workshops that teach guests how to make fake food.

Photographer Techniques:
The photographer took a photograph of a banana split and composited it with a landscape from an Alaskan cruise.

Suggested Improvement Techniques:
Although this image is clearly a cut-and-paste composite, make sure the lighting is consistently applied to give the humorous picture a more cohesive look.

Photographer Joe Polevoi came home from Japan with a replica of a banana split that literally looked good enough to eat. (See Figure 11.15.) He noticed a remarkable resemblance to the cruise ship that carried him through a scenic area of Alaska. He combined the original photograph with the Alaska vista. (See Figure 11.16.) He added portholes along the side of the bowl and a reflection in the water to complete the illusion.

This is a fun and wonderful idea, and Polevoi did a great job cutting out the banana split for compositing onto the Alaskan scene. However, it definitely looks like it was cut and pasted. Making the individual images in a composite look like they belong together requires the lighting to be interactive. In the composite image, the illumination in the background is coming from the upper left, while the light falling on the replica is coming from the upper right.

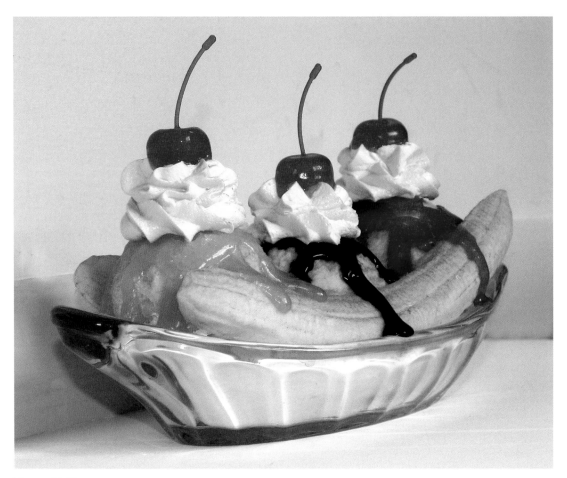

Figure 11.15 This food replica is extremely realistic.

Figure 11.16
Putting it in an unrealistic setting provides a humorous touch.

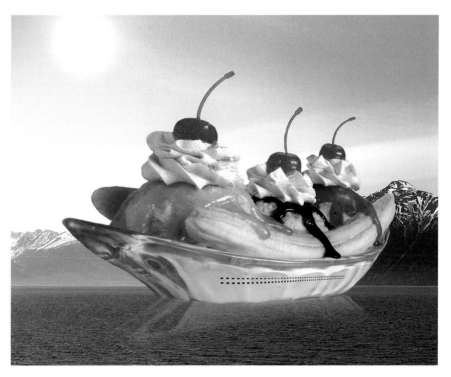

Figure 11.17
The lighting is not quite right.

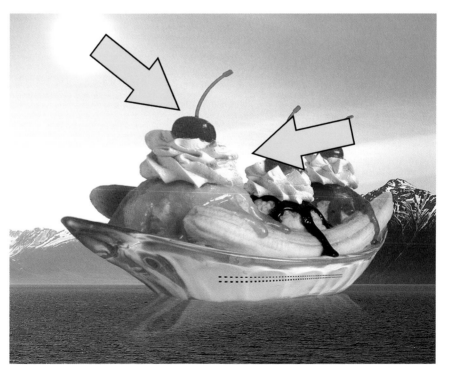

Flip the background from left to right so the sun is now on the right side, then add some shadows to the left side of parts of the banana split. (See Figure 11.18.) For my version, the reflection of the "boat" is very distinct for such a rough bit of water, and is not stretched along the plane of the water as it normally would be. Some sort of shadow on the water underneath the "bow" of the boat is missing as well.

Of course, this attention to detail may be something of a tempest in a teapot. No one is going to examine Polevoi's composite to analyze whether it's "real" or not. It's obviously intended as a humorous picture that you admire for its visual punch line, and then move on. So I used this example as the basis for a simple lesson on what you may need to do when you are creating a composite that isn't meant to be a complete fantasy. Polevoi's thought-provoking image provided a springboard for that lesson.

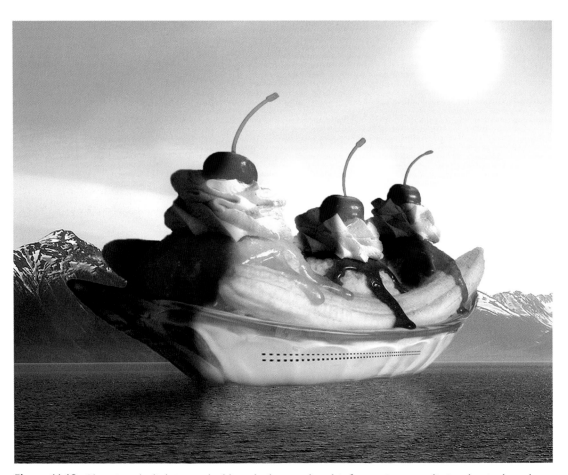

Figure 11.18 Changing the lighting and adding shadows makes this fantasy image realistic—but is that what you really want?

Dreamt About Space Battle *Photographer: Joe Polevoi*

Polevoi's active imagination obviously can't stop at merely bringing food replicas to life. He turned an image of his electric shaver into a battling space ship, starting with the rather mundane image shown in Figure 11.19. Many hours later, he arrived at the fantasy image shown in Figure 11.20. The cropping of this scene into a vertical that just clips the edges of the ship at the upper left gives a dynamic quality to the composition (and the change of perspective of that big ship also helps), making it seem like this electric razor space ship has burst onto the scene, firing lasers as it arrived.

> **Photographer Techniques:**
> The photographer turned a photo of an electric shaver into a space ship in full battle mode.

> **Suggested Improvement Techniques:**
> None.

In outer space, you don't have all of the limitations of light and color that you might have on Earth, like the banana "boat" assemblage of the previous section. That makes this scene a little easier to deal with. All of the light comes from an imagined sun off to the lower right, and is very consistent throughout the photograph, which is important. If you want to pick nits: in space, light does not fall off except at huge distances. Light coming from the sun would illuminate all of the space ships we see in this scene equally, not making distant ones darker as seen here. An alternate way of making the more distant space ships seem like they are at a distance is to give them a little less contrast and slightly less sharpness. You don't want to do this enough that it becomes obvious—just enough that it creates less emphasis on the more distant ships. Overall, this is an entertaining and effective image.

Figure 11.19
A space-age shaving device.

Figure 11.20 The shaver has been transformed into a space ship.

Clown in City Hall

Photographer: George Sipl

Photographer George Sipl captured the interesting angles and features of this city hall tower, but on a cloudy day, which made the sky gray and blank looking. (See Figure 11.21.) Then he manipulated the image to emphasize some superb detail in the tower and added a new sky. Sipl did a great job of combining the sky and the building, including using some color from the sky to help integrate the tower with the overall photo. In addition, he emphasized the pieces of the building at the left and right of the tower.

The adjacent buildings are almost touching the central tower, which tends to make the tower itself less significant. I suggest adding a little space between the tower and its side buildings, as well as to the top of the frame (see Figure 11.23). This seems to fit the photographer's original intent to create a very bold look. It also helps to bring out that figure on the top of the tower enough to see it.

Photographer Techniques:
The photographer captured a photo of a city hall on a very gray day, then manipulated the image to create a colorful and dramatic look.

Suggested Improvement Techniques:
Pay special attention to the areas that touch or nearly touch one another as you rearrange your photo.

Figure 11.21
This structure is mundane in its present incarnation.

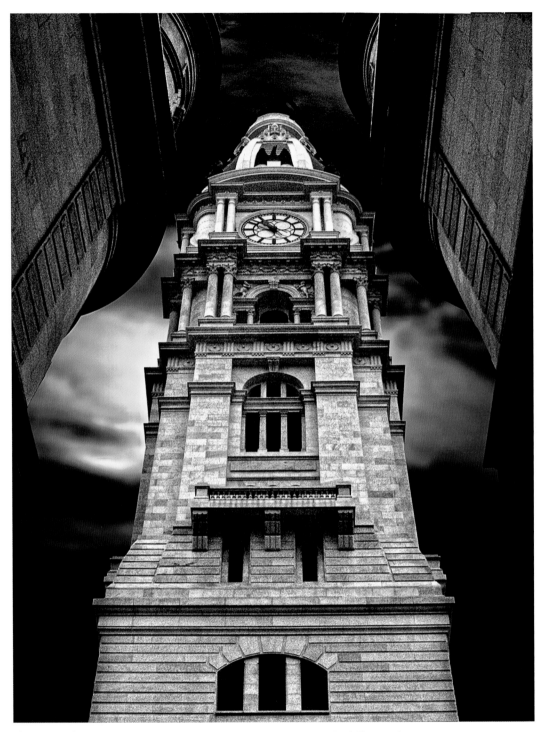

Figure 11.22 Creative image editing transforms it into a completely different object.

Figure 11.23 Adding space around the sides and top make the image seem less crowded.

Tall Ship

Photographer: Shirley DeWitte

The tall ships, the clipper ships of the past, are amazing craft (see Figure 11.24). They are wonderful to see in person, though it would be really cool to see them out at sea. Photographer Shirley DeWitte imagined just such a thing and brought her vision to life in an image editor. She composited a ship against a new sky and added the water and even added a name to the boat. She put all these things together in a very interesting and theatrical way.

Photographer Techniques:
The photographer captured a photo of a docked clipper ship. She then composited the image into an at-sea environment.

Suggested Improvement Techniques:
The top half of the picture looks great, but the waves at the bottom don't fit in. Connect those waves to the overall picture.

Figure 11.24 This beautiful ship belongs at sea.

Figure 11.25 Now the image is a piece of art worthy of an aftershave bottle.

As you can see in Figure 11.25, DeWitte did a great job of maintaining the detail in the boat, including all the rigging, while placing it against an interesting sky. She also brought some of the color from the sky across the boat so that the two feel connected. Adding the waves was an excellent idea, but they are a different color, scale, and intensity than the rest of the photo. (See Figure 11.26.)

Simply bringing the color of the rest of the image into these waves helps immediately, as you can see in my version. (See Figure 11.27). Toning down the waves with a filter reduces their sharpness and blends them with the rest of the picture. This image actually looks quite good if you use an oil painting filter on it. It is not a realistic image, anyway, so the texture of the oil painting goes well with the very strong colors and contrasts of the scene, and helps blend everything together more.

Figure 11.26
The off-color wave in the foreground doesn't quite fit in.

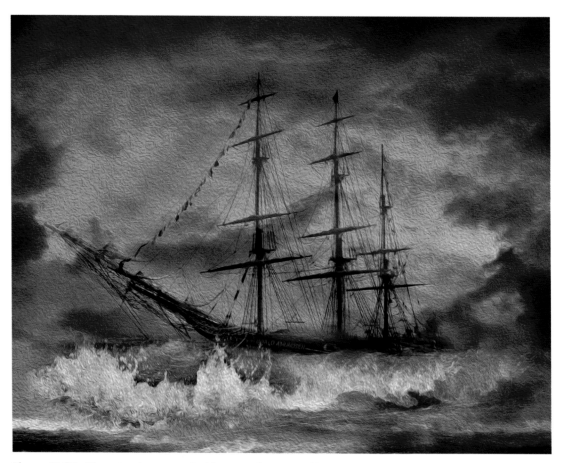

Figure 11.27 Changing the tone and adding an oil painting filter produces an artistic rendition.

Carla

Photographer: Nancy Balluck

Photographer Nancy Balluck captured a quiet moment with this fiddle player as she was taking a break between songs. This moment has a pensive, gentle feel to it. The light is beautiful, and includes a rim light that highlights her face and separates her head from the background.

Balluck processed the original shot to achieve better tonality and color, and then added a background to that open doorway. (See Figure 11.29.) In the original image, the open doorway is bright and somewhat distracting, but, in truth, the picture of the woman is strong

> **Photographer Techniques:**
> The photographer captured a fiddle player in front of an open door; she then added an outdoor scene to tone down the brightness of the doorway.

> **Suggested Improvement Techniques:**
> When compositing something into a scene, make sure the perspective and height match the scene.

Figure 11.28
A fiddler at rest.

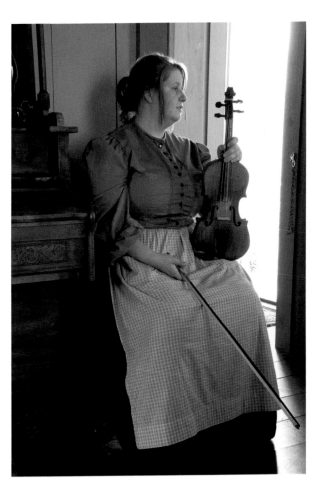

enough that she can compete with the open doorway without adding that outside scene. Even so, it is a nice idea to connect with the outdoors.

Balluck did an excellent job of compositing the background into the doorway. There are no telltale edges that would give this away. However, the background does seem a bit sharp. The background should look further away and be more out of focus. Indeed, the background makes it look like this woman is in some sort of upper-story room high in a house. Moving the horizon higher in the doorframe helps. (See Figure 11.30).

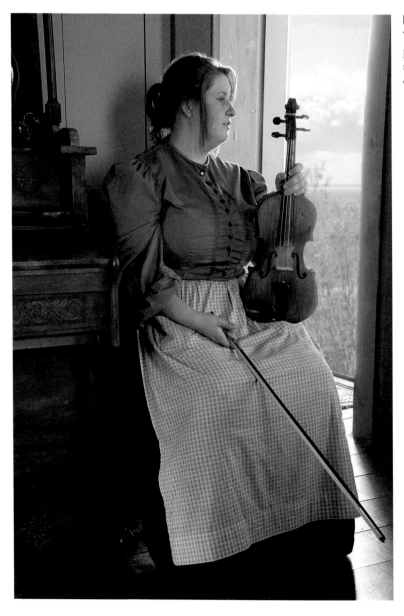

Figure 11.29
The outdoor scene produces a view outside the open doorway.

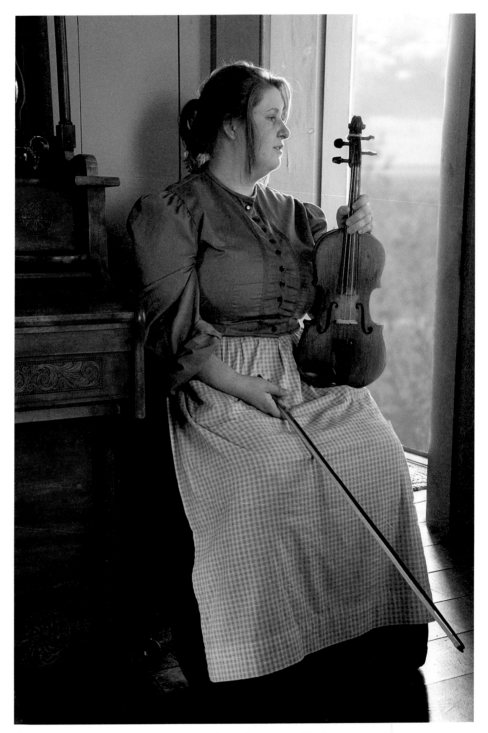

Figure 11.30 Moving the horizon up reduces the perceived high vantage point.

Beaver Marsh Sunrise

Photographer: Daniel Kozminski

Fog can make almost anything magical and mystical, like this photo of a winter marsh. (See Figure 11.31.) Photographer Daniel Kozminski added a heron and sun to the empty upper-right background. (See Figure 11.32.) This makes for a more interesting composition. In addition, he added a stroke border around the picture itself, then a larger background that acts like a matte. This is an interesting treatment for the photograph, especially the dark brown stroke border.

While this is a striking image as is, because this chapter deals with compositing techniques, I'm going to look a little closer at this photograph.

Photographer Techniques:
The photographer captured a foggy marsh then added color and composited the sun and a heron into the scene.

Suggested Improvement Techniques:
When compositing pictorial elements into a new photograph, make sure the edges look like photographic edges and not computer sharp edges. Also monitor how the light is interacting with the scene and the added pictorial elements.

Figure 11.31 While this is an attractive marsh scene, the empty space at upper right would look better with some content.

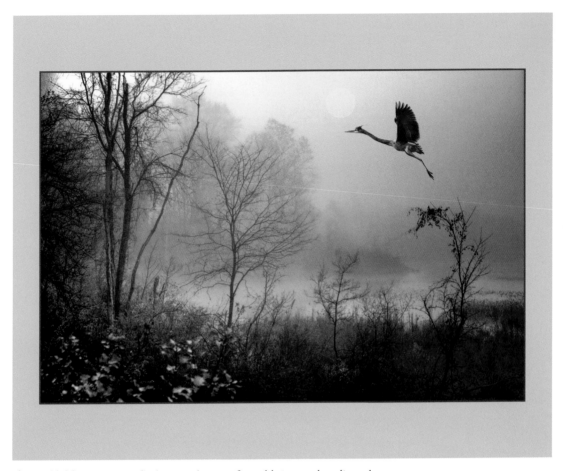

Figure 11.32 A heron in flight provides a perfect addition to the adjusted scene.

In Figure 11.32, notice the light that is hitting the side of the heron. When the sun is behind an object, this type of lighting is impossible. In addition, the edges of the sun and the heron have computer-sharp edges, not photographic edges.

My adjusted image (see Figure 11.33) uses some softening to blur the sun and edges of the heron. I darkened and added a fog-like quality to the rest of the heron to create a more realistic image that still preserves the photographer's original vision for this appealing image.

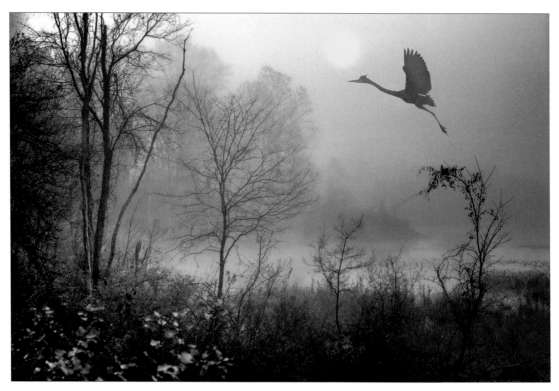

Figure 11.33 A little blurring restores the foggy mood.

12

Scenics

If you think landscapes aren't embedded deeply into our modern-day psyches, the next time you print a photograph, keep in mind that the name applied to any picture or document that's wider than it is tall is *landscape*. While scenic vistas were considered a lower form of Western art for centuries, from around the 15th Century onward landscape images have increasingly gained favor. That was especially true after the advent of photography, which, in its earliest forms, demanded subjects willing to remain immobile for the long periods required to capture an exposure.

Today, landscapes are a favored subject for photographers because they offer an opportunity to create thoughtful and interesting compositions with painstaking care. Those mountains aren't going anywhere. You're free to move around a bit to get the best angle, and, unless you're including people in your pictures for scale, you don't have to worry about an impatient subject. If you can't pull all the elements of a scenic photograph together to create a pleasing composition, you're not trying hard enough.

Even better, scenic photography isn't particularly equipment- or gadget-intensive. Any digital camera and its standard zoom lens will be fine in most cases, as long as your lens has a sufficiently wide focal length to take in expansive vistas. A wide zoom range, extending from a true wide-angle perspective to a decent telephoto setting, gives you the flexibility you need to photograph wide-open spaces or focus in on a distant mountain. Choice of focal length is important when shooting scenics, because it's not always practical to drive a few miles closer to a mountain, and it may be impossible to back up any further for a wider view (thanks to a cliff, forest, ocean, or other impediment at your back). This chapter shows you some interesting landscape images, and how they were made even better.

Yucca Sunset *Photographer: Donna Schneider*

This is a really lovely scene captured by photographer Donna Schneider. She captured the image shown in Figure 12.1 just after sunset, when the light is gentle, with subtle tonalities and colors. The sky has bolder colors and is an attractive background to these yucca plants. The image has excellent composition, especially the placement of the yuccas within the scene.

Photographer Techniques:
The photographer changed the camera height and focal length.

Suggested Improvement Techniques:
Correct underexposure.

The second image (see Figure 12.2) was taken from a lower angle, which, surprisingly, offers a dramatically different view of virtually the same scene. It's actually a much more effective image than the shot with the higher camera angle. Unlike the first image, in which the horizon is placed very close to the middle of the frame and cuts right through the middle of the yucca stalks, Schneider's second version places the horizon much lower in the frame. The stalks look better when they are placed totally with the sky as a background behind them. In addition, with the lower horizon of the second version, there is a much more

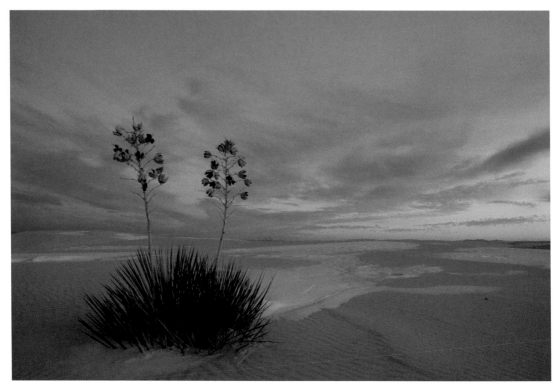

Figure 12.1 A view of yucca plants at sunset.

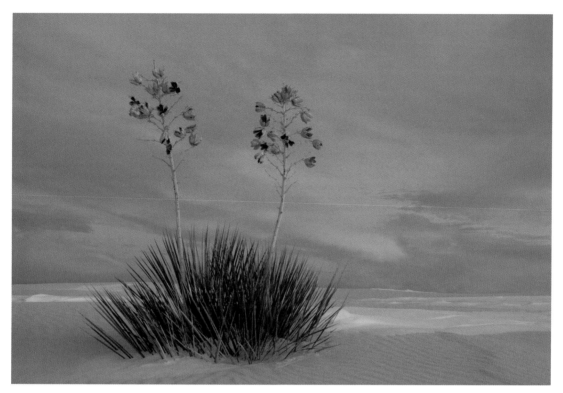

Figure 12.2 A lower vantage point dramatically emphasizes the stalks.

dramatic look to the sky, and there's a vivid contrast between it and the ground. When the two were roughly equal in size, as in the initial shot, their relationship was much less interesting.

The lower angle of the yuccas also gives them a very stately, almost regal look. It adds a sense of presence for the plants that the other shot simply does not have. Any time the photographer moves significantly above or below the "default" height that so many photographers use for landscapes, the change immediately creates interest for the viewer: you are showing something that isn't ordinarily seen.

The second image is slightly underexposed, which preserves the moody look often found as the sun sets at the end of the day. However, the darker rendition does render both the sand and snow a rather dingy gray. Underexposure is also affecting the appearance of the yuccas. The somber renditions looks like the image has been shot through a gray filter.

The histogram for this image shows that all of the tones are pushed to the middle and left side (see Figure 12.3). Had the photograph been taken in daylight, it would have been a largely white and bright scene, and the tones of the histogram would be clustered on the right side instead. In this dusk view, the tonalities appear to be darker than they really are, and lower in contrast. For my alternate take, I brightened the image a bit, preserving the rich colors and marvelous composition, but giving the lighter areas a less dull look.

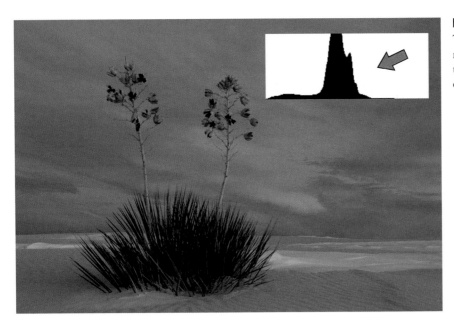

Figure 12.3
The histogram
reveals that all the
tones are in the mid-
dle of the image.

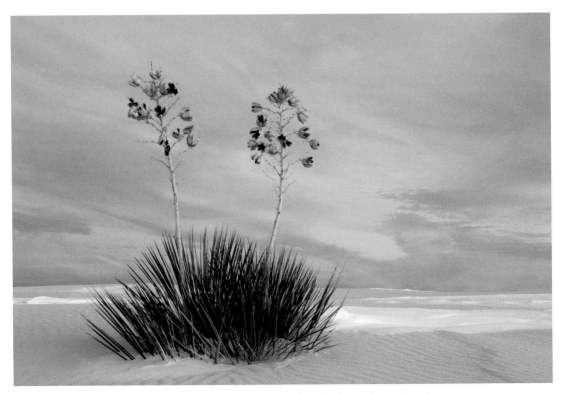

Figure 12.4 This alternate view retains the sunset's colors, but brightens the sand and snow.

Crystal Cove Waves

Photographer: Matthew Kuhns

Crystal Cove is a wonderful sunset location on the Southern California coast. It offers dramatic rocks and constantly changing water due to the shifting tides and size of the waves. In this sequence, photographer Matthew Kuhns found a very interesting set of rocks for the foreground, then shot multiple images, finding different waves each time (see Figure 12.5). The scene has wonderful colors; the sun is still filling the

Photographer Techniques:
The photographer changed his timing to capture different wave patterns.

Suggested Improvement Techniques:
Correct the halo problem along the horizon.

clouds with rich colors, while the rocks and water are absorbing indirect light from the bright western sky. Indeed, the reflected color of the clouds in the ocean adds a lot to the scene. Each of the individual images displays interesting movement of the water, movement that is enhanced by the flow captured using a slow shutter speed. The exposure is perfect: the bright areas of the water are pristine, and there is a good range of detail where fine detail is important.

The triptych of the three images is compelling, creating an impression of the place that a single image could not convey. You can see the wave come in and gradually explode over the rock. Still photography is always about moments in time; presenting several of them in succession is even more powerful.

When viewed alone, other images selected by the photographer from the same series are very strong. The view seen in Figure 12.6 is certainly attractive, but since the left side does not have the white detail of the surf, the image is not completely balanced. A better shot is seen in Figure 12.7, which has white water on both sides of the large foreground rock.

Figure 12.5 Three views showing the action of the waves.

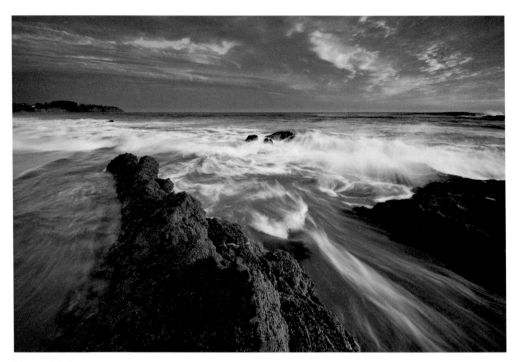

Figure 12.6 This view shows the waves crashing on the shore.

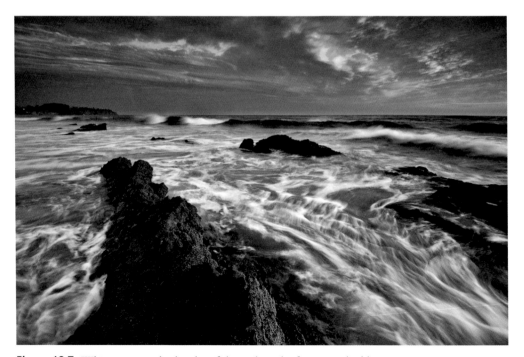

Figure 12.7 White water on both sides of the rock in the foreground adds interest.

The patterns of the surf in that image are extremely interesting to look at, and serve to pull the viewer deeply into the picture. There's a lot of detail there for the viewer to explore, yet the picture is still strongly structured so that the wealth of information is not confusing. That large rock in the foreground anchors the composition and complements the other rocks extending into the distance. The large rock also balances the bright area of sky at the upper right.

However, even though the brightness of the sky and water are well balanced, there is a halo effect along the horizon. That is something that viewers do often notice, and unfortunately, people will start discounting the image as being "Photoshopped." Such haloed edges, including the horizon, can be extremely important and worth the extra time to make them look right, as I did with my version (see Figure 12.8), in which I also restored the ruddy glow of the sunset to see what it would look like.

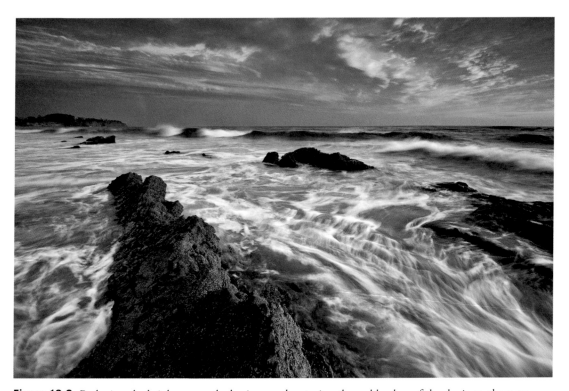

Figure 12.8 Reducing the brightness at the horizon and restoring the ruddy glow of the sky is an alternate treatment.

El Capitan

Photographer: Matthew Kuhns

This next set of images by photographer Matthew Kuhns illustrates how weather conditions and time of day can dramatically affect the rendition of an image. On first glance, the "after" shot in this pair might appear to be the result of some remarkable Photoshop manipulation, while, in fact, it was created primarily as a consequence of decisions the photographer made on site. In this case, the changing weather radically transformed the entire image.

> **Photographer Techniques:**
> The photographer captured weather conditions at two very different times. Some processing has been done to enhance the contrast and color of both images.

> **Suggested Improvement Techniques:**
> None.

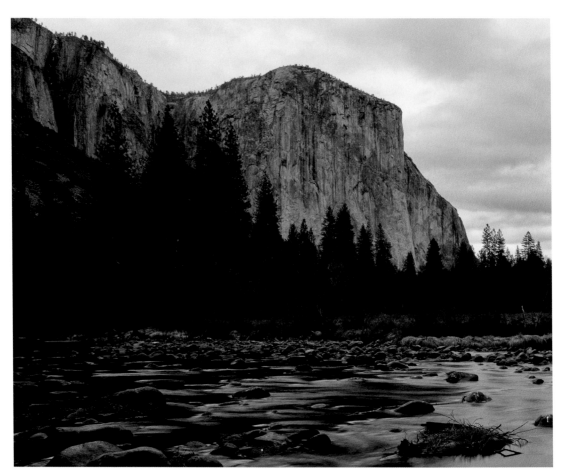

Figure 12.9 Given the weather conditions, most photographers would be happy with this shot of El Capitan.

The "before" image is an attractive image of El Capitan, a 3,000-foot granite rock formation in Yosemite National Park, taken on a cloudy day (see Figure 12.9). Kuhns brought out detail in the clouds as well as giving a rich look to the water in the foreground. But the image is not outstanding, because its overall appearance is somewhat gray, as you'd expect on a very gray day.

Kuhns decided to capture the monolith at a different time, when the weather had changed dramatically (see Figure 12.10). Now the vista includes a breaking storm that adds a bright spot of warm light on the rock face and which is reflected in the water. The resulting view is dramatic and quite attractive, and doesn't require a lot in terms of fine-tuning with an image editor.

It looks as if the photographer may have done some minor edits to brighten the trees and bring out some additional color. That helps the visual relationship between the cliff and the water. By keeping the far left side dark and just brightening the top of the trees a bit, at least giving them some transition other than going directly from bright to dark, an already attractive picture is made even better.

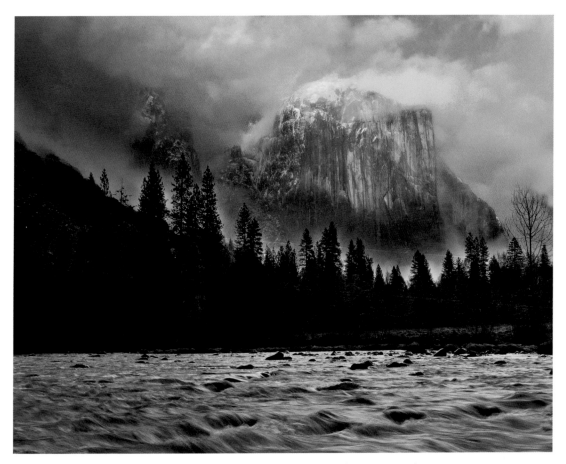

Figure 12.10 Improved weather conditions offered an opportunity for an outstanding image.

Oregon Coast *Photographer: Barbara Pennington*

One of the great things about photography is that there are often many possibilities for images if you are open to exploring the opportunities within a scene. Photographer Barbara Pennington felt that her original inspiring sunrise scene at an attractive location (see Figure 12.11) could be improved, so she started looking for details inside the image. She zoomed in tight on parts of the scene, taking a second shot that includes a lovely pattern of rocks and plants contrasting with the reflection of the sunrise in the water. (See Figure 12.12.)

Photographer Techniques:
The photographer shot an early morning sunrise but felt the overall scene was boring so she emphasized a more interesting detail.

Suggested Improvement Techniques:
Try some more adventurous compositions of the original scene that show off the sunrise and create dramatic visual relationships within the frame.

This "after" picture is a beautiful image. It has some very abstract qualities and an excellent set of design elements within it, from the contrasting branches and rocks to the horizontal stripes of color in the water. Pennington trusted her instincts and worked with the beautiful colors that were already present, rather than indulging in the urge to overenhance them in an image editor.

The detail shot has a good sense of balance. There's just enough of the dark rocks, but not too much. The pattern of the tree branches then creates a nice counterpoint to the bolder shapes of the rocks. And the colors throughout are beautiful, including this change of color from very warm at the top to cool down at the bottom.

The original scene of the sunrise was open for improvement because it's not clear which elements are the most important part of the shot. Is the sky most important, or is it the water? Because those two areas are about equal in size and space, the image becomes less interesting because the viewer will be unsure of the focus point. In addition, the horizon is essentially right through the middle of the picture. (See Figure 12.13.) The center is rarely the most interesting place to put a horizon.

In addition to the marvelous close-up that Pennington selected, there are many other picture-within-a-picture possibilities in this overall landscape, all of which start by moving that horizon out of the center. (See Figures 12.14, 12.15, and 12.16 for my suggestions.) All three of these possibilities use the photographer's basic shot and create images that have a clearer emphasis on the focus in the picture.

Figure 12.11 This is an excellent photo, but the horizon is centered.

Figure 12.12
The photographer took a second picture, zooming in on a detail that made a much better image.

Figure 12.13 The original image would be more interesting if the horizon weren't in the middle.

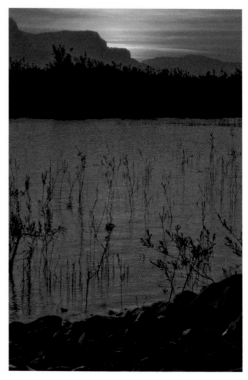

Figure 12.14 This vertical shot moves the horizon to the top of the image, emphasizing the foreground.

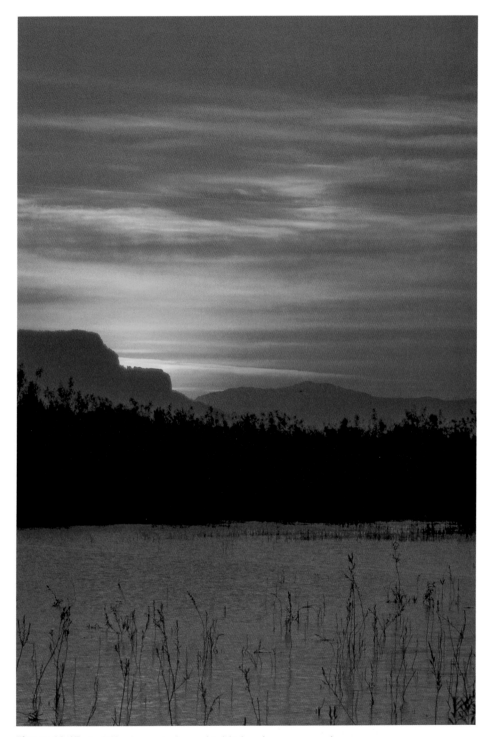

Figure 12.15 A different vertical crop highlights that gorgeous sky.

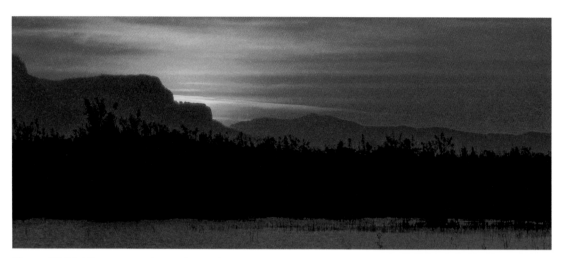

Figure 12.16 This picture also works as a horizontal image.

Sunflowers *Photographer: Maria Kaiser*

Both of these images of a sunflower field are interesting uses of a panoramic framing. They could be a multi-shot panorama stitched together (some cameras will do this for you; but multiple images can be assembled manually in an image editor) or the same effect could be achieved by cropping out the top and bottom of a single shot. Today's cameras have enough megapixels to spare that it is easy to create a very good panoramic image simply by cropping.

Each approach photographer Maria Kaiser used work well. In the photo that includes the sky (see Figure 12.17), there is a feeling of depth and space, because the distant background provides a place for the eye to venture within the broad expanse.

Photographer Techniques:
The original "before" photo actually has had quite a bit of work done to it. The scene is a panoramic image either cropped from the original image or created from a multi-shot panorama, and the colors and tonalities have been intensified. The "after" image takes a different approach to the composition by cropping the first photo from the top and bottom.

Suggested Improvement Techniques:
Tone down the over-saturated red field; darken the lower-left corner for the wider shot.

Figure 12.17 One panorama includes the sky and water in the foreground.

In the cropped image (see Figure 12.18), the photograph definitely has a more linear feeling to it, and it is also a much "flatter" image visually. The image is cropped to remove the sky and the tops of the hills. The viewer is now encouraged to see the scene as more of an abstract pattern of color and shape, instead of a specific place within a particular setting. Both approaches are valid, and both are correct if they reflect the photographer's vision. One has a more realistic feel, while the other imbues more of a graphic design with an abstract approach.

Overall, the color and tonalities of the images look good. The exception is that the center reddish field might look out of place to some. When it is toned down, the image looks more natural. (See Figures 12.19 and 12.20.) Even in the more abstract image without the sky, that red color competes with the lovely greens of the sunflowers. That said, the red field does work well with the tighter composition because it becomes more abstract.

Figure 12.18 Simply cropping at top or bottom transforms the image into a sumptuous abstract image.

Figure 12.19 Reducing the saturation of the reddish field makes the original image more realistic.

Figure 12.20 The less-saturated tight panorama also looks good.

Perhaps one reason to remove the sky was because of the washed out clouds at the top. However, they are a small enough part of the picture that they don't really affect it too much. There is such a strong visual relationship from foreground flowers to the background hill that the clouds are less important. Cropping the water at the bottom of the frame does simplify the foreground, but also starts to cram the sunflowers against the bottom edge. An alternate way of minimizing the effect of the water would be to simply darken it in an image editor.

Antelope Canyon

Photographer: Susan Bestul

Slot canyons are challenging to photograph. They have extremes of light and contrast that can be difficult to capture. Yet these unique canyons offer great opportunities for photographers to find interesting images. Photographer Susan Bestul made the most of her tour of Antelope Canyon by photographing a section that was filled with an interesting group of shapes, colors, and patterns. In her first image, she exposed maximum detail in the darker areas while letting the bright area go very bright. (See Figure 12.21.)

Photographer Techniques:
The photographer adjusted the color and tonality of the original photo, which is a bit flat and gray. She then cropped the image to a different framing.

Suggested Improvement Techniques:
Don't overexpose bright areas; tone down bright areas to bring them in balance with the rest of the picture; try a square crop.

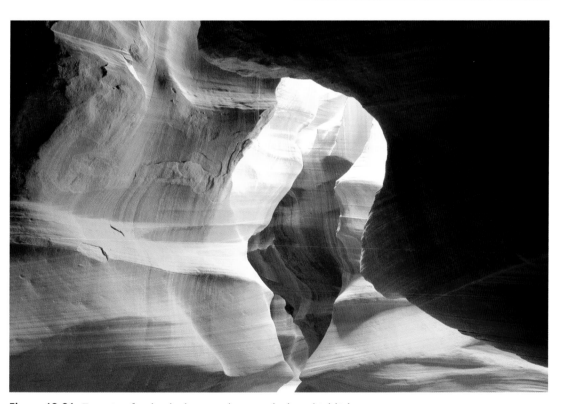

Figure 12.21 Exposing for the shadows produces washed out highlights.

Of course, that compromise made the original image a bit low in contrast, which is typical in the way digital cameras deal with scenes like this. The second version has improved contrast and better color to create a much richer looking photo. (See Figure 12.22.) It also has been trimmed to a more effective crop. One challenge that remains is the bright area in the background. It is still bright enough in the adjusted image that it looks a little washed out. (See Figure 12.23.) There is no question that having the bright area in that part of the image does create a feeling of depth.

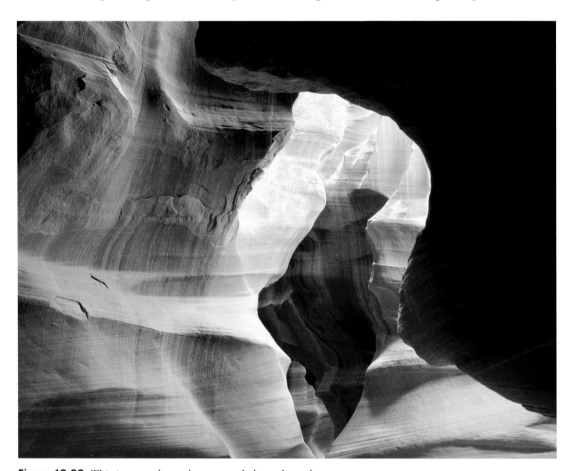

Figure 12.22 This improved crop has a more balanced tonal range.

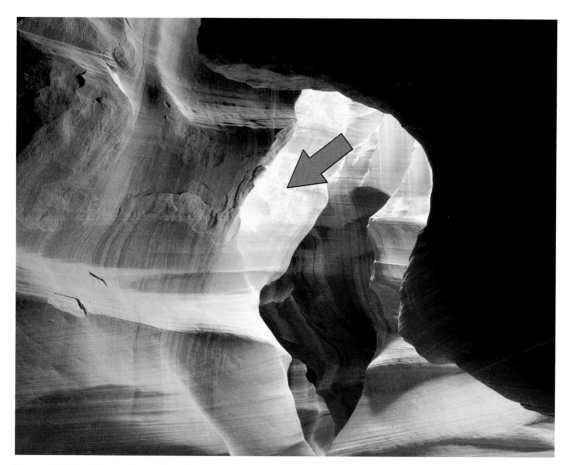

Figure 12.23 This rock is still too bright, but it's virtually impossible to capture the canyon's full dynamic range in the camera.

Consider darkening the bright rocks to bring them in balance with the rest of the image. You can only darken it somewhat here without picking up some problems with color and contrast because of the inherent limitations of an image captured with a digital sensor.

Bestul's original composition is great, and the horizontal orientation is perfect, especially with the way the dark, curving rock at right contrasts with the medium-tone rocks at left, and the lighter shapes in the middle. One of the strengths of this image is that it could also look good in a square format, as with my alternate cropping shown in Figure 12.24.

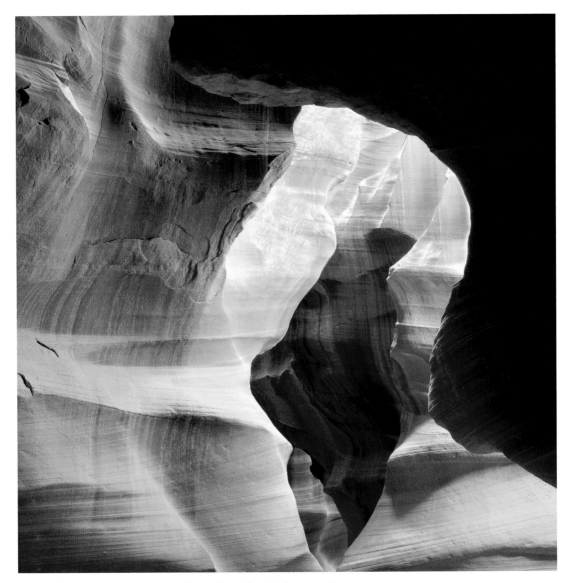

Figure 12.24 A square cropping also works well with this versatile image.

About the Photographers

All of the photographs submitted for critique in this book were supplied by members of the Cleveland Photographic Society (CPS), which has been in continuous operation for more than 125 years. Founded in 1887, the organization is one of the oldest photography clubs in the United States. With more than 500 members, CPS includes a healthy mix of well-known professional photographers, up-and-coming pros, serious amateurs, and fledgling shooters. The Society has always maintained a dedicated club house in which meetings, workshops, and classes are held three to four times each week. The CPS School of Photography has been in operation since 1920, and offers courses ranging from Fundamentals of Good Photography to Adobe Lightroom.

For this "photo clinic" book, I asked CPS members to submit at least two images that represented their first take on a particularly inspiring photographic subject, and a follow-up picture that shows how they resolved the challenge. I then brought in Rob Sheppard, an internationally known photographer and former editor of *Outdoor Photography*, to select representative images, comment and explain the photographers' solutions, and offer alternative ways of making these great pictures even better. Of the hundreds of submissions received, the photos included in this book were selected solely based on how well they illustrated essential photographic techniques. That's why, among the 40 CPS photographers showcased in this book, some have one or two pictures represented, while others have more. Despite the title of this book, none of these images are terrible, and all of them ended up terrific. My thanks go out to the following CPS members who took the time to offer their images, and who were confident enough to submit them for critique.

—David D. Busch

Nancy Balluck

Several years ago, I had an overwhelming need to become a more creative photographer. I love using various software programs for enhancing my photos, but I wanted to challenge myself by producing creative photos...through the lens.

After spending several weeks doing research on creative photographic techniques, one of my friends recommended that I try shooting with a Lensbaby. I had heard that the Lensbaby was complicated to use so I ignored her suggestion and continued on with my unsuccessful pursuit for a creative outlet. During a shoot on a beautiful fall afternoon, my friend handed me her Lensbaby and told me to give it a try. Reluctantly, I put it on my camera, fired off two shots and immediately fell in love with this magnificent lens. It was truly a "Eureka, I found it!" moment for me.

Thanks to the Lensbaby, and its numerous creative optics, I never have a photographic slump anymore. It has renewed my joy for all types of photography and I use it about 95% of the time. The Lensbaby slogan "See In A New Way" couldn't be more true.

I have been a photographer for the past 14 years and teach Environmental Portraiture and conduct Lensbaby workshops through the Cleveland Photographic Society and other venues in Northeast Ohio.

Elizabeth Barker

I have taken family photos since I was a teenager, progressing from 35mm cameras to digital photography. After having a child, photos became even more important to me, as my son was into sports. My camera equipment needed to be improved as well as my knowledge of my equipment. I knew that when his collegiate sports career ended I would have to find other subjects to satisfy my growing photographic passion.

I then joined CPS. With CPS classes and help from many generous club members, I learned how to use my equipment better and was exposed to new and different venues of photography. My passion continues to grow and I am never bored, since I combined a 35-plus-years medical imaging career with digital photography.

Susan Bestul

Susan Bestul, of University Heights, feels very lucky to have grown up in a home where artistic expression was encouraged. Her mother, who was a visual artist teaching wood engraving and etching at the Boston Museum School of Fine Arts, has prints on file at the Smithsonian. Susan fondly remembers, as a child, her mother conducting summer art lessons for all of the neighborhood kids and credits her mother for her "artist's eye."

Susan went on to earn her Bachelor of Music degree from the Cincinnati College-Conservatory of Music and then continued her studies at Yale University School of Music. Today, Susan is a professional cellist who performs regularly in Severance Hall with the Cleveland Pops Orchestra. From this valuable perspective, Susan truly believes that music and photography exist in perfect harmony with one another.

In addition to achieving recognition from the Cleveland Photographic Society Competitions, Susan also won third place in the 2013 Plain Dealer Travel Photo Contest. She has had her work exhibited at The 2013 Print Club Show at the Cleveland Museum of Art, as well as on the main campus of the University Hospital and at the Cleveland Institute of Music. She shoots with a Nikon D800 and a variety of Nikon lenses. Susan is an active member of the Cleveland Photographic Society as well as the Photographic Society of America.

Susan enjoys taking an ordinary scene and finding something unique to see through visual composition. "Expressing myself through the arts has always been an important aspect of who I am as a person. I am passionate about creating photographs. They provide a way to share, with others, the beauty that I see all around me."

Robert Boyle

I have been taking pictures on and off since I graduated from high school. However, it wasn't until the dawn of digital photography and my joining the Cleveland Photographic Society (CPS) that the quality of my photographs began to noticeably improve. I think this improvement is a result of the activities provided by CPS and the willingness of their membership to share their expertise.

I enjoy all types of photography, but I particularly enjoy photographing things that are old…old buildings, old cars, etc. Old subjects don't necessarily have to be in an advanced state of deterioration. For example, I photographed a bank vault that was built in the early 1900s. The craftsmanship of the engraving on that vault door was amazing, truly a work of art. I enjoy photographing artwork such as that and sharing it with others.

Zach Bright

Zachary Bright grew up in the southwest and developed a love of nature from a young age through backpacking trips with his father. In his photography, he seeks to capture the moment when weather, light, and scene combine to form something more than the sum of their parts. When he isn't photographing landscapes, Zachary enjoys traveling and exploring nature with his family. He currently resides in Cleveland with his wife and two young boys.

John Earl Brown

After receiving his BA from Ohio State University in 1972 and spending months traveling through Europe after graduation, John Earl's passion for photography grew. He spent two years studying photography at Ohio University and several years photographing in Colorado and the Four Corners area of the American West. After many years away from photography, the purchase of a digital camera in 2004 renewed the passion. Since then he has been active with the Cleveland Photography Society, regularly exhibits his work, and has been published in numerous books.

Shirley DeWitte

I've always loved photography. It started with the usual photos of family. As my boys grew up they were no longer willing participants. My next subjects became my dogs. They would do anything for a treat. So training began to pose them for their photos. Then I started experimenting with editing programs. This unlocked endless new potential. Each year I create Christmas cards using my dog photos. After joining CPS I learned so much as I saw other people's photos in competition and heard the judge's critiques. Photography is a never-ending learning process.

Debbie DiCarlo

Debbie DiCarlo's photographic journey began in the 1960s when she received a Kodak Instamatic film cartridge camera as a gift. More recently with a digital SLR in hand, Debbie started to travel near and far, drawn by the awe-inspiring natural beauty of our world and its wild inhabitants.

Her photography has been exhibited in various locations in Northern Ohio including the Cleveland Institute of Music, North Chagrin Nature Center, Rocky River Nature Center, Twinsburg Library Gallery, Westfield Bank Branch, and Beck Center for the Arts, to name a few. An image of the Cuyahoga Valley National Park was featured in *Cleveland Magazine* in 2013.

A photo of the Chagrin River won the 2013 *Popular Photography Magazine*'s Annual Readers Photo Contest—chosen from thousands of entries from around the world and was featured as a full-page spread in the February 2014 magazine. That same image was featured in an online photography publication called *Photography Masterclass*.

"The Howling Lesson," a photo of an adult and two coyote pups howling, garnered much notoriety and has been blogged about and featured in online stories around the world including the Huffington Post, GrindTV.com, MSNnow.com, DailyMail.co.uk and more. In the 2014 Solon Center for the Arts Focus competition, Debbie's photo of a Costa Rican hummingbird won the top prize—Best of Show—in the seasoned professional category.

Some of her bird photos are being used in the soon-to-be-published *Ohio Breeding Bird Atlas II*. Her work can be seen and purchased at www.debbiedicarlophotography.com.

Rob Erick

My dad let me hold and take a picture with his Kodak 35 rangefinder when we were on a family beach vacation when I was five years old. He was feeding seagulls in flight and my job was to capture the moment. I fiddled too long with the shutter and finally snapped the picture when he was done and walking back toward me. I failed to capture the "decisive moment" on that occasion, but photography has been a part of my life ever since—and that 35mm slide still remains in my collection.

From my first Brownie through my first SLR to my trusty Nikon D70 to this day, photography has allowed me to see the world in a special way and to share what I see with others. To that end, I am privileged to have learned from the best at the Cleveland Photographic Society, where friends old and new strive to grow and challenge each other to see and record light in all its magic, nuance, and subtlety.

Photography presents me technical puzzles to solve and the challenge to present the ordinary in extraordinary ways. It takes me places I wouldn't ordinarily go, allows me to see and appreciate things others bypass or take for granted and, thousands of slides, tens of thousands of negatives, and 4 terabytes of digital images later, it never grows old.

Erik C. Heinrich

My love for photography started at a very young age. My grandfather, for as far back as I can remember, pursued photography as a hobby. You could call him a closet photographer. He would disappear into his closet, (dark room), and come out with amazing photographs. This "magic," impressed me. I knew that someday I would follow in his footsteps.

In high school, I rediscovered that photographic "magic," when I enrolled in a photography class. I also worked after school and on summer break, at a one hour photo lab inside the mall. After high school, I put the photography hobby on the backburner. I went on to pharmacy school at the University of Toledo, where I graduated. Currently I am a pharmacist at University Hospitals.

A few years ago I decided to dust off that old photography hobby I once loved so much. There was so much to learn in this new digital age. I joined the Cleveland Photographic Society, and enrolled in photography classes. Once again I fell in love with the "magic" of photography. In December of 2012 we celebrated the birth of our first son, Aaron. He is the subject of many of my recent photos. I look forward to someday sharing the "magic" of this utterly amazing hobby with him.

Jerry Hilinski

Jerry Hilinski is a registered nurse and health care consultant who began snapping photos before the age of 10. When he worked as an ICU nurse in a local hospital, he got more serious about exploring photography as a creative pursuit and outlet from the stress of dealing with the daily life-and-death drama of the ICU. As a consultant, he has traveled extensively around the country and has been fortunate to photograph some of the most amazing sights in America. In one memorable two-week period, he photographed beaches on the Atlantic, Pacific, and Gulf coasts. Every once in a while, corporate travel DOES have its advantages.

Angelo Jacobs

I've been taking pictures for about 40 years. My first camera was the Polaroid Swinger, which I won as a prize when I was a paperboy for the *Plain Dealer*. People who know me consider me a wedding photographer, because that's what I shoot the most of (mostly for family and friends). I love to shoot weddings; they are such a joyous time. Everyone is dressed up, happy, and ready to have a good time. I really like to photograph people in general, not sunsets, mountains, or flowers. That's just me.

Harry Kaulfersch

Two of my great passions in life are travel and photography. For the past twenty years, my leisure time has been spent trying to improve my photography skills and techniques. Being a self-taught photographer, I continually learn by reading books, magazines, attending seminars, watching webinars, and participating in judged photo competitions. With photography you never stop learning—there is always something new to experience, be it equipment, techniques, or traveling to places you've never been before. My favorite subjects to photograph are landscapes and nature. By researching wildlife and understanding my subject, it offers me the best opportunity for success. I'm a member of KelbyOne and the Cleveland Photographic Society.

My photos have been on display at the Cleveland Institute of Music, Cleveland State University, Cleveland Public Library Main Branch, and North Chagrin Reservation Nature Center through the Cleveland Photographic Society. Some of my images are on permanent display at the Osceola County Welcome Center and Historical Museum in Florida.

Maria Kaiser

Interests of mine, early in life, suggested that one of the directions in which I would go would be art. Throughout school it was a special focus, which resulted in a fine arts minor at Adelphi College in New York. Photography became an interest as my five children were growing up and when I was working in positions with young children in preschools and with children with disabilities. It was in 1983 that I pursued more in-depth information in the Cleveland Photographic Society's Fundamentals and Darkroom classes. I've been a member of this fine club since that time.

Photography, for me, has been thrilling principally because of the ability to isolate magnificent vistas and their mysteries of atmosphere and mood and of the astonishing details of nature close up. I also thoroughly enjoy the humor and character I find in people in everyday circumstances. Photography has also become a recording device for images I later translate into watercolors, etchings, and woodcuts.

I have now been in more than 15 gallery art shows in Cleveland and Toronto and was awarded both second place and honorable mention in the Cuyahoga Community College Juried art shows.

Don Keller

After "toying "with cameras for several years, my desires were changed when my wife and I visited the Grand Canyon for the first time in 2002. At that time I had my first digital camera, a Nikon Coolpix 5700, with which I took incredibly bad images (no fault of the camera). That experience gave me the desire to learn more about this craft. Joining CPS, taking classes and photo workshops has helped me achieve better results when I photograph God's beautiful creation, which I do as often as possible.

Jan Kocsis

I have been keenly interested in photography since being introduced to this art form by my husband, John, 35 years ago. I am a nonprofessional photographer, love to travel, and use both a Nikon D80 and Nikon Coolpix 510 to capture my images. In addition to having taken photography classes at a local college, I have learned a great deal over the years through membership in two photography clubs: the Southwest Camera Club, a nature photography club located in the Cleveland Metroparks where I am a past treasurer, and, more recently, the Cleveland Photographic Society.

Dan Kozminski

I first became seriously interested in photography while I was in the navy stationed in Hawaii. I lived on the beach and there were just so many wonderful sites and views that I felt the need to capture them on film. (You remember film, right?) My first real camera was a Minolta SRT-101. I loved that camera and wish I still owned one today. My photographic focus eventually evolved to include not only nature but people as well.

A few years ago I was fortunate to have one of my photographs published in *Digital Photography Techniques*, a British publication focusing on Photoshop. Some of my work has also been on exhibit at the Cleveland State University Art Gallery, Cleveland Hopkins International Airport, Cleveland Institute of Art, University Hospitals of Cleveland Atrium Gallery and other venues around the city. I currently use Photoshop and the Nik software plug-ins, which I love. The combination of these two programs can transform an average photograph into a more compelling work of art.

Matthew Kuhns

Matthew Kuhns started his photographic adventures in Cleveland, OH, and now lives on the West Coast near Los Angeles, CA. His award-winning photographs strive to capture nature in all its glory, venturing out in wild weather or even climbing erupting volcanoes. When not working as an aerospace engineer or inventing new types of camera equipment, he can be found exploring the Eastern Sierra mountains and Yosemite.

Roger Moore

I have been an avid photographer since I was a teenager, and worked on the newspaper staff as a photojournalist when I was at Ball State University. I owe my interest in photography to my father who was a photography hobbyist and who bought me my first manual 35mm rangefinder camera when I was 13. I was born and raised in Indiana, and have lived in Germany while in the U.S. Army, Japan while serving as an executive at GE, and several locations across the U.S. from California to Massachusetts and have been blessed to have traveled to, and taken photographs in, 45-plus countries around the world. I currently reside in the Cleveland, Ohio area. I'm a father to my two beautiful children

(Christine and Andrew), friend to some very special people in my life, and colleague to many. I enjoy photography in all of its creative forms including astrophotography, architectural, cityscapes, landscapes, macro, nature, portrait, special effects, and night photography (low light). I am a member of the Cleveland Photographic Society, Photographic Society of America, and the International Freelance Photographers Association. I have exhibited my work at many art venues throughout the Cleveland metropolitan area.

My bag includes two Canon 5D Mark III bodies and I employ the following lenses: Canon EF 15mm f/2.8 Fisheye, Canon EF 70-200mm f/2.8L IS II USM, Sigma 120-300mm f/2.8 DG OS HSM, and my new Tamron SP 24-70mm F/2.8 Di VC USD (super-sharp all-purpose lens!) I enjoy life and enjoy the activity of capturing life's golden moments as well as God's beautiful creations through photography. I can be reached at moorerd007@ yahoo.com.

Susan Onysko

Susan Onysko is a travel photographer who has devoted the last decade to the art of capturing evocative stories from some of the most remote and extreme locations of our world. In places like Bhutan, Mongolia, New Zealand, Morocco, Patagonia, Death Valley, Alaska, Cuba, India, Thailand, Cambodia, Antarctica, Tibet, Scotland, The Galapagos, Vietnam, Myanmar, and Turkey, Susan has an eye for unexpected images that evoke that locale's purest essence. Because she quietly positions herself to convey a relatable moment that unites us in our similarities, her well-rounded, professional work has garnered numerous awards and exhibits and has been featured in *Popular Photography Magazine* and *Photo District News*.

Her photos have been on display at the Joseph-Saxton Gallery, Hudson Fine Art and Framing, the Cleveland Institute of Music, Cuyahoga Valley Art Center, the Moos Gallery at WRA, the Butler Institute of American Art, Akron-Canton Airport, and Cleveland Hopkins International Airport. She also has a long-term exhibit on display at Chagrin Arts in Chagrin Falls. Her photos have appeared in *Popular Photography Magazine*, *Photo District News*, *Cat Fancy*, and countless other local publications. Susan is available for speaking engagements on travel photography and competition judging. Visit susanonyskophoto.com to view more of her work.

Anita Orenick

My grandfather passed his love of photography to my dad and it seems that there's been a camera in my hand my whole life. When I chose graphic design as my major in college, I added photography as a specialty so that I could make my own photos and not rely on stock photography. I took every photo course that was offered and then continued with independent study, working primarily with film in both black-and-white and color darkrooms until beginning to explore digital in my senior year. At the Cleveland Photographic Society, I act as one of the co-directors of the Fundamentals of Good Photography class and serve as a primary instructor in the Photoshop Editing course. My involvement in the school's programs helps me continue to learn and grow.

Brian O'Riordan

I have been a research physical chemist, a fighter pilot, an executive (with worldwide travel), a consultant, and an expert witness—some of which have made being a photography enthusiast all the more pleasant (and vice versa). Vacations, grandchildren, and an understanding wife more so!

Barb Pennington

Photography has disciplined me to be patient, to be still, to look beyond the obvious, to step outside my comfort zone, to take chances, and invite challenges. My Nikon does not discriminate over age, gender, ethnicity, physical condition, or neighborhood.

Photography opens the lens and the path to capture, record, surprise, and gift. It pushes me, frustrates me, motivates me, sooths me, and comforts me. By joining the Cleveland Photographic Society in 2004, I have learned and developed my skills through education, mentoring, competing, and pleading for help. Fellow members have been gracious, kind, encouraging, and supportive. Some will be my friends for life. Photography…what an exciting adventure!

Joseph Polevoi

A native of Akron, Ohio, Joseph Polevoi received his BFA from the Akron Art Institute Professional School. After serving in the U.S. Army as an illustrator during the Korean War, he moved to Cleveland and worked as an artist at the *Cleveland Press* newspaper. He later designed corporate publications and served as public relations art director at Ohio Bell/Ameritech until his retirement in 1986.

Polevoi is a past president of the Cleveland Society of Communicating Arts and past president of the Cleveland Chapter of the American Institute of Graphic Arts. Since his retirement, he has developed photographic techniques using kaleidoscope lenses and computer graphics. The results are compelling and a unique visual imagery of "everyday" objects and settings.

As part of his effort to share these photographic impressions, Polevoi has made presentations to more than 300 audiences in cities across the United States. A recent article in *Popular Photography* described his photographic and digital art compositions as "a world of vibrant color, swirling shapes, and pulsing patterns." His photographic style, the magazine declared, "harks back to the kaleidoscopic Sixties and forward to a digital future."

Polevoi's prints have been featured in numerous photography exhibitions in the U.S. and Japan. A set of his classic car prints is in the Progressive Auto Insurance permanent art collection, and his kaleidoscopic photos are in a museum in Japan as well as private collections.

Shannon Rice

I took my first photography class in 1997 and immediately fell in love with it, especially people photography. After briefly considering pursuing photography as a career, I decided against it because it was "not practical." I went off to college and studied the practical field of computer science, graduated, and got a job in my field. Through all of this I remained a photographer, taking pictures everywhere I went.

As digital photography became popular, I knew it was the way I wanted to go. I love the idea of taking photos of everything without the added expense of processing film, then instantly reviewing the pictures to see what I can create. I strive for a great picture in the camera that can be turned into an extraordinary image in the computer. In 2008 I discovered the Cleveland Photographic Society. I took some of the classes and attended field trips and meetings—and realized that "practical" isn't as important as doing what you love.

Debra Rozin

I feel as though I live the life of the average photography enthusiast whose path has been marked by two very special events. The first was my ability to finally take a true black-and-white film photography course with darkroom instruction while in the midst of a busy medical career. At my local community college, I fell in love with the basics of black-and-white photography, and was inspired by teachers and students. The second event occurred 15 years later, when, after a hiatus from the hobby, I found in the Cleveland Photographic Society a group of like-minded photographers and instructors who taught me the nuances of digital photography, helped me further my photographic interests and abilities, and became some of my dearest friends. It is because of these two events that my photographic journey is rich, rewarding, and far from ordinary.

Ed Rynes

Ed Rynes has been capturing photographic images since obtaining his first camera when he was an 18-year-old GI in Occupied Japan after WW II. He began taking art and photography classes as an undergraduate at Ohio University and continued his interest in photography from film to the digital technology of today. His images have appeared in a number of venues: books, magazines, newspapers, photo exhibits, and private collections.

He enjoys photographing classic cars, architecture, people, street scenes, flora, fauna, and anything that will result in an interesting visual image. He is fond of producing whimsical imagery using Photoshop techniques. He especially likes stalking the wildlife that he and his wife discover during their winter retreats in Florida. The beauty and elegance of the shorebirds and raptors of the Gulf Coast have captivated them since their first encounters with these magnificent birds.

Ed states that photography is his therapy and has taught him the difference between looking and seeing.

Dan Sandy

Inspired at a young age by my older brother, I've had a passion for photography for the better part of two decades. It was only about 10 years ago that my hobby became a passion. I enjoy most subject matters, but spend most of my time volunteering at the Cleveland Animal Protective League as a cat photographer. This is also where I was honored with the title of 2012 Volunteer of the Year, and have had several photos used in a variety of print and online publications.

Along with being a board member, I've also won several awards and contests at the Cleveland Photographic Society. This includes a Photo of the Year in both 2011 and 2013, and placing in several competitions! I'm not certain what the future holds, but I look forward to capturing it through a lens!

Donna Schneider

Donna Schneider has enjoyed photography since high school when she was introduced to photography by her father. Since retiring three years ago, she has had the opportunity to spend much more time pursuing her photography passion. She enjoys traveling worldwide with her husband to experience and capture the beauty of God's creation. She lives in Broadview Heights, Ohio, where she is a member of the Cleveland Photographic Society.

Michele Schneider

Michele's love for nature and photography started at an early age. Cameras were a part of her childhood and were always present in the household. Her favorite was a Polaroid SX70 because she received instant gratification from the fact that photos developed on the spot. This feature sparked her interest in photography.

As a young girl, she grew up in the Blue Mountains of Pennsylvania surrounded by an abundance of wildlife. At the advice of her mother, who was also a scout, she joined Girl Scouts and learned a deeper appreciation for birds, insects, and butterflies.

As a teen, Michele's father always had a video camera or a camera with him at her baton and cheerleading performances. Her father's influence to go into television lead her to college and she earned her BA in Broadcast Journalism. After her graduation from Kent State University, she worked as a radio news reporter at WEOL. She was awarded a Cleveland Press Club award for her investigative reporting.

Presently, Michele is employed as a videographer, editor, and department manager for OSV STUDIOS. She decided to take up photography again, when digital cameras companies began to combine video and photo in the same device. Michele experienced a renewed enthusiasm for photography after taking "Camera Fundamentals" and an "Elements" course through the Cleveland Photographic Society.

In her spare time, she enjoys spending time with family, her husband John, her daughter Brittany, CPS members, and other photo club friends. Her work has been on display in several nature centers and exhibits around the Cleveland area.

Mawele Shamaila

My name is Dr. Mawele Shamaila, and I am a Food Scientist working for Nestle R&D in Ohio, USA. I was born and grew up in Zambia and moved to Canada for my graduate university degrees and later to the U.S. for work. I started serious photography in 2008 after a good friend of mine bought me a Canon XT camera and I took a class with the Cleveland Photographic Society, to which I belong as a member. I have improved my photographic skills over time by entering competitions, checking what other photographers shoot, and just having passion for photography. I have a website (www.mawele.smugmug.com) and regularly get about 10,000–20,000 hits per month. I have no particular genre but shoot anything interesting and have taken photos in many places in Africa, North and South America, and Europe.

Martin Shook

I have always been around cameras. As a child, my parents took a lot of family photos and actually put them in albums. My dad always had a good camera, although he never really understood photography. I always had a camera available, though nothing fancy. More like a Brownie Hawkeye; the popular point-and-shoot 60 years ago.

I switched to photography as a serious hobby after I retired from racing sports cars. It is much less expensive, less physically demanding, more creative and, for the most part, safer.

My grandfather, on my mother's side, was an acclaimed studio photographer in New York City around the start of the last century. Sometimes I think I may have inherited his gift for photography although I have not won any competitions yet. But of course it took a few years of racing before I started winning.

I began my working career as an electrical engineer, but after ten years I switched to accounting. I became a CPA in 1979 and the only reason that I haven't retired is that I can't afford to be a full-time photographer having spent too much on racing.

The photography bug bit me about eight years ago when I started shooting with a Sony PowerShot S2. I thought some of my shots were pretty decent and decided I could justify shooting with a better camera. I moved up to a Pentax KX, bought some good glass, some books, some software, and began taking photography seriously. Of course, I had to get my wife a KX too and a couple of lenses. Good tripods and ball heads were added to complete the basic gear. We have since moved on to a Pentax K5 and a K5IIs and I am starting to acquire some studio lighting equipment. Buying more stuff never ends, but at least it lasts for more than one season.

While my wife likes to take nature shots featuring patterns and textures, I try to make artistic compositions of landscapes and buildings. I look for strong lines, patterns, depth, contrast, and unusual views. I also do pretty well with flowers and people. So far, I have avoided the kind of photography that requires optimized equipment choices, such as wildlife, BIF, action sports, underwater, aerial, and panoramic shots. I prefer the kind of shooting that is more about composition than catching the moment. I post-process with Lightroom and I use Elements for touch-up work. I use HDR for indoor ambient light shooting, and I do stacking when taking close-up shots of flowers.

Aside from finding good shooting locations in Cleveland, I find the most difficult thing to do is criticizing my own work. Seeing the good and bad in other peoples' work is much easier than seeing it in my own work. Revisiting a shot weeks after completing post-processing helps a lot, and waiting months helps even more.

If I have one goal for my photography, it is to make good art photos. I have always thought analytically and been good with mechanical designs. Learning to see the world as an artist is challenging and rewarding. It is a long road to travel. The destination is never clear, but the journey makes it worthwhile.

George Sipl

I've been a musician as long as I can remember. I was 6 when I started piano lessons. Played in bands through high school, then went on to major in music education in college. During my senior year, I joined with the Eric Carmen Band and recorded "All By Myself," which became a top-5 hit on the national charts. After 3 years, I went on to study audio engineering. Between engineering, performing, arranging, and producing I am able to support my photography habit!

Photography is an excellent get-away for someone who uses his ears for a living. I struggled taking slides for years, but my creativity blossomed with the advent of digital photography. I took a number of college courses in Photoshop, and am proud to share with you the fruits of my labor.

Alexander Stulock

The satisfaction of seeing the final image, crafted from the shutter click to the software clicks, is what really makes my work feel like art. I enjoy percolating over a photo and deciding where to take it, and the challenge of turning my creative vision into the finished work. I recently completed an archival photo book of my abstract works and will soon be working on a book for the 365 Project series that was completed in April of 2014. Film is something that caught my eye and heart recently and I've since started shooting medium format, both instants and negatives. I shoot a broad range of subjects and soon want to join the online market for archival art prints.

Jon Theobald

Jon Theobald is a native Clevelander and worked for 31 years as a high school teacher and English department chairman in the Cleveland Municipal School system. He has a Masters Degree in the Arts from John Carroll University.

His main interest in photography involves documenting his travels throughout the United States and to just under 100 countries. He has given travel presentations using his photographs at various venues in Northeast Ohio. For the past two years, he has been a member of the Cleveland Photographic Society.

Jamie Umlauf

My love of photography began with my parents. As far back as I can remember my mom and dad always had cameras in their hands. I can prove it with the stacks of scrapbooks hiding in the cabinet full of old photos, slides, and slide projectors. The photography "bug" really bit me my junior year in high school. I had taken an introduction to photography class. This is what began my love of black-and-white photos. Along with the basic rules and techniques of taking a good photograph, I learned the art of developing. My senior year I took Intro to Photography II and Advanced Color Photography. I loved every minute of it. One of my life goals was to spend eight years in college and become a veterinarian. After seeing a few of my photos, my aunt told me I was going into the wrong profession. Today, I am a college graduate with a degree in wildlife biology and a minor in nature interpretation. Did I make the right choice? I'm not really sure, but one thing is definite. I'm confident in the photographs I take, and photography is a true passion I will have for the rest of my life.

Dennis Wert

Dennis Wert, a retired structural designer and accomplished wood-worker, joined the Cleveland Photographic Society in 2010. In 1950 he received a "Kodak Baby Brownie Special" from his grandmother for his eighth birthday. Though it was a fascinating item for many years, he did not develop a real interest in photography until 1985 when his wife gave him a 35mm film camera. Dennis photographed everything that passed the front of his lens. Now in the digital world, Dennis enjoys landscape, wildlife, architecture, auto, and aviation subjects. He is honored to have photos chosen for exhibits at Cleveland State University, Cleveland Institute of Music, Beachwood Civic Center, and the Cleveland Public Library. Three-plus years of membership in the Cleveland Photographic Society has provided Dennis with the opportunity to improve his skills, and he is humbled to have received photo-of-the-year awards by the Cleveland Photographic Society.

Vicki Wert

Vicki Wert's interest in photography began more than 30 years ago when she was given her first SLR, an Olympus OM-1. Photography was a casual hobby for those decades, but four years ago, she became a member of the Cleveland Photographic Society, and has become very serious in her pursuit of the art of photography. Vicki is honored to have images selected for numerous exhibitions in the Cleveland area. She enjoys all types of subject matter, but particularly pursues landscape and wildlife photography. She currently serves on the Board of Directors of the Cleveland Photographic Society and is an instructor for the club's Photoshop Elements class. A CPA by profession, she is also a lifelong musician who has been principal oboist for the Cleveland Philharmonic Orchestra for more than 20 years.

Eric Wethington

Eric Wethington is a photographer from Brunswick, Ohio. He is an active member of the Cleveland Photographic Society. He is currently working on a second Assc degree (Photography) from Tri-C. He does presentations at local photographic clubs (CPS, Lakewood, Medina, Wooster, CDPUG, Botanical Gardens) many times a year.

Currently, Eric shoots with a Pentax K5 and has been a loyal Pentaxian since 2004. He has been employed by Dodd Camera & Video for the past 20 years.

Eric has had an image in the CPS exhibit at the Cleveland Institute of Music and Broadview Heights Community Center. He has an exhibit called "Running the Red Line," a photo journalistic approach to the Cleveland's RTA Red Line that was shown at the Barberton Gallery of Fine Art, and has been published in the Cuyahoga Community College Literary Journal "Breakwall" (Spring 2012).

Rick Wetterau

Rich Wetterau is an amateur photographer who enjoys shooting most aspects of nature, specializing in near-infrared captures from converted digital cameras. Other photography endeavors include table-top macro, light-painting effects, low light, and night shooting. Wetterau also has had the opportunity to "attempt" to shoot modern ballet. He's still working on perfecting that one.

Index